To the Field
with love +
solidarity,
Fred 8.15

Those who were expelled from humanity and from human history and thereby deprived of their human condition need the solidarity of all men to assure them of their rightful place in "man's enduring chronicle." At least we can cry out to each one of those who rightly is in despair: "Do thyself no harm; for we are all here." (Acts: 16:28)

> Hannah Arendt, final sentence of *The Burden of Our Time*, 1951, UK edition, retitled in the US *The Origins of Totalitarianism*

If we can liken life, for a moment, to a furnace, then freedom is the fire which burns away illusion. Any honest examination of the national life proves how far we are from the standard of human freedom with which we began. The recovery of this standard demands of everyone who loves this country a hard look at himself, for the greatest achievements must begin somewhere, and they always begin with the person. If we are not capable of this examination, we may yet become one of the most distinguished and monumental failures in the history of nations.

> James Baldwin, "Nobody Knows My Name," *Partisan Review*, Winter 1959

Thus spake the potato.

> Bertolt Brecht

Introduction

What about the *people*?

I find myself asking this increasingly in gatherings where knowledge and authority are claimed. The most obvious question we might ask is almost never asked. Who are we, and what is around us, who are others, and what about them? Instead, everywhere, people and reality, our reality, are jumped over as if they'd been dealt with, as if they'd already been encompassed in practice, theory, made things, and fact. But this is rarely the case.

After millennia of employing concepts, categories, made things, and others to govern, we have a hard time, in interactions, meetings, in our thinking and work, in every assembly and thing, attending to the ground our lives and world come out of and upon which they depend. The political, commercial, and knowledge orders have seized this ground, claiming the power not only to describe, track, make up, and even dismiss who, what, when, and where we actually are, but every thing and fact that could fruitfully bear on this. This has produced a strange, confusing condition. It has turned the people, as we are, things in the world as they are, and the world between us as it is, off their foundation.

There is a reason we have gotten to such a point. Crucial terms we would need, like "the public," "public life," "the public realm," and "the people" no longer mean what we would, in due course and fully, define and enact them to be and to mean for ourselves, with each other, with all our rightful power preserved. We get every version of public life, the people, and our realm except the actuality itself. We are offered, and turn to embrace, substitute after substitute, tricked out of what is our right and our due. The public, public life, and finally the people themselves have become what society, media, cartels, parties, administration, bureaucrats, officials, leaders, and all those who

claim knowledge and authority say and do. People sense they are lied to and constantly outmaneuvered, that the public realm has become only the realm of the unjust, untrustworthy, false, and perilous, of fruitless battles, fake contest inside or between factions, a hardly public media and press, and officiousness signaling trouble on its way. It is no wonder people whose concerns and power are ignored flee the so-called "public" realm, for, just as it was in the former Communist bloc, and remains under dictatorships everywhere, this realm is not the people's in any way. We have come to accept that we cannot know or be protected as we are in every interaction, expression, sense, appearance, and action. We have come to accept power is not there to secure our plural sense as it arises, and finally that power is not what secures the fullest and richest life for all of us. It is hard to imagine power *could* secure and protect such a life, no less our governing of it, or that actuality, in the end, decides, and needs very much to be found and addressed. How would we even find out what actuality is, no less govern from it? Knowledge, authority, and reality have been thrown into unparalleled disarray. One thing is consistent, however. Systems and establishments win nearly every time. Do systems and establishments care or have a clue what they are doing? It is doubtful. How could they? The real and actual have become what systems and establishments think they create and govern, and that we, the people, must suffer. Everything is in the wrong place. Subterranean streams rise to disclose themselves only when it is too late. We are nothing, and we must submit. We think, we fight back, we organize, we come together every day to answer our world. But in the end, we, the people, and our fullest possible reality do not govern. We, and reality, are instead *governed*.

The School of Public Life starts from a premise—that this is deadly, that it demands remedy, and that a new way of thinking and acting is possible, right there, and needed.

For what is called "public" and "real" has perhaps never truly belonged to the people themselves. We have everything *but* a realm for us—what plural and free people convening, face-to-face, would be able, in every place, wherever and whenever we chose, to find out, discuss, engage, witness, answer, and govern, certain we are protected by every power in doing so. By contrast, a truly public realm, were it to exist, would be the realm where we could *find* actuality and govern from it, face-to-face, from all our differences, with every fact, action, made thing, and experience necessary. The public is not a virtual space or space of ideas, nor is it a party, administrative, social, production, machine, or official space, whatever we are told. It is the full life of the people, lived by and for the people. It is where actuality and reality, in all their plurality, diversity, and factuality could be sensed and decided, on *our* terms, for *our* benefit. Public life is *not* the school of what society, officials, administrators, media, technology, "knowledge," and "authority" say and do. It is we who make up this world and the living that concerns us—whoever, whatever, whenever, and wherever we are. It is our life that is the foundation of every country, place, thing, and condition. It is the plurality we are, have been, and remain—as strangers, neighbors, and friends to each other.

The school of public life, insofar as it seeks to address reality, is not about a new movement or process, the logic of an idea, nor is it about process or ideas at all. It is a venture into a real space and time, both new and extremely old, where power, things, and reality arise, can arise, do arise, and will arise—between us. It is the realm of political and cultural question, of how things are and have been organized, why they are or are not organized for us, and what could be done about that. For what constitutes our world does not conform, just as people do not conform. What constitutes our world is only the given. It is what is happening. To find this out requires every vantage, and it

demands these have full stability and protection. The more our vantages are assembled, the more secure they are, the more what is actual can be experienced, be addressed, and be dealt with. Do we find out from each other, and share, all that helps and harms us, all that helps us understand who and what and where we are, and all that is worse than false and only more outrage? The school of public life would address such things, precisely so our world could be sensed, addressed, and answered, by us. A true public realm, and public life, would disclose all of this. It would reveal how much what could help us has been lost and how much what harms us has not been understood. It would reveal how much what is called public and real has been neither public nor real.

The school of public life is not concerned with all types of life. It is not about a natural life, a life sequestered from the world like the private, a life functionalized from the world like the social, nor is it concept-driven or something distant to be studied and manufactured. It bears on these, but through its own modes and structures. It is concerned with the world we share, all of us, as *people*. This world constitutes our lives—not in universals or abstractions, in polls or trends, in classes or crowds, in personal or mass psychologies, in ideas, concepts, or theories, in technological artifacts, data, nations, markets, multitudes, or global orders, but as infinitely plural people living and gathering in a shared world and concerned with that every day.

What is at stake, when one asks "what about the *people*," are our capacities. For people remain the issue. Contrary to long-held assumptions, thinking—like judging, willing, imagining, and acting—depends on who one is, where, when, with whom, under what conditions, and where this goes. Human factuality governs each thing and activity's meaning, truth, and durability. The school of public life would be the space to experience and finally sort this out—not through mere "discourse" or mere "communication,"

but through sensing each other and the world as they are, having a space for the depths of that, and all it lends and establishes. Like other places or forms, it would be the place where one *could* respond and answer, a "structure," if you will, that is at once hypothetical, descriptive, and actual. Other types of places—the playroom, classroom, bedroom, nature, courtroom, factory floor, congress hall, office, farm, laboratory, spaceship, keyboard, screen, battlefield, and open space—are fully places from which to sense, respond, and answer as well. But they are not even partially a school for the world we are all in, with its full breadth, depth, and memory. Only we, when we come together, face-to-face, to govern, can get at this and secure this, can answer what is so, has been so, and what, altogether, in due course and due process, we decide should remain so. It is a venture because it is existential. It embodies the risks and realities we face. Like "the school of hard knocks," the school of public life is not a metaphor. It is what would help us grasp and answer what otherwise, without such a secure space and time, would destroy, elude, or undo us, and so the world.

II

What follows is developed from a series of interventions, in text and action, made over a two-decade span, from 1992 to 2012. It is aimed at outlining some examples of what a school of public life might be, and what living for it is like. The interventions have been developed by the light of the context and principle of each initiating gesture. References from each time, core words, examples, and arguments have been heightened in their vantage, principle, moment, and meaning. The result is not a documentary record, though a narrative attempts that. The overall effort instead is a probing of principles, that they were initiated and explored, how they were lived, and what that meant, for myself and for some others. The result is a thought experiment drawn

from experience in an evolving present. It seeks to ask and rethink what the political and public are and might be, what the cultural is and might be, what coming together is and might be, and what these are for.

The book's argument is that our concepts, and our focus on ideas and theories, have led us astray. What is aimed for here is different. It is concerned with what would and does arise in a space of appearance. The texts have not been "cut" or "trimmed" to form an image, philosophy, or dream of a life that never was or merely might be. They have been developed to be as true as possible to what was sought and found. The French-Swiss director Jean-Luc Godard, in 1975, in his first feature using electronic media, *Numero Deux*, asked that we look at, and examine, a thing from life and work once, then a second time, or *deux fois*, using the tools at hand. The effort here is related: to re-examine texts and actions as they occurred, then once again, and so stitch account and accountability together. The focus is on principles and where they led. Events and situations change, experiences accumulate, precipitated by all that happened before, sometimes mere moments ago. One may be wrong, for what was sought can be outmatched by actuality and fact. The effort, as a result, is to bring thinking and practice, knowing and doing, gesture and consequence back together. This produces a jumping and veering effect, precisely as a life is lived and posed.

The original sources for the book include a manifesto, works between prose and poetry, a letter, pamphleteering, experimental public address, reflections on practice, and even the creation of an invented persona. Each was made to open up a space, with all the gaps, missteps, and discoveries that result. Words used—like who, where, what, and when we are, plurality, reality, action, speech, taking turns around shared objects, site, the space of appearance, and so on—are not concepts or images. The words are offered as aspects of a school one can find oneself in the middle of again and again.

They are shaped by that school, and have in turn shaped it. This school is very real, though it is something we have paid little attention to.

The effort began with a conversation two years ago. In October 2011, two friends from Berlin were visiting at the log house my maternal grandmother built in the late '30s, with the help of two brothers and local craftsmen, in the mountains of Western North Carolina. A tall locust tree had long tilted over the house, and I had brought it down. One of the friends, Mathias Heyden, and I, sat at a table cut from the tree. Locust is hard, impervious to rot, and heavy. Looking out over a field, leaning on this rough thing, we swapped stories of our shared passion for being rooted in place, and for things best organized by all those concerned coming together. Heyden had dedicated himself to what he calls "participatory, community design," beginning his work at the K77 squat in Berlin after the Wall fell. He and his partner, Ines Schaber, an artist and writer, were documenting this type of design in the U.S.A., where, they say, its practice is more advanced than anywhere. Heyden recounted his experiences, and I mine, in Los Angeles, pushing for neighborhood councils beginning in the early 1990s, then running a poetry and cultural center, Beyond Baroque Literary/Arts Center, near Venice Beach, for fifteen years. We swapped publications. I had only the next to last text here, a 2010 pamphlet, on the work of others. In the back and forth, Heyden suggested my own work, and texts from that, could be valuable. I quickly turned in my mind to the brief, public texts I'd written pushing for councils many years before. These seemed to me, while not at the time, and only in retrospect given what was actually achieved, grounded and real.

The book's theme and title, it would turn out, had emerged earlier in the year, in May, in Berlin. I'd been invited to participate in a weekly, month-long reading group on Hannah Arendt's essay, "The Crisis in Culture," organized

by a friend and colleague, the artist Jeremiah Day, to mark the text's fiftieth anniversary. In the late 1990s, while working together at Beyond Baroque, I had introduced Day to the work of Arendt and the experience of reading her texts out loud, around a table, person by person. For his Berlin gathering, I addressed this, delivering a talk that looked at the framing Arendt herself used for all her "exercises in thinking": what does it mean to think in the present, without guidance from broken traditions, standing between the forces of the past and future? My title for this was "Why Arendt? Or Building the School of Public Life." I did not, at the time, detail or explore what this school was, focusing only on a precondition for it. After the conversation with Heyden, and months later, upon returning to Los Angeles, looking through my council texts and other proposals and efforts, I discovered, to my happy surprise, that I'd used the phrase "the school of public life," from my Berlin talk, during those early efforts. I realized then that this "school" I had invoked again recently was the phrase that tied my work together.

When I give public talks now, I improvise, to speak and think from what I've been gathering and researching, face-to-face with those I am speaking with. I do this to develop thinking as a kind of intervention, for myself and others, in the moment. This is different from theorizing. It avoids the logic ideas and theories can lend, masking all that is at stake. I have delivered "papers," the emblem of this being a boy, summers years ago, throwing ready-made bundles of news, thoughts, and opinions onto doorsteps. One goes one's way among others who also go their way. Public space, and thinking, demand something else. Being in the midst of others who are as needed as you are, in the moment, and letting the tension of that shape what can be found, helps bring such spaces fully to life, for the speaker as well as the listener.

When the American poet Amiri Baraka was asked during an interview for a biographical film to describe his

fellow poet Charles Olson—the polymathic thinker and activator of countless relations and enterprises—Baraka described his friend's extensive work as an effort, quoting a phrase Olson himself invented, to "put the hinge back on the door." This book, and the thinking in it, is my effort to find out, if from a very different direction, what such a hinge and door might be. Starting with a major expansion of a short manifesto I published in 1992, whose initial cursory thoughts shaped all that followed, I move in sequence, through texts I wrote for neighborhood councils—to build public life at the local level—then to a never-sent appeal to a famous political activist, followed by further interventions on behalf of councils. I include two texts written after taking on the directorship of Beyond Baroque in 1996—a short prose poem, and the first face-to-face appearance of a persona I'd created. These are followed by further texts marking the climax, and success, of the council effort, and what unfolded after. Building on a piece that began in 2003, I reflect on my practice and thinking concerning culture, using the example of activities initiated first at Beyond Baroque. The persona comes back to make a plea, then I proceed to a talk given in London. There, I began to improvise thinking, drawing on a crucial intervention Olson made, in public, in 1965, concerning "conditions." This is followed, as it unfolded in my life, with a text addressing what a "polis"—that ancient term from the classic Greeks embedded in the word "politics," and used often by Olson and Arendt—might be for new conditions. The penultimate text comes from a talk delivered in Berlin, in January 2012, before a group of younger artists, writers, and professionals. It examines a word crucial for us all, "power," and how I believe it has been fatally misunderstood. An epilogue looks at the fate of the Los Angeles councils and addresses a few remaining matters.

To think is to think in the present. Being caught, as Arendt suggested, using a metaphor drawn from Kafka,

between past and future, we cannot, in fact, hope to escape the winds bearing down on us from these regions. The only way to not to be knocked down, Arendt argued, is to stand upright, in the present, between them. This she called thinking. And so the thinking here is held upright from one direction, as it were, by the short, rough manifesto in 1992 that began all I recount. Titled "First Principles for a New American Revolution," I sought there to return to a principle many Americans, and others, believe—coming to us as a kind of bequest—that we, all of us, have the inviolable right to govern all our affairs, and with that, the right to everything we might need for that. The word pointing to this—"self-government"—has, however, been degraded by centuries of abuse. In 1992, I began to wrestle with this, starting, through that initial effort, to detail what I suspected had undone the depth and meaning of the word. This began the story, and comedy, the book chronicles. Written for the art and avant-garde theory world, with vocabulary and concerns alien to that world, I was not joined by any of those I hoped to stir. I had knocked a pebble down a glacial crevasse, and the piece was greeted by resounding silence. The one response I received, from a former professor, historiographer, and friend, was rage.

In the beginning years of the internet, I posed the assault on self-government not in conventional political terms but as a matter of our relation to, and possession of, reality itself. The assault, I argued, was born of a long-accumulating capacity, built as it were *ad hoc*, to "manufacture reality." I argued this had rendered us, in turn, rather less than real. This latter subject, explored in a literary way by American science fiction writers, in particular Philip K. Dick, would become the theme of very good American science fiction films some years later. My piece was hardly science fiction. I recall my former professor's response: "Are you saying I am not real? What is *that*?" This stopped me in my tracks. I concluded that my well-meaning intervention

had been misplaced. The piece occasioned dialogue only with myself, and doors began quietly closing. I would now, years on, more convinced of my intuitions, offer up a question posed by the musician and composer Sun Ra, in the film *Space Is The Place*: "If you do not have rights, how can you ever expect to be real?" My professor's charge, which I did not understand then, was legitimate. To learn none of us are as real as we might be is very upsetting. The point is not to rage against the message, but to remedy the problem, for all would benefit. I have tried to ground my original intent more deeply, expanding it with historical facts. It may well upset even more. But it is followed by my own efforts, however imperfect, to try out, and work for peaceful, if not entirely painless, remedies.

My trust in this degraded word "self-government," and certainty of widespread fictions besieging it, gained life from an obscure, underground political historian, H.R. Shapiro. A Hungarian friend introduced me to Shapiro's small Sunday gatherings in his Santa Monica apartment, reading aloud, around a table, his investigations into the unknown political history of the United States, informed by the writings of Hannah Arendt. Shapiro had studied Arendt as a drop-in on her classes at New York's New School for Social Research in the 1960s. Advocating for local, council democracy in New York, Shapiro had formed a group including artist Donald Judd and others, drawing Arendt as one of its advisors, to push for this. Shapiro had found in Arendt a kindred spirit. I remembered her *Crises of the Republic* and *On Revolution* from my university days. But Shapiro's take was decisively different. Politics and thinking were, for him, not a matter of ideas and theories, but a powerful contest of living principles. Starting in 1969, Shapiro had published a short-lived but influential underground newsletter-magazine with Walter Karp, *The Public Life*, circling back to founding American traditions and principles to look at current events in a more constructive way. Karp went on to pub-

lish at *Harper's* and elsewhere, taking Shapiro's insights as his own. Shapiro, a working class teacher and veteran, had been active in the Oceanhill-Brownsville community control movement, and, averse to intellectual versions of principles, parted with Karp. He ran for office, lost, was bankrupted by the effort, and resettled, years on, making a new life in Santa Monica, where we met. Fortuna, that challenging thing in life, had intervened for the first time.

Shapiro had self-published and self-distributed two books exploring the history of "Democracy in America." The later one, *USA: Total State*, filled with difficult facts and telegraphed, awkwardly phrased conclusions, nonetheless contributed crucial elements to two key essays by Gore Vidal on the U.S. national security state, the debt noted only in a brief footnote. Such appropriation had driven Shapiro ever further outward. I, however, had found a home. Principles, critique, history, politics, and events gathered in his living room, Arendt floating alongside Jefferson, Lincoln, the Populists, LaFollette, de Tocqueville, Malcolm X, and an obscure political theorist by the name of Ostrogorsky. Tales of American political parties fusing and defusing, endless presidential maneuvers, and the people fighting mightily, against all of this, took on real life. We were studying public life, and it was different from anything I had ever learned. Reading out-loud, accepted wisdom after accepted wisdom turned into cliché. My perspective on what is real changed fundamentally. What mattered, it was clear, was to "remember the Republic." At every reading, behind Shapiro, on the wall, beside a framed and yellowed copy of *The Public Life*, was a tattered, black and white photo of Aleksandr Solzhenitsyn, in rough-hewn prison garb, a prison number stamped on his uniform. The comparison was clear. I had given up hope that real, thinking bravery existed in the United States, and having now found countless examples of it, I did what I could to help him. I wanted to apply what I was learning any way I could, partly to

break Shapiro's tragic isolation. I failed at the latter, as the story will show. But my text from 1992, and still more now, reflects this determination to remember our foundations, and strengthen them, for a great deal rests on that.

One can have an idea where one is going, and where one is, but it is often mistaken. One thinks one is on a clear path, only to find one has circled and gone nowhere. But when one makes the effort to circle back, one can find one has reached the place one sought all along. My first, rough intervention, in 1992, inspired partly by Shapiro, was written to trigger something. None of what I had hoped for resulted. Then, months later, and following the principle I'd explored, I discovered residents of Los Angeles, unconnected to anything I knew, addressing the very principle I'd outlined. I'd been thrown into the world, there to find the people not only ignored, but for those who govern authority and knowledge, a negative. My new efforts, now with others, were met by even more puzzling silence. When I took up my work at the Venice culture and poetry center a few years later, the comedy deepened. I began re-reading the work of Czech playwright, writer, and eventual Czech president Vaclav Havel, a notable in Central Europe's "Velvet Revolution." I'd read his texts on "a parallel public realm" for my council efforts. But it was his vision of "living in truth" that now truly struck me. At the center, I sought to trigger something again, this time, as Havel had, through culture. Again, little of what I hoped for resulted. How long and hard I fought, how little I understood, and how little lasting public effect there *could* have been! While my council efforts bore fruit, I had hoped for a larger cultural transformation. The pebble cast down an icy crevasse flew up out of its deep hole and turned to dust on a warm, desert wind. The majority of those who felt my cultural challenge saw public space as an arena for their own ends, and I fought them to the ground. This ended up, when all is said and done, being nearly everyone.

In a piece that began in 2003 and that I develop later in this book, I try to examine some of the principles I explored in culture. But a larger failure, to my lights, was becoming painfully clear. In 2008, near the end of a decade and a half at Beyond Baroque, taking a break from a bitter, second lease struggle, and after delivering a plea from my invented persona in an L.A. parking lot, I travelled east to Montgomery, Alabama, the "cradle" of the original Southern Confederacy, to dig into events that started there in December 1955. I visited, and spent time in, Dexter Memorial Baptist Church, where Martin Luther King, Jr., hired from Atlanta, had begun a very different kind of public work. King had taken on his ministry a few hundred yards from the first capitol of what I would now call the most dangerous form of government ever created. There, in the heart of the old Confederacy, I discovered the blacks of Montgomery, almost a century later, had not pursued a "parallel public realm" at all. They had discovered public life itself. In my first improvisatory address, with friends Simone Forti and Day, in London in 2009, I dug deeper, briefly connecting poetry, new modes of public appearance, and Olson. Less than a year after this, preparing a text to give out at a performance with Forti and Day in L.A., I tried to work out Arendt's description of "the space of appearance," from her best-known work, *The Human Condition*. I connected this to the "polis," what I now believed it was up against, to Olson's time at Black Mountain College and in Gloucester, Massachusetts, and to the courageous actions of African-Americans in Montgomery. This text, and the thinking that grew out of it, drive the final intervention here, concerning that one word, "power."

The conditions my interventions faced, beginning in 1992, are those we all face in countless ways. They are conditions, however unwitting and even unintended, of silencing, suppression, denial, and the masking of fact. They are conditions, in the body politic—though not for some

determined souls—of a serious demoralization born of flawed categories, thinking's retreat, endless doubt sown, and centuries, if not millennia, of mistakes. By now, it is hard to imagine what public life is, could be, or would be, or how crucial it remains. Its absence, arriving in my life in the form of no echo and my response to that, became a binding thread. The ending of one long period of my life had circled back to its beginning, to reveal something new.

III

The word "self-government" is indeed a damaged gift. It tugs and pulls through a dim binding that can be sensed but is thoroughly obscured. While editing this book, two recollections from my early years shed light on this, and why my life would finally take the course it did. A looming presence in my family, a well-known relative who had died a few years before I was born, "Gramps" as my father called him in passing, and an old Vermonter, was rarely the subject of family storytelling. Trying to address this, I found my way, for an American history class assignment in high school, to the first grain of sand that would drive everything forward. My famous great-grandfather, the philosopher and educator John Dewey, had written an early book, *School and Society*, on his Laboratory School, founded in the 1890s at the University of Chicago, where he had begun his public career. In this book, Dewey argued that the space for democratic practice, by the end of the 19th century in America, was shrinking. He turned to the child's education, to build, for the child, and for schools, a democratic grounding in practiced knowledge. In reading his book, so many years ago, something had begun to gnaw at me. The words and thoughts struck me then, and resonated long after, as empty and cold, concerned mainly with a strangely construed concept of knowledge and experience. This echoed in every school I encountered after, from uni-

versity to grad programs, to the workplace, social life, and the many bureaucracies of life and knowledge we all encounter. In the book, and in the years that followed, I found little trace of a politically and culturally rich education in self-government and power. Still more puzzling was the almost complete absence of any recognition that this realm and a structure to properly protect it were entirely missing.

No doubt my great-grandfather's supporters, and some historians, would say his principles were never realized, in schooling or society, and as to his democratic intentions, this is quite true. I learned subsequently of Dewey's influence on various artists and on the principles of a remarkable school, Black Mountain College—not far from our family home in Western North Carolina—where new thinking and imagining took shape. Neither this, nor other schools his principles helped steer, not even his help in forming the American Civil Liberties Union, or A.C.L.U. and many other such organizations could shake out that grain of sand. An administrator from a technical school in rural, mainland China, having tracked me down as a direct descendant, ended up shocked, for I no doubt was rather impolite towards my lauded, if controversial, ancestor. Dewey had helped start, and influence, a modern educational system in China. But even with this, I conveyed to my visitor how much my great-grandfather had answered crucial matters, if one dares say so, *backwards*. I learned later of a critique by Randolph Bourne, a disciple of my great-grandfather, of Dewey's acquiescence before President Woodrow Wilson's transformation of American society before and after World War I. While editing this book, grappling with my memory and Bourne's criticisms, I re-read parts of Christopher Lasch's work on the Populist imagination and its fate in America, *The True and Only Heaven*. There, I came upon a side comment my great-grandfather made at the conclusion of a later work: "It is outside the scope of our discussion to look into the prospect of the reconstruction of face-to-face communities."

Suddenly it all became clear. My great-grandfather had put off for another day, not always, but always consequentially, what was in fact the real problem. For training schools and philosophy are a weak reed, and children a weaker reed still, upon which to build a democracy when the progress of society, its political system, and the intellect itself are organized to different purposes. The problem was not solvable by science, philosophy, and new methods of classroom schooling. It was a political problem for adults in a world where politics and responsibility are always at stake. The one school where such things might be learned by all the people had been steadily undone and forgotten.

A second, crucial recollection shed light on this, from around the same time in my life. For my last semester in high school, in 1975, I'd landed an internship in Washington, D.C., with the man I had asked to work for, Congressman Pete McCloskey Jr., from the Bay Area in California. A highly decorated Korean War vet, relentless critic of the American war in Vietnam, and, as I learned more recently, defender of fellow Marine Daniel Ellsberg in the Pentagon Papers trial in 1973, McCloskey had challenged the head of his own party, President Richard Nixon, then running for re-election, in the primaries. McCloskey ran on opposition to the war and all that would emerge, however briefly, after the election. I admired him. By the time of my arrival in Washington, Nixon had taken the presidency in a rout, had been forced to resign in disgrace for serious crimes, and had been promptly and fully pardoned. McCloskey had been moved to a backwater. As his intern, I remember him passing behind me twice, through a lifeless office, saying hello, and disappearing behind a door. I was tasked with editing form letters to constituents on energy policy and other subjects, placed in front of an enormous plastic and metal box that printed and "personally" signed the letters. Feeling guilty but under-nourished, I drew on a perk, calling up, from the Library of Congress, bound volumes

of a weekly newsletter I'd tracked down, *Manas*, from Los Angeles. Founded in 1968, this philosophical effort, written for the general public, had committed itself to "intelligent idealism"; in a 1971 *Reader*, it held that "the courage of good men is not dampened by evil prospects, but rather increased." I devoured pieces by Gandhi, E.F. Schumacher, and many others. Sitting at my table reading, keeping an eye on the machine nearby signing its "personal" letters, what was I thinking? I was in a Congressman's office, reading *philosophy*. This remains embarrassing to this day. My fellow interns, scrubbed and shiny in their fresh ambition, were working their way up through what felt to me, nonetheless, like a well-oiled, ladder-system to nowhere. I met amazing figures who'd had careers in public life, and was moved by them. But I was already at odds. I concluded this apparently dead thing called "public life" was not for me. I understood nothing. But a second, crucial grain of sand had begun grinding.

My experience in Washington, and subsequently, was not so different from what ordinary people, rather than those who consider themselves experts and professionals, experience as public life in America—as remote bureaucracies, politicians, their staffs, and activists, operating in back rooms, even in open spaces, where the people, their life, and facts have little governing and lasting weight. We see politics and public life as we are permitted to see them. Insofar as one could say a candidate, Congressperson, mayor, CEO, councilperson, president, lawyer, museum head, film director, scientist, head of a school or university, issue group activist, artist, theorist, or intellectual helps shape conditions, this does not mean, and *has not meant*, remaining face-to-face, without elevated status, working among the people to build their rightful education in self-government. Those who are able to rise in society, and who are permitted visibility, conclude, it seems, that the school of public life, that school for the people, cannot, and must

never arise among, for, and with the people themselves. It is impossible to conceive such a thing. For those who land in the public "eye" are seldom the people. What they are are administrators, party politicians, leaders, activists, crowds, celebrities, intellectuals, and officials. None of these are in a realm we the people govern. Society pays lip service to such a realm, the political system pays great lip service to such a realm, but the system and society, in the end, regard the people, their power, and their life as an archaism, a nuisance, and most of all, in no way the home of knowledge and authority.

The man I worked for in Washington—like my great-grandfather—no doubt knew or sensed this. But neither could appear to me, face-to-face, as a full human exemplar, in all their responsibility, nor could I to them. We were buried by a realm where every challenger is replaced by what Arendt, a portrait of Kafka adorning her apartment entryway—dying at the end of the year I worked in Washington, writing on "chickens home to roost," the final word on her typewriter "Judgment"—called, from Kafka, the *rule of nobody*. Its rule stretches now from horizon to horizon, in a country where countless people sacrificed everything to make sure such a thing would never, ever happen. It is a mode of rule able to defy every word and thought. My experiences of such rule were repeated again and again until they would gather, at last, in the work recounted here.

IV

My sense of a "school of public life" is drawn from multiple sources. The crucial one is factual and historical. It reaches back centuries to a discovery of early American settlers, forming the first binding compacts initiating a then-new political form. For all their flaws, limits, and the crimes of some, a large number of New England settlers created a practice that constitutes the frame for the principle of

self-government of the people and law commensurate with that. While we know the story of early newcomers establishing the first binding compact for this before touching land—the Mayflower Compact, a still unimaginably radical text—once on that land, settlers drew both on principles from Anglo-Saxon folk-moot traditions and ancient practices of convening and federation observed among natives, fully as classical and worthy as the ancient Greeks or Romans, who had tended the Americas for millennia.

The ensuing collision of cultures and worldviews was the violent first act in a veritable cascade of violation, as some sought to steal, kill, enslave, and destroy. There was, nonetheless, resistance to such violation in a founding form: the practice of governing by the assembled people, in town meetings, face-to-face. As towns arose across New England, experiment balanced experiment, lending shape—however tainted it may be for us now—to founding practice. Any person or thing that sought to rule, through secrecy and outside coalition, through conquest or expropriation, could be challenged and answered by a good many of the people, face-to-face. The constraints on who could "vote" in the town meetings were real. But even with such limits, the practice embodied a new principle. It is what today might be called the town-meeting/federal principle. It was not merely the federal principle, of continually building and balancing new powers to protect the old, and so preserving the power to constitute, as Arendt explored in her great work, *On Revolution*. It required, and built out of, in principle, not merely the "self-government" that binding and covenanting across a region made possible, but all this protected. It was not merely a radical, new principle of power, but one of *mutuality* and *security*.

However imperfect this form was, and however much this may have tragically sidelined crucial participants, the town-meeting/federal principle built out of, and embodied, as Arendt showed, the most basic principle of

action. Town and village members could, in a town meeting, learn how to be constitutors, legislators, governors, and organizers of their affairs, face-to-face. The idea of any power above them was, for the first time in the West, in practice and thought, anathema. Action and power came together in the people governing themselves. Even with its known limits, Thomas Jefferson—long after the settler beginnings, and quite keen, in spite of criticisms, to the danger of faction, empire, and even slavery—called this a living, and real fabric of "elementary republics." It was the birthplace of revolution, but perhaps more importantly, protected its spirit, for a good while. Through this, the people discovered themselves as they actually were, as who they were, able to examine each thing and proposal from multiple vantages, publicly, before the gathered sense of the people then decided. Many then and now dismiss such a practice, regarding its principle with cynicism, reducing it to hollow terms like "discourse," "consensus" or "participation." Arendt, in no way cynical, hardly naive, and no friend to race-imperialism or domination, described this, in *On Revolution*, instead, as a new principle, grounding practice, thinking, action, and governing in a durable, secure, institutional form. The old world principle of politics as the art of rule by governing castes was cast off, for a while. A new principle was birthed, in New England, of "no rule."

The first natives and others, of course, experienced things quite differently. Our prejudice, blindness, and deafness work forward and backward ineluctably. What is indisputable, however, is that the extraordinary violence bordering the town-meeting/federal principle, and forever seeking to invade and conquer it, has hidden its lessons. It was a living practice, however limited in its beginnings, of *political equality*. A significant number of those concerned could govern in the open, where they lived and worked, peaceably, against empire, war, rule, and the degradations occasioned by clerics, society, trading, and commerce, by

remaining face-to-face with, and so able to answer—to the greatest extent known to Western political thought and practice until that time—those who sought, as they will, to expropriate the people's self-governing power. Objects, things, people, and policies could be evaluated and decided in the open, together, by a large number of those concerned. Such a principle, in its governing nature, remains, to this day, fully as fundamental as the crimes that have mounted steadily to conquer and destroy it.

In 1835, Ralph Waldo Emerson, for an address titled "Historical Discourse," on the 200th anniversary of the incorporation of Concord, Massachusetts, put the discovery of "no rule" and a new mutuality and security for the people into a clear axiom: "In a town-meeting, the great secret of political science was uncovered, and the problem solved, how to give every individual his fair weight in the government, without any disorder from numbers." This was not some utopia, hypocritical polity, or space for race, class, and gender persecutors, as its principle is now often portrayed. "In a town meeting," Emerson explained, getting at the most important aspect of all, "the roots of society were reached. Here the rich gave counsel, but the poor also; and moreover, the just and the unjust."

Such an extraordinary and primary space disclosed, and exposed, not merely what was admired but what was feared and loathed by the people. It was a space for fact, reality, and people to appear. It was the space for some, and more than anyone might imagine, to learn to govern, hold to account, to remedy, and to repair. The result was a principle and fabric of schools for power among the people, linked across New England, strong enough to challenge every factional, party, hierarchical, social, "center," administrative, and secret model of governing, and most importantly for us, the models of government and politics used by most scientists and theorists today. It was the principle of a school for the people over a whole region. How-

ever limited this may have been in particular situations, its principle, from the beginning, proved capable of infinite extension. This founding experience informs all who have worked since, at such great sacrifice, again and again, to have the principle of political equality and appearance extended to, and secured for all.

The School of Public Life is an effort—through a troubling history, stumbling as one will—to join those who, with real courage, again and again, have answered those who would expropriate the people's power and reality—by pursuing, for all, greater self-government. Self-government is not a concept or an idea. It is, in every way, a practice, in life and memory, carried in the United States, by New Englanders, their descendants, and others, across a continent, there to face the genocide of first peoples and chattel slavery, imperial conquest, civil war, depressions, two world wars, relentless adventurism, and the horrors born of these, dating back four hundred years and beyond. Its principle and memory remain, in the face of all that has arisen to undo them, an anchor, not merely for us, but for anyone, anywhere. For as Arendt took care to point out, we are not children. We are adults facing the world as it is. Truth, remedy, power, thinking, and reconciliation can be found. But to find them, a space of appearance is necessary. It must be secure, and be secured, even when it has not yet been secured. The lack today of such a security has consequences, not only for those who have long suffered its lack, but for all of us in anguish and despair, in every space and place, facing what is so without the tools or spaces to answer it. The anchor, however burdened by real crimes, remains.

In using the term "self-government," a distinction needs to be made at the outset. I do not mean only self-organization, self-rule, self-determination, autonomy, or anarchy. The spirit of the people's freedom is found in each of these, but they do not, in turn, demand that freedom have an enduring structure in law and practice, gov-

erned by all. The people's self-government alone contains this widest sense. This is crucial for the school of public life to mean anything. For it bears on all situations, gatherings, assemblies, work, objects, and problems of our living. So with other words and phrases used, in particular "plurality," a favorite of Arendt's. Plurality does not mean, and is distinguished from, here, collective, group, mass, or multitude. It may well be their opposite. It means something simple: that we are each different and unique, that this factuality constitutes our true world, and that this difference and uniqueness demand protection and a secured space to disclose themselves if reality and power are to mean anything. So with the related term "the space of appearance." Devised, I believe for the first time, by Arendt, this points to what politics would be if it were not official, party, society, bureaucracy, or faction, but the disclosing of who we all are and all that happens and that we do, have done, and might do. The space of appearance concerns us all. It is the space that takes us, and who we are, into account, making this account real, relating and separating us by what is between us, the factual world we share, and the power that exists between us. The phrase veritably defines public life, and most of all what self-government for all, in every realm, would protect and secure. Who could not say we suffer from the lack of such a fundamental security and space now, in every domain? The book, in its own small way, looks into that.

Because of the range of activities and claims here, it is reassuring to find that what originally was disconnected in one life, and even flawed, nonetheless retains a kind of backbone. Terms and figures that arose in varied situations have been brought together to focus on a principle. A person's life makes sense, and can only be thought out, as it is lived and described with others. Theoretically and practically, this affirms the vantage each of us brings to the world, to build from, with, through, and even at odds with

each other. This is the fortune of being able to re-visit past actions and words. For this, I am grateful to Doormats publisher Brandon LaBelle, with whom I was lucky enough to share several years in Los Angeles rebuilding one tiny cultural institution, as best we could, from the rubble of a hidden war. This book comes out of that, for without that, this book could not have appeared. There are many other crucial contributors along the way. Insofar as thinking is an enterprise done with others, as I am certain it must be, it can, and must, take place in and for the world. Our world, and the future, depend on it. If this effort has too-personal, American, or local a focus, bear with me. For this is one contest I know, and though I cannot have known it fully, I committed myself fully to it. Mine is only one example among others, its aim to point to that realm where more examples not only would but do appear, so that they might, in turn, endure.

July 4th, 2014

When a government turns its back on its people, is it a civil war?
 Gran Fury, 1988

*I see the court house full of armed men holding prisoner and try-
ing a Man to find out if he is not really a Slave. It is a question
about which there is great doubt. It is really the trial of Massa-
chusetts—every moment that she hesitates to set this man free—
she is convicted. The Commissioner on her case is God.*
 Henry David Thoreau, Journals, May 29, 1854

*America is false to the past, false to the present, and solemnly
binds herself to be false to the future.*
 *Frederick Douglass, Rochester, N.Y., July 5,
 1852*

1.

By the late summer of 1992, in Los Angeles, I'd been writing for some time on culture and politics for alternative and foreign periodicals, and working in the movie industry. I was frustrated, and my time in "Hollywood" was nearing a close. The alternative press in the U.S.A. was beginning a shift from serious political investigation and cultural criticism to lifestyle; the foreign press seemed more receptive to criticism, especially about Los Angeles, but opportunities were sporadic. In the cultural and art realms, especially in cutting-edge theory, there seemed little interest in pushing core principles of a democratic republic forward, and, more frequently, contempt for the very endeavor. An atmosphere of unreality was growing, building on a base established by a long and increasingly depressing succession of presidents and congresses. Asked to contribute to a local photography non-profit's magazine, Framework, for an issue on politics and the upcoming 1992 election, I decided to work a core, founding principle, at least as I saw it, and place it against what I believed had the capacity to permanently undo it. Bill Clinton was campaigning and there was optimism in the air, after years of assault on grass-roots politics, artists, political art, and thinking. On one core issue, however, there was deafening silence: the effects of the Cold War, and "national security," on the people, the society, and the government of the United States. In the avant-garde theory realm, this inattention was clear and, to my lights, very problematic. There was, however, a second, more pressing matter. The internet was in its formative stages, and the topic on everyone's tongues was "virtual reality." This signaled, for me, a final turn from correction and repair. I wanted to address this from a broader political, historical, and philosophical vantage.

The context for my first intervention was an event of only a few months before, in April 1992. For days, riots had erupted across Los Angeles. A gang of police officers had been captured on video, seen across the world, savagely beating a black motorist. They were tried, and, in a stunning gesture, fully acquitted.

The system had declared itself: evidence of a system out of control could be glibly dismissed, in law. Fury in the body politic—at the absence of power at a citizen and resident level, and against a society that now seemed utterly hostile to fact—exploded. I broke curfew during the first day of the explosion, driving across the L.A. basin to see things for myself, independent of the confusing and, I presumed, slanted coverage from TV, radio, and newspapers. Towering columns of black smoke dotted the horizon. On the streets, there was indeed looting by angry and poor minorities. But I saw people of all colors and classes participating. This did not appear in the news or in commentaries. Los Angeles, for a moment, seemed poised over an abyss.

The abyss that had emerged, to my lights, was between actuality and what we are told is so. To put this another way, an abyss had opened that seized reality and ungrounded every grappling with fact. The true event, or signal, for me, was not the riots at all, which were understandable, but the acquittal. Avant-garde theory had little to say about that. The work of thinkers like Guy Debord on the spectacle, new Marxist theories, Noam Chomsky's notion of "manufactured consent," Michel Foucault's deconstruction of power and knowledge systems, and post-structuralists like Jean Baudrillard on simulation and the post-political had been taken up by the academy and avant-garde. They expressed a truth, but seemed, to me, to offer little on the real clash occurring before our very eyes and ears. How could vital political matters remain so unaddressed, with society able to go for so long, so thoughtlessly, on its way, to such a point? Wasn't theory accountable? In reality, processes were in charge. For a while, professionals and academics fell all over themselves talking about the sources of the riots, rarely the deep problems behind the acquittal, surpassing, in every sense, mere racism. Inexorably, the chorus grew for "healing." Only minutes before the verdict, everything had appeared to be just fine and orderly. Soon enough, everything would be just fine and orderly again. The "virtual" provided me with a term to dig into this.

The initial, unfashionable combination of elements, thoughts, thinkers, and approach, in my short, rough manifesto

in 1992—to call the original cursory would be charitable—proved strange to my avant-garde theory and culture friends, my co-workers, and former professors. Mainly, I think, was the understandable offense my critique of the rise of "professionals" and "experts" over the people caused. My effort to return to first principle was, nonetheless, my attempt to take clichés and challenge them in a new direction. The aim was to provoke. It was meant as an intervention, in no uncertain terms, and it provoked no positive response. In the end, the only consequence, and a serious one, was in the path I chose because of it, and this gained momentum only a few months later. The gesture, as a result, marked a watershed divide in my life. It did not examine local conditions, specific politics, or then-recent events at all. I chose, instead, to look at animating principles.

The reference in my original title to "first principles" has been reduced to one, as the content of the piece then had it, concerning "self-government." The thesis, structure, concerns, and many of their limitations have been kept, leaving this, still, as the outline of a person beginning to think in a new way. My expansion of the manifesto here has sought to keep out the lessons and refinements intervening years might have lent, to prevent altering its original frame. Instead, crucial observations and discoveries have been added to illuminate the clash as I sensed it then, staying as true to the intent of the first gesture as possible. Much that seemed extreme then, and is likely still extreme, seeming outlandish to me even then—concerning the role and function of the professional and expert, the nature of "information," existentialism as a first reckoning with a new era, and the relevance for all of us today of the first great contest between freedom and slavery in the United States—has to my lights been substantiated in the meantime. The thesis remains, with its flaws, focusing, as if by a flickering light, on a continuous, if far-fetched progression. The rise of the virtual has become so extensive, and is such an embedded part of our lives now, that it is called a way of life. I propose a distinctly American genealogy for this. Its lessons can, I believe, be applied in different countries and contexts, for the larger problem I point to is hardly

unique to America, though some of the responses to it certainly were. The original manifesto was a passionate clarion call. It was designed to address what I saw, then, as a crisis. Its spirit and purpose, and the crisis, remain. I had cast an anchor far into unfamiliar territory, and pulled myself across an invisible, and rather strange, threshold. The book that follows takes place, as it were, on the other side of that threshold.

First Principle for a New American Revolution

Down to the Roots

With each election, the people vote for reform, yet each time, in the end, it is as if the people are driven, and drive themselves, deeper into powerlessness. A new world opens up, then, inexorably, old forms return in more devious shapes. While the Cold War is said to have ended in 1989, waged for "national security" since the late 1940s, there is singular silence concerning its effect on core principles that bound this country, the people, and the United States together. It is as if we think we now know answers to questions like "What is government?" "What is freedom?" and "What is identity?" But do we? The results of the Cold War, and its goal of "national security," have in fact supplanted all serious debate over political life and structure in the United States. As such, it has become impossible to find the original question that drives deep beneath this:

What is security?

In the United States, the principle that "security" could be military, technological, and "national" is recent, inserted into law, against freedom principles embodied in the Constitution and Declaration of Independence, in secrecy, by President Harry Truman and his many helpers, in the late 1940s. This deed was justified by conditions of apparently dire threat. Unbeknownst to the people, however, a massive political change, hidden under the guise of

answering that threat, gradually severed ties, for the government and the society, to the Declaration of Independence, the Constitution, and back further still, to fundamental, originary compacts like the Mayflower Compact, and further beyond, even to the Magna Carta. However shocking this may seem, this new, over-arching principle would be invisible to the people both in its effects and implications. It was to become a new, invisible, and never-public *first* principle.

The genealogy of this fundamental break traces back through the policies of presidents, from Franklin Roosevelt further back to Woodrow Wilson, to the Progressive movement, and finally to the crucial structure of the Southern Confederacy and its method of rule. The link that was severed for the government and society was to first principle as the people understood, and still understand, it to be. In the founding era, and up through the Civil War, first principle, however imperfectly enacted, meant that the only security could be the people's self-government. Abraham Lincoln reframed this as a beautiful axiom at the Gettysburg cemetery, on Thursday, November 19, 1863, eight decades after the founding, and right in the midst of a brutal war for its very viability: "self-government of, by, and for the people." Laws securing and assuring this first principle were, up to that point and presumably ever after, meant to be the only security, legitimacy, and basis for the people, economics, and government. The people still, against all odds, believe this to be so.

What the new system obscured, thanks to Truman's handiwork, was what our founding legal compacts all held—the Mayflower Compact, the Declaration of Independence, and Constitution, among them—that power and government's legitimacy could not be derived from war, nation, economy, parties, technology, or society. They could only be drawn from a structure protecting and advancing a people free, in mutual support of each other, combining and covenanting, to practice and advance their self-government.

Whatever flaws or limits existed in the original framings were to be remedied, from the new founding in the Constitution, by a public, and visible, amending capacity in fully public law. Not only could there be no legitimate power other than that which secured self-government, anything else was, for those in New England especially, but in many other places over the decades and centuries, the re-establishment of tyranny. The entire U.S. body politic rested, and still rests, on this innate and explicit sense, however imperfectly it may have been embodied or protected. Self-government, the foundation of a new body politic, was the core of the Mayflower Compact. It infused the Declaration of Independence, and was then, to secure it, placed in the preamble, body of, and rights of the Constitution. James Madison, a key architect of that Constitution, expressed concern that rights securing self-government be spread throughout the new charter—not as "amendments," so they could never be seen as an afterthought. He failed. But the rights remained in basic law and were its foundation. All rights were not only to guide a state and society, but to protect, over time, the people's practice of freely exercised self-government. The purpose and existence of power was not merely an expression of this, but to assure nothing could *undo* it. This was the thread binding a fractious and plural people over space and time, assuring obstacles or flaws could be identified and addressed in due course. This was the source of principles of liberty, freedom, identity, power, and government in the United States of America.

Problems of daily life—today, what we would call those of economics and work, race, gender, class, opportunity, technology, and so on—were, from the beginning, to be grounded in the moral control and exercise of power *not* by officials, parties, society, or state, not by anything economic, military, technological, or "national," but by a fully constituted, compact-making, constituting people, with the space and time needed for this to unfold, be re-

formed, deepen, and spread. Representation was a technique. It was the best technique those who had studied the history of democracies, republics, and empires could devise for an order grounded sufficiently in the people and freedom to avoid descent, as all previous forms of government had, into mass poverty, violence, absolutism, and internecine and ongoing war. This first principle, secured in a framework born of revolution, grew out of practices and compacts in New England in the centuries preceding the framing. Representation was never meant, contrary to arguments of so many then and now, to overthrow and block the people's self-government. The republic was based on representation, but representation was based on first principle—of a people firmly secure in the evolving perfection of their self-governing.

It was this first principle that Truman carefully, successfully, and decisively undid. Self-government, and the people, were rendered secondary as the site, legitimacy, and sole purpose of power. Control over politics and society could now be asserted in secret, with political actuality hidden, to protect and spread an alien nation-state principle, and its society. A completely new, and utterly foreign principle of security, that of a nation and its society, a source of long and well-told horror in Europe, was elevated to rule. How Truman secured this extra-party and extra-Constitutional, and finally extra-republican form, proposing and enforcing rule over the people, their republic, and their power, demands wide public debate and understanding. One thing is clear, though. It would have been impossible without a long and prior obscuring, born at the beginning but developing ever more intensively from the mid-19th century through the 20th century. Truman merely consolidated what was already latent into a "legal" shape, one that never went before the people in full debate and examination. Because it would fundamentally violate first principle, Truman knew, as one of the most skilled and

ruthless, deceptive politicians the country has ever known, the rule of this new principle had to remain a secret, with all that would inevitably come to enforce this secrecy. Making military, technological, economic, and "the nation's" security into a first principle violated all first principle formed by the people themselves for their power and security. Because of the revolutionary founding and a body politic born of it, this epochal change needed to remain unknown and, if possible, unknowable and henceforth unthinkable.

Poisoning the Roots

Truman built upon a whole nest of genuine and widespread confusions. While Lincoln himself helped spread the notion of nation, it was always balanced by the republic in which power rested in, and was born of, and from the people. But something was born and grew, in spite of this, in the early years, that would come to infuse and spread this notion of nation-state, and its society, to violate first principle in every way.

Jefferson and Madison had, some years after the founding, campaigned, successfully, to wrest the presidency from John Adams, a great revolutionary, who had turned to push through laws labeling all dissent and opposition treasonous. Adams, with Treasury Secretary Alexander Hamilton, had begun to build a financial, political, and military center against the people and the republic. In spite of Jefferson and Madison's intentions and even efforts, this center gathered speed and force during the first U.S. war, the War of 1812, with new party cells created to win Madison's presidential election, following Jefferson's two terms. The evolution of permanent party, never in the Constitution, facilitated the growth of this system of finance, control, and war-making that could be employed by extra-Constitutional factions. While slavery, for example, existed at the founding and was protected, ghoulishly, by the Constitution, few note, even today, that legal requirements

were built into the Constitution—by Madison, guided by Jefferson, at its founding—to answer this, called rights: to assembly for redress of all grievances, free speech, due process, safety from seizure, no standing or permanent military or cartels, and so on. Unfortunately, and devastatingly for the future, the political order of the plantation South had inserted, at the beginning, a veto over all founding rights in law and appearance.

Through inclusion of the "3/5ths-of-a-person" principle in the original Constitutional frame, to rule in the plantation South, blacks in the South were robbed of political existence, power, and rights secured in the Declaration of Independence and all the rights enshrined in the Constitution to protect that. Rendered non-persons, and in effect smashed to bits and recomposed as productive animals, their numbers—for they could now be reduced to numbers and statistics—could be used for districting, allocation of representation, and the centralization of power. This gave Southern legislators and leaders a center advantage in Congressional votes, debates, and most of all, over their own communities. Combined with a growing financial, military, and party center in New York and Washington, this produced a new and unprecedented form. The Democratic party, born outside the Constitution in New York State—the heart of continental and slave finance—came to rule across the South after the passing of Jefferson and Madison, by exploiting this 3/5ths Constitutional "compromise"—a bald and brutal fiction about people—to accumulate power, wealth, and advantage against the people's compacts, rights, and first principle.

The evil made possible by the Southerners' crucial insertion was single-minded: destruction of first principle by an effective *legalism* inserted in the framing of continental government. In the South, "independence," "self-government," "the people," and "freedom" meant keeping power and rights from the majority before birth and at every point in their lives, handing these over to those

with "legal" power and the full means to accumulate and expropriate it. What the political order protecting slavery maintained was a lie, attributing to the Declaration of Independence something anathema to it: political *inequality*. With the insertion of the "3/5ths" principle into the Constitution, the South seceded at the start from, and attempted to pull the entire country out of, the Declaration, but not yet the Constitution.

The political order using chattel slavery, or *Slavocracy*, from the beginning, rested on a fiction and the absolute advantage this produced to overthrow the people's rights to power and freedom. The people, the majority, in the South, were turned by the 3/5ths fiction into a rubber stamp against first principle. By reducing the majority to animal status, a vast part of the Southern people was "legally" transformed, for the first time in American history in a broad frame of law, into non-human, producing, laboring, and consuming units in a trans-continental economy, fueled by the expansion of "capital," or *chattel*, generated North and South. This fiction overthrew the fact and principle that, contrary to what a few held then and now, power can only be the people's participation in, and constitution of, their own government. It cannot exist in a center way, nor as an economy or as an abstraction, nor can it rule over humans remade into 3/5ths animals, and remain legitimate by rights in all the founding compacts of the body politic. What was produced could only be unreal—that is, a lie.

With the Confederate secession, this enslavement and inequality, and the lie undergirding it, were turned into a new first principle, based on reducing the majority to a perpetually dead vote. This was achieved by emancipation from the people and the rest of the Constitution outside the 3/5ths clause. When the Confederacy seceded to create their own version of a Constitution, based in effect on a nation-state model, with its society in full violation of founding principles, this lie came to blanket, and undo, the

people of the South. A fatal poison, and a fiction, had been planted in the principle of the people's government. For a nation-state, with its necessarily unified society, organized by a single principle, pushes and reforms to secure everything to one form, in effect turning into bits, to non-fully-human singularities, the plural people and their power. It elevates something alien to the people, and so a governing able to grow out of this. Through the slave power, this was based in the subversion of self-government itself. This was defeated, we think, by a bloody, continental civil war. Yet in spite of Lincoln's efforts and the bitter struggle of so many, the decisive and total defeat of the Confederacy, their second Constitution, and the principle of slave power, was never seen as securing, for all, in perpetuity, the indisputable principle of universal political equality, by right, as the foundation of all law and the protection and security of the people and reality. Lincoln failed, and his murder was one of the reasons for the deadly confusion over the meaning of equality to this day. A revolutionary was assassinated in public, and in power, and the discussion of the violation he had helped contest and answer fell from debate, and was overwhelmed.

The "victory" over the Southern Confederacy is usually described in racial, economic, military, national, political, and technological terms, rather than as a strict matter of contest over first principle. What is effectively unknown is the result of this confusion: the principle of political *inequality*, of absolute advantage over a majority made up of 3/5ths un-people, effectively reduced to bits, and the notion the people are actually incapable of self-government, though removed from all law in the 13th, 14th, and 15th amendments, was able to hold on by continuing where it was harder to stop: in society and extra-Constitutional, permanent parties. Lincoln and the Reconstruction Republicans had attempted to end the possibility of this, permitting and securing blacks in political office across

the South. This was overthrown, with Lincoln's murder and all that followed, under an absolved Southern and Northern center. The result was a Southern majority held, now socially and culturally, to 3/5ths-of-a-person status. The Civil War in America, a gruesome completion of the founding revolution, was brought to an end in a defeat for the people by society. Laws were invented, steadily and deviously, from then on, to secure the overthrow of first principle, South and North.

After the Civil War, now unprotected in fact, self-government at the local level, South and North, was no match for budding mass parties and their cartels, just as the unknown architect of this monstrous scheme, Martin van Buren, had known when he began building it—using two mass parties to protect and advance center interests—from the 1820s on, from New York State outwards. On the face of it, his effort was to build and expand his Democratic party. Van Buren—called, at the time, "the little magician"—devised a perfect solution for permanent rule: when you control and manage the contest for power, and you yourself create that contest, you can blind the people to expropriation. You render it impossible to reverse by means of elections. One party is raised by the center and so a second must *also* be raised by the center.

Van Buren worked tirelessly to establish and secure, in secret, the rule of both parties by the center over all elections. Van Buren's goal, nationalized in the rise of his political creation, the military general and Indian killer Andrew Jackson, and consolidating under van Buren and Jackson's slave-holding military protegé, President James Polk, was to protect this expropriation from appearing to, and being answerable by, the people in assembly. The secessionist Confederacy achieved this with one party, the Democratic party, presaging 20th century forms of this abroad, but was defeated, opening the way for the realization, and darker, more total genius, of van Buren's two-party control scheme.

The subsequent attack on, and infiltration of, the people by van Buren's hidden center system was fierce, and though described accurately and resisted by the Northern and Southern Populists and others after the Civil War, it continued spreading, defeating the Populists, to take permanent control of all elections in the election of 1896. The two extra-Constitutional factions, by infiltrating and seizing all political space, could transform the people into masses, using a facade to disguise center rule by ever-growing political and economic cartels.

Permanent parties, and cartels, because they never were, and are not, in the Constitution, can only be, as the founders and people in New England knew, an attack on the people's space from outside the Constitution. They were and remain the first expropriators; they secured and protected all expropriation to follow. With the election of 1896, and the push for empire to secure a now-locked system, a new movement arose: the Progressives. Unlike the Populists' attempts, the Progressives, everywhere but in parts of the American West—where referendums gave some power to the people—basically left a devilish political transformation intact. Rather than focusing on how to renew and expand the people's power of self-government against permanent parties and cartels, the Progressives focused on the new environment of industrialism and corruption, treating science as the solution and ignoring the spread of a *de facto* 3/5ths principle in society. Unfortunately, the disenfranchisement of the people as rights-bearing and fully governing, in the open, had expanded, as assemblies from the Knights of Labor to the Populists had argued and sought unsuccessfully to answer.

Rather than taking on the center's destruction and voiding of first principle, the Progressives, in the late 19th century and into the 20th, acceding to defeat of assemblies for power and redress, responded to an easier, but misleading issue: *corruption*—of evolving fiefdoms, political

machines, and concentrated wealth and power, built by politicians and their cartels. The stated goal was to remake the emerging center and its society into "cleaner" organizations, based on expert management devised by the center and effected through what we would today call bureaucracy. Managing organizations would be built by and for technicians and professionals, dedicated to clean administration and policy, not to dirty political corruption, bribery, and so on. The political contest would now come to be over the new forms. The two parties, meanwhile, from 1896, defined and controlled almost all political space, assuring political contest could not arise to reform or abolish the emerging structure. The matter ceased to be whether or not all people had held onto, and retained first principle, that is, the right to power and security in self-government. Forms of knowledge and discipline, and their purpose, became part of, and so subordinate to, administrative organizations.

By turning government and society into something rational, "scientific," professional, and bureaucratic, these "reformers" turned from the first principle of a free people governing and protected in their self-government—by law and open understanding—to an incontestable form able to steer and control the meaning of power, knowledge, education, and discipline. No longer would these be measurable, defined, and remade by the people assembling freely, wherever they were, to govern representation. Instead, new forms were devised to turn the body politic away from first principle. What was lost was the obvious fact that science as a source for the people's self-government is entirely different from science to buttress benefits for, and control by, the political and economic center. Similarly, discipline as part of the people's self-governing power is vastly different from discipline as a tool to surveil, manage, control, and conquer. To merely teach new forms of "knowledge" will always be distinct from knowledge growing out of a space where people learn and deepen the practice and meaning

of governing themselves. Concentrated power, in effect, neutered knowledge and discipline and turned them into the handmaidens of a new order.

The Tree of Liberty Falls In the Woods and No One Hears It
The Progressives and the growing system they sought to "reform" were able to do this, if more unwittingly than not, and van Buren's devilish system of center cartels was able to prevail, through the help of a crucial alteration of the founding frame following the Civil War and passage of the 13th, 14th, and 15th amendments, abolishing slavery and correcting the flaws in the founding that had produced war. Originally, the notion of a corporation, or public body, meant only a temporary formation of, by, and for the people, for the conduct of purposes or tasks needing to take place across the broader public, or shared realm, to then be dissolved upon completion of that business or tasks. Through a devious maneuver by a Supreme Court clerk and the Chief Justice, this crucial, originary practice, born in New England, was upended, with profound, wide-reaching implications for the future. An 1886 Supreme Court ruling, *Santa Clara County v. Southern Pacific Railroad*—the latter one of the first large cartels in the U.S.A., working with the parties—in effect, and crucially *retroactively*, rewrote the 14th "equal protection" amendment, passed in 1868, that granted all those born or naturalized in the U.S.A. essentially full political rights. Though even then it was not interpreted as such, the extraordinary threat to the growing center cartels of the 14th amendment's restoration of first principle was serious. As a result, through a devious maneuver, *Santa Clara v. Southern Pacific Railroad* effectively and ingeniously handed political rights to "corporations," which were now called, for legal purpose, "persons." This fiction, which has finally begun to receive serious consideration, would prove quite as pivotal as the previous 3/5ths fiction, and was in fact, unbeknownst to Americans, merely

a new form of it. Factually, the 14th amendment did not in any way suggest or propose this. It had legalized equal protection under the law and so emancipation of blacks, permanently destroying the pernicious 3/5ths principle in the Constitution. This gave blacks power they would not, even still, get in reality for a century and not even then. But because of the extraordinary threat of equal protection, in permanent law, to the center—with its clear, revolutionary re-establishment of full political equality, now, at last, for all the people—the center determined something had to be done. Nearly two decades after the 14th amendment, a short header or "preface" was inserted into the ruling to favor the railroad cartel, "legalizing" cartels, saying that, because of equal protection in the 14th amendment, it was "understood" by the court, effectively, that individuals and the people were no longer supreme in their rights. This was done not in the ruling itself, but merely through a phrase inserted as a comment at the beginning of the ruling, to suggest that making corporations into "persons" had been the consensus opinion of the court when it was not. This *comment* was then quickly turned into a legal precedent by a majority on the court, in rulings that followed in deadly succession, building the entirely un-Constitutional, non-public cartel structure of American society.

Achieved by collusion of court, cartel, and party, this simple trick granted greater power than the citizens could ever attain to center political and commercial bodies. It was, in effect, a neutralization and destruction of the 14th amendment. It uprooted the entire citizenry of individuals and the people, secured and protected in their rights by the 14th amendment, from their political space and political equality. A trick was indeed needed to hand such absolute, permanent advantage over all the people to these new "corporations," reducing the people proportionately, and universally, once again, but this time all of them, no longer merely in the South, to fictional, and *secret* 3/5ths status.

What discussions of this devious and hidden move today neglect to note, speaking solely of the problems of "corporate personhood," is that, in *Santa Clara*'s reframing, the emancipation of slaves, and the 14th amendment, were both retroactively redefined in a broad and lasting way. This redefinition turned the entire people, no longer merely blacks, into political and economic slaves, in a completely new way. This was never stated openly, of course, precisely because corporate bodies, *including* the two cartelizing parties, already non-mortal, would no longer be dissolvable or governable by the people, as they had been in all founding and tacit principle. The people could now never equal corporate bodies' combined, rights-wielding power. By this illegal conglomeration of people and interest, granted rights only individuals and the people can have, what was reframed and elevated to universality, North and South, was a modernization of the plantation model New Englanders had countered and abolished and that a bloody civil war had been fought to permanently end. Every person and political assembly of the people would now be proportionately overwhelmed, shifting the inherent power of people and individuals, with the only rights, to combinations of center political and business interests *called* corporate bodies. This very much included, and was no doubt meant to include, the political parties expanding at the center. Just as it had in the slave South, law was turned upside down to restore political inequality, but for the first time, everywhere, and in secret.

This was the birth and protection of society in America, frozen forever in degraded shape. Based on the principle of an economic, collectivizing supremacy of the center, there could now be no challenge to a new fictional thing called the "corporate" order, and its evolving proposal of invisible rule through society and the market. This was, in bald fact, overthrow of the Declaration and the rights in the Constitution, concentrating center power implacably. What had stood eternally in the way of such

rule, the people and their rights, was legalistically undone, expropriating the people's pre-eminent power and rights, and so enabling the center, now re-defined as an economy but not a politics, to outlast, out-organize, and overwhelm the people and their rights. For any combination of center interests called a corporate body will always have more power and wealth than any combination of the people, as individual persons, can ever have, once its permanent, immortal existence is granted the rights of a person. A corporation would cease to have a mortal lifespan, as a person does. Corporations are not human. They are legal contrivances or fictions, and with this clever comment inserted into a ruling by a very few people, working in secret, they became ruling contrivances, or fictions, to conquer the people, and all individuals, in the U.S.A., and beyond.

With the now protected corporate bodies of the extra-Constitutional political parties in control of political space, from 1896, there was no longer a way for the people to organize as bodies equal to or surpassing so-called "corporate" combinations. Anything new that tried to form from out of the body of the people would be outmaneuvered, from before birth and at every point of life, by the far-greater rights of the now "legal" cartels. Utilization of this trick, unacknowledged and unrecognized as a devastating political maneuver to this day, took much time and effort. But by the turn of the century, with the Populists and independent worker power defeated and channeled into society, few at the center hesitated to employ its dark, collectivizing genius, darker still, because even more secret, than the 3/5ths clause or Van Buren's extra-Constitutional two-party scheme. Constitutional contrivance had seized founding rights and handed them to a proportional, impersonal, and permanent supremacy. The retroactive reframing of the 14th Amendment meant the *de facto* end of political equality, at every point and in every place, and the certainty of a rubber stamp, or fictional people, vastly ex-

panding the enslaved and disenfranchised majority in the South. A new kind of equality would be folded under society, insulated from the people's right to govern and abolish whatever they chose. Henceforth the people could not rise above or control the cartels, which were, of course, political first, but obscured as such by economics and market rule. The plural and constituting people were replaced by a plural and constituting center, and so the people and first principle were reduced to a nullity.

The rise of "corporations," including permanent, immortal political parties, as we know these today, can be dated to this tiny, secret insertion, as peoples' bodies formed for public business were transformed into, and permitted to exist as, "center" bodies, their concern not at all the people's business, but rather the business of center rule. Business no longer meant the people convening, deciding and, when a particular task was completed, dissolving. Power and freedom could be subordinated in concept and language to impersonal, economic, social organization, its processes renamed as laws. No longer was all organization to be, over time, ever more rooted in control by political freedom deriving from the people's self-government. Just as the Southern center had expropriated the meaning of self-government, independence, the people, and freedom to itself under the Confederacy, so now the center, North and South, expropriated the meaning of self-government, independence, the people, and freedom to itself. A new thing could now easily replace the advance of political freedom and equality: freedom and equality for the system, that is, economic and social freedom and equality. The rise of the eternal corporation, falsely protected now by the Bill of Rights from dissolution or correction, universalized the Confederacy's "first principle" of political and "legal" inequality—the 3/5ths-of-a-person principle.

The people's space, unbeknownst to the people, had been legalistically annulled, ceasing to be genuinely

public, visible, or fully accountable to the body of the people governing. The people were turned into what would, in time, become producing, laboring, consuming, and voting units. From there, the people, blocked politically, could be accorded and granted the expansion of mere voting rights. They were no longer able to grasp or exercise their rights to *govern*. The now permanent, or immortal political cartels, the parties, would protect this, as the supreme "corporate" bodies, determining who could run for any election, who would be elevated politically and economically, and so on.

This method, as it evolved into the 20th century, embodied a new and deadly view of power, completely violating all founding compacts. It fatally, progressively, and ever more secretly advanced the old reductionist, and corrupting, slaver view of human beings and organization. The 3/5ths fiction turning persons into un-persons took on a "modern" appearance, disappearing its grizzly agenda, and dissolving, by universally diminishing, the comparative power of real, that is individual, plural persons in alliance, combination, and covenanting. While the law had excised this principle in public, organizational and social laws could now be crafted by a new science. The social means was the model of people as social, psychological, behaving creatures, no longer full, political, human, and equal beings with all rights to govern and abolish. Two-party politics became the science of blocking political equality and the people's right to govern, through corporate, economic, knowledge, and bureaucratic society. While the founders and the people of New England had sought to build structures to defuse, constrain, and most of all reveal politicians' and cartels' inherent tendencies—learned from early plantation history and the repeated clash with British imperial cartels—structural reality, that is actuality for the people, could now be hidden and disguised. Theories proliferated in every direction to secure and enforce the disappearance of primary political fact and first principle.

The New England town meeting, the birthplace of revolution, had put all tendencies against the people's body and persons as a whole on full, visible, face-to-face display, there to be held to account and governed in assembly, in the open. For the New Englanders, all corporate forms could only be public, which meant not merely visible but *governed* in the people's assembly and thus dissolvable by a people that, alone, permitted them to exist and were there to decide their purposes. This was born as a deliberate and tested answer to, and abolition of, the corporate plantation form of the British and Dutch. In the post-*Santa Clara* order, corporate bodies, including the two parties and their cartels, became effectively mega-plantations, just as no 3/5ths person or popular assembly of 3/5ths persons could hope to equal, exceed, or abolish the Southern plantations' combined, immortal rights in the pre-Civil War era. No one under these new plantations could have more power than the eternal "person," a corporate body with its center function disguised, ruling from outside and over public space. The people henceforth could only protest these new, politically and "legally" protected entities, though they had never constituted them, and could, now, no longer abolish them. The plantation model of society was reframed and re-established in universal, color-blind, technical, and modern form. The 3/5ths slaver principle had been universalized, invisibly.

The Constitution—the clear and undeniable product, in law, of a people's revolution—enumerated protected rights and excluded none. Now, with bureaucracy and corporate bodies as eternal and rights-bearing, power could be severed from assembled accountability, responsibility, redress, and remedy. For a while, the Progressive push for "public control" would be used as a mask, as center business, commerce, and the two parties, now unleashed, could grab everything in sight. The masking term "public control" was used by the now supreme and un-dissolvable center

in Congress, Executive, and courts, to further consolidate and expropriate the people's power. Real public control—full, open self-government—was annulled, and replaced by so-called "regulation"—a regulation that was never by the people in full and open assembly, with their delegated representatives effecting this. Everything became a matter of a state and its economy, subjugating and so neutralizing all true public life. Public life was turned into social and psychological, center life. The people would struggle, trying desperately to combine politically, but could no longer prevail or abolish these alien forms and processes ruling over their plural body and experience.

The result, building on what the two extra-Constitutional parties learned from defeat of their single progenitor under Slavocracy, turned into a two-fisted political and economic frenzy of expropriation that continues unimpeded to this day. Mass society, built by political and economic cartels, could steer all rights over power back to the hidden and permanent center, against the people. Human beings, as actors and speakers, could be rendered invisible, and governed, making it impossible to pinpoint, check, challenge, oppose, hold to account, and if necessary, abolish and reform all organization and representation—to restore the people's founding space, and so first principle. Rather than being eliminated, corruption and depravity were emancipated, now in productive, invisible, rationalized, and abstract forms, to outmaneuver the people. Rather than remaining answerable, human attributes, doings, and designs—the expropriation of power and wealth, kindness and cruelty, giving and thieving, forcing and remedying, being just and unjust, and most of all, who people are—could be "disappeared" into social forms, the political disenfranchisement at the root of this hidden by bureaucracy, organization, and a nature as ubiquitous and untraceable as air. In terms of brute politics, the two-party "corporations" protected all the cartels of knowledge and power. A

permanent political and economic caste came into existence which could not be checked, balanced, adjusted, or ended. The parties, in fact ruling bodies in Congress and the Executive, could organize against the people and outmaneuver them, permanently, *out of sight*.

The Rise of Manufactured Reality

What has remained taboo in historical discourse and discussion since these Progressive "reforms"—and in particular since Woodrow Wilson's wartime loyalty oaths and other measures purged, in principle, all "corporate" bodies of opposition and political life by the people in them, before WWI—was the fundamental question of where power comes from and what makes it legitimate. By replacing the people and first principle with center and bureaucratic organization, all that was left for the people was lobbying and voting. All efforts among the people to repair and correct were rendered non-political, that is without real power. They could only work "politically" through the two parties, which were now, structurally and "legally," but really fictionally, above them. Power, as a principle, supposedly no longer grounded among the people in every locality, became a national, technical, administrative matter, one of center representation, organization, and life—a matter of how some would rule the rest, never whether they were ever permitted to do so in the first place.

Instead of exercising and perfecting political equality, over time, as secured by the people's founding compacts, a new concept spread of the people as a *governed* body. The single, most striking product of this was that political machines, once visible and detestable as political and human, gave way, in theories and practices, to what was, in effect, a false constitution of reality: a permanent, scientifically legitimated political and economic *manufacturing of reality*. The political question became amoral and narrow: is "power" effective and scientific? Is administration rational? Is com-

merce and industry efficient and orderly? Can society be made to be smoothly functioning? That what was in question was no longer power, but rather the expropriation of rights and power to the center and thus *force*, was completely hidden, and could be. This political and economic consolidation in the latter half of the 19th and early 20th century in the United States came to infuse modern political and social discourse and knowledge, its genealogy hidden and forgotten through a series of traumas, misfortunes, and endless two-party and cartel competition for rule, forming the pattern we now know so well, one that has in turn spread across the earth to undo self-government in principle everywhere. The British and Dutch imperial corporations were never constituted by the people in their origins, as corporations came to be in New England, in response to their imperial forms. The rise of the "modern" corporation in the United States, by contrast, was an explicit, political attack on the founding compacts of a revolutionary people in its origins. Core structural facts could be removed from the table and from the people's right to see, challenge, abolish, and remake. At the time, so-called reform efforts, for example to monitor and regulate "the Trusts," never turned back to restore the people's power to constitute and abolish, but in fact "legally" eliminated it, replacing it with regulatory, center bureaucracies. Monopoly became, in effect, a naturalized economic form, protected in its "nature" by total state and center electoral control.

To assure such an un-American abolition of public space and power would be accepted, Progressives devised a still more devious solution to replace, rather than strengthen, the people's inalienable right to govern, initiate, and abolish. "Power" as it was held and would continue to be held would now reflect "public opinion." Theorized and designed for Woodrow Wilson's total re-organization of society by war, fellow intellectuals Walter Lippman and Herbert Croly devised the concept of "public opinion" to shift mat-

ters, and concerns of the new center caste system, away from the development, strengthening, and advance of the theory and practice of first principle. The public, the people, needed to cease to be the arbiter and source of all organization and legitimacy, now to be measured and governed by organizations ruling over them based on so-called laws of science, administration, and most of all, information. Reality was no longer something non-conforming, residing among the people on their terms, but something controllable, measurable, and manufacturable, advanced by a technical, intellectual, bureaucratic, and political caste, for its benefit, on its terms. All society would be re-organized to this end, and "public opinion" would be one of its key propaganda tools.

What was undone by this, theoretically and practically, was the democratic and republican principle of how opinion, power, and government remain real—through accuracy of representation not in and of itself, but enforced by a people that retain all power and the free means to covenant, govern, define, exercise, and abolish. This invidious replacement of first principle, so brutal and ultimately visible under Slavocracy, replaced crude Southern party and plantation rule with industrial and party bosses and cartels, including those of knowledge, now to be far less traceable or openly brutal than chattel rule. The brutality, of course, would prove fully as shocking, as the primitive early years of political, economic, and industrial expropriation showed. The people, reduced to social functions, as laborers, voters, and, in time, consumers, disguised, if in a new, softened form, the old 3/5ths principle, now hidden by a scientific model of transcendent and un-dissolvable processes. Decision, description, and definition were reserved to the ruling, expert caste, to be adjusted, reformed, defined and refined by it, to sustain permanent caste rule.

New anti-party parties and assemblies arose continually to oppose this dual monstrosity, but over time opposition to the center grew less and less possible practically. The

center could outmaneuver and crush the people and claim law and science were on its side; when this failed, it could turn to "scientific" economic arguments. Every assembly and person that arose to contest this collectivizing social order and its two-party cartel administration was framed as effectively illegal, a threat to managerial control, as unstable, or as a threat to rationality, expertise, and "clean" government. Corruption was, by this means, hardly answered, but instead hidden and vastly expanded.

The premise that all organization, including the bureaucracies called corporations, can only come out of full, non-conforming persons acting, and free, covenanting and combining for governing, was transformed, year by year, and decade by decade, into ever more invisible machineries, national claims, war claims, economic claims, technological claims, psychological claims, and social claims. Freed from the people's assembled moral control and self-government, this new social and political order of rationalization, production, psychology, and consumption could evolve much faster and further than the people, precisely because it could now forever outmaneuver the people politically, turning them, all of them, into 3/5ths people. "Freedom" could only emerge out of those at the center and in all the bureaucracies, through market and society, vetted not by the people, or politically, in assembly, but by expanding and spreading hierarchies steered from the center. Citizen power became voting. Worker power became labor. Human diffidence and uniqueness became behavior. All organizations could be controlled. The social became the regulating realm, replacing the people's political existence and control. New political forms would be developed to attempt to address this, but the basic, fundamental "legal" change could deflect and abolish all challenges through a new order of knowledge and so-called rights.

By the 20th century, for the first time in American history, as a principle, power's purpose and sole legitimacy was no longer what the founding Declaration so

beautifully held and that has driven all true political reform: that political equality is eternally and forever first. The very word "self-government" lost its primary political and living significance, among intellectuals especially, for intellectuals now became the crucial gear of the bureaucracies, separated from the people's space by society, expert knowledge, and rule. The presumption was that this would be fairer—the bureaucracies were scientific, or "empirically" based, measurable, and more knowledgeable, after all. Government would include agencies, commissions, and economic and political bodies to produce and regulate society, informed by theories and social processes—in order, as it were, to keep an eye on things, steering them in an ever more rational, efficient, and productive direction. The body politic would be regulated, but the cartels and people would be administered. "Public opinion" would be used to adjust this, precisely because it had been severed from the people's power and right to constitute, bind, and abolish. Rather than orders and definitions flowing downwards from the people, checking every return of absolutism and tyranny, the Progressive vision rationalized a so-called "power" over the people, adjusted according to what the center would call the people, but that the people could not define, contest, abolish, or alter. By this means, the center, with its instruments and processes, was emancipated.

This emancipation, in reality a completely *novel* slavocrat form, blanched the center of the taint of slavery and explicit race slavery, through a more socially equal form, North and South, of industrial and cartel political domination. Rule was reshaped into that of general society, based on so-called "scientific" evidence and a so-called "scientific" model of human beings. In reality, domination and production would be adjusted to secure, stabilize, and expand center and cartels as mirrors for a people robbed of founding power and self-definition. Rather than protecting power and reality, the new order turned, in resistance to

the people and reality, to hide the often sordid facts about power, politics, political history, and political actuality. The people, rendered an expanding body of consumers, job-holders, and voters, could then be easily managed by economic and social cartels and the two permanent controlling center parties, with all their proliferating arms and legs.

Emancipated from the people's moral and political control—regarded by the accumulating center as unreliable, unpredictable, reckless, and ignorant—government could now unfold in a functional, faceless, collectivized, and unaccountable order of politics and business, immune from redress, restructuring, or abolition. In a true sense, it ceased to be government, that is, what all founding theory held and that was learned from New England: that government can only be the embodied, actualized, advancing, and protected people defining, enacting, and conducting their own affairs. Political reality would be manufactured from outside the Constitution to infiltrate the people, preventing them from assembling to contest the veracity and justice of the order, reassert their power, and form their own, independent political organizations for elections and public life. Should such organizations, among communities, workers, and even consumers, dare to form, they could be infiltrated by persons controlled by, and continually constituting and reconstituting, the permanent center and its ever-growing bureaucracies. Force would be determined, divided, and allotted by professionals for policy and administrative ends. The party-political and economic, or social, form could perpetually *anticipate* the people, transforming the body politic into blocs of voters to back and adjust the eternal center. In essence, the people were "scientifically" robbed of power, as before in the South, from before birth and at every point of life.

A people robbed of power cannot then be reflected in "opinion" *or* in "votes." Such things can only be determined as real by the people on their terms. It does not mat-

ter how ingenious theories are at describing such a people and world, for the *people* no longer constitute power, legitimacy, and reality. The system instead organizes and manufactures reality for the purposes of a fiction, or *lie*. This lie is built by parties and cartels, or society, using votes, controlled and adjusted to legitimate and renew itself. In the end, such a notion of measurable and manageable publics and voters, really managed, behaving, and steered masses of behaving animals and units, was incontestable and slippery enough to protect the concentration and expropriation of power, wealth, technology, and enterprise—not because of theories, but because the power to abolish fiction was taken from the people and so out of reality. Whoever controls political space does not merely represent but defines reality, as politicians and consultants have long told us. As Walter Lippman put it in his *Public Opinion*, "For the most part we do not first see, and then define, we define first and then see." Bureaucracies, parties, and cartels might be adjusted according to "public" opinion and votes for party men and women, its figureheads adjusted by processes, but who finally has the power to define, produce, shape, control, and create the reality on which all opinions and theories rest? The question of who is permitted to do so, as Lippman and so many others understood all too well, is everything.

This progression—from an incontestable, clannish, white supremacist ruling caste in the South to its more expert, broad, impersonal, and multi-racial form in the 20th century—has remained invisible, unchecked, and supported by ever more devious science and theory, in economics, sociology, political science, anthropology, culture, and linguistics, that is, by all that can remove the public's business from the people's definition themselves, and so their capacity to see, understand, and answer. That is why it is not merely militarization and ever-expanding secrecy and bureaucracy that block and crush the people. Truman's obscuring of first principle, through a new and hidden over-

arching principle of national security ruling over a cartelized society, was only the final, consummate, and logical expression of alien processes and forms invented and developed mercilessly, beginning, most likely, with the undoing of Reconstruction in the 1860s and 1870s. The problem is now of an entire culture—of two parties and their bureaucratic cartel plantations—manufacturing a ruling society and reality, blocking and expropriating the people's political power, and burying every actuality experienced by the people themselves in a permanent, unmarked grave.

The Rise To Rule of Fiction and the Virtual
The transformation of political and economic cartels into eternal entities, partly by the devious, retroactive, and secret destruction of the 14th amendment, ended up overthrowing the people and the first principle of their self-government. It allowed a center system bent on disguising the abolition of founding principles, and most of all first principle, to grow and manufacture its so-called order in every direction. The cartel center, with its forms of knowledge and science, could now disappear each of us as full, different, actual, and nonconforming people with inherent rights to govern in, and be protected by, face-to-face assembly, defining all that is real and that we decide ought to remain real. We, all the "whos" of us together, could be replaced with something that *looks* like us, that looks like a people and a reality. This was possible only because the people had been reduced to a universal, 3/5ths non-existence. Structures of knowledge "proved" this was real, when it was, and is, in no way real. The manufactured result is masses organized, subordinated, and carved up to hide truth, reality, and all the facts and rights with which a people could assert, and protect, their reality and right to govern. The plantation reality of Southern society had become the manufactured reality of general society. Incontestable slavocrat reality had become incontestable party, center, and bureaucratically manufactured reality.

The 20th century in the U.S.A. marks the rise of false and crushing reality, or *unreality*, to power, through emancipation of a permanent political and economic center caste from the people. Policies and commitments that the people would want and would have effected on their own, and may even have voted for—with all the facts, resources, rights, and power to govern through elections—can be cast off with impunity. A false world is constructed, not because the people are manipulated and inherently ignorant, but because they have been robbed of their rights to discover, convene, constitute, bind, abolish, and re-form, that is, to be and unfold as full, plural, political people granted a right to full public life. The principle of the people's power to constitute and establish what is real is undone. This is buttressed by the rise, to aid domination, of multiple forms of so-called knowledge and life, for example so-called "economics," "science," and "technology." The result, however, is rule by *fiction*. The result is not "manufactured consensus" built of manufactured opinions, products, services, and technologies, creating artificial reality people are manipulated into buying. The people have no choice but to accept what they are sold and told because they lack the space to contest and abolish, and thus decide and actualize how they would do, be, and sense differently. Instead, the people can only accept choices, things, knowledge, and realities made for them by the society. The result is a *fiction* of consensus, of reality, of plurality, of representation and participation, of legitimacy, and finally, most devastatingly of all, *of the people*.

The people can, of course, participate in false representation endlessly. What the people would on their own want, do, be, create, and sense, however, becomes steadily more unimaginable and practically unrealizable. The space and power to establish and constitute has been occupied and seized. The people can be framed and described precisely as the cartels and "government" want them to be.

There is no alternative. The space of representation and participation is built against the forever non-conforming. No more are the people assumed and described, to themselves and the world, to be serious, engaged, and knowledgeable on their own terms, with full capacities and power as fully non-conforming 5/5ths people, dealing with the world as it is. No more are the people assumed and described to be the wisest repository of freedom and good government. The people are there to be managed, expropriated, and used. They can be described and be shown to be shallow, ignorant, and gullible. They can be described and be shown to be a mass audience buying, accepting, participating in, and supporting utter fiction. Most of all, they can be described and be shown to be willing consenters to endless conflict, war, and the abolition of democratic control. If ruin attends such domination, well, the people are shown to themselves and described and defined, as participating in, and supporting this ruin. They cannot reliably and enduringly establish, or constitute, anything different.

The people, as a governing body, of course, consented to none of this, because this order ruling over them was not built by them to bind and compact in this way, at any point. That they cannot challenge it is enough. The very notion of consent is voided, because, for the system, the people do not exist except as a mass to be saturated and steered. The people become, instead, voters approving ballots, as consumers, job-holders, and those enfranchised and disempowered by society. Actuality and our worldly home is propelled into an abyss, filled and hidden by cartels and all their commercial, political, scientific, technological instruments, knowledge, and processes. That this could be enormously profitable, which it would be, as the Confederacy was, is merely the payoff for coordinating with a nefarious fairytale. For the people would undoubtedly develop in an unexpected direction if they governed and had the secure space to do so, as founding compacts held

the people had the immortal and ever-lasting right to do. The people, however, can no longer find themselves or be themselves; they can only be what cartels, state, and their society say they are, and make sure they remain. They are not allowed to reject this and create their own forms and being, with all law rooted in, and strengthening, their self-government. They are not permitted a lasting experience of even who they are, of what they would want, do, be, or create, because the space to explore and establish this on their own terms, defined by them, has been taken away and replaced with something else. The result is an ever-evolving progress that keeps the people, as a plural body, five steps behind the fictions that organize and saturate them. The ruling order's definition and fabrication of reality is designed to outpace every challenge and challenger. The result is hardly consensus, manufactured or otherwise. It is not our world. It is, instead, a virtual world, a world that is, by definition, possible but not real, that might be, but would otherwise not be, that controls, steers, and swallows all that is real and actual, placing power—inherently and by right belonging only to the people—in an unreachable, existential, and captivating nowhere. The increasingly total manufacturing of reality becomes the manufacturing of the people into nothingness, posed against an incontestable order that only seems theirs and "power," when it is in fact not power at all, but something else.

An American fable arose in the 19th century to describe this, crafted first in literary form by Frank Baum, a staunch supporter of the Populists, in a series of books for children. Baum understood well the machinery taking over in its early days, turning it into a kind of metaphor. It was, decades later, during the Depression, that this fable took on a focused, more visceral, more vivid shape. In the film made from Baum's books, *The Wizard of Oz*, we find Oz ruled by a great and powerful magician, the screen on which he appears filled with frightening images of unimaginable pow-

ers and capacity. This great magician rules a non-existent and cheerful polity of munchkins, entered by a small group of outsiders who in turn cower in fear before the great screen. Under the rule of the great magician, the cowed travellers cannot get what they need to be full and real, and they are turned away. Only a little dog pulls back a curtain to reveal the power as abject, pathetic falsehood. By the 21st century, unfortunately, due to the pursuit of control over all space—and so the destruction of first principle—there is no little dog able to pull back the curtain and reveal the circus barker pulling the levers of a completely unreal "power." The curtain has become, decade after decade, heavier, more ubiquitous, more unreal, and finally irremovable, made not of cloth, as in the 1930s, or iron, as in the East, but of something far more flexible and durable. The system, of course, is no fairytale, though it is based on one. After a century and a half, an order manufacturing un-Constitutional sovereignty, not at all power, assaults the people and reality from every direction. The intelligentsia, the order of professionals granted managerial and expert status over ideas and principles, renews and legitimates this by whitewashing its sordid history, renewing the ghoulish fictions spread by Slavocracy—that the people were and are committed to this and built it for their own independence and freedom. It is true the people may now have voted for it over and over. But they never controlled the votes, the ballots, the matters at hand, or the power of removing and abolishing whatever violates factual, shared sense and the people's inherent and inviolable, *real* power. Today, in more advanced and incontestable form, data, monitoring, the statistical, and the technical manufacture new screens eroding actuality by turning our attention from what is around us. In part, everything is true. In part, we certainly appear as if we really are all now only 3/5ths of a person. Yet none of this, of course, is actually so.

Since 1946, building on the centralization of power, war, and finance during the 1930s and early '40s, the rise of

a virtual order of manufactured reality, or fiction, rooted in the rule of an expert order, has tracked the ever more total protection of a "security" based in overthrow of founding, binding, public compacts and principles designed to permit actuality to appear and be addressed. The old and first principle of security based only in the people's self-government, and thinking about that, has been rendered tractionless. Now, few who consider themselves advanced or theoretically innovative bother to make self-government among the people, and the people's constituting power, the focus of thinking in the public realm. To advance and develop new thinking from founding documents, principles, and the long history of struggle born of them, thereby giving the people back their foundation, is to be considered archaic, to inhabit a fringe, to be infiltrated, silenced, crushed or taken over by a continental and finally global center and its global society—precisely what the Southern Confederacy and Slavocracy sought so tenaciously, if primitively, to build. The foundation of the people, for the people, by the people is renamed as a conspiracy of the center, the wealthy, the disgruntled, and so on. Before one can bat an eye, if one talks about restoring self-government, one is worked over by a thousand hidden hands making it ridiculous, party-based, or insane, when, were it spontaneous, uncoerced, and free, it would be none of these. The development and evolution of the people's independent thinking, assembly, sense, and knowledge is blocked and undone, and so the development, in theory and practice, of first principle. The people are left, in the end, with a dream, a hope, and a memory, tinkering amidst the rubble of what they thought was theirs, and firmly, and rightly, believe remains theirs.

To get at this, it is entirely unhelpful to say opinion and thinking are manipulated by knowledge, information, and image-making, as if there could ever be a public in "public opinion," as if consensus could indeed be manufactured. Opinions are personal, held by one person or by plural peo-

ple. One might share an opinion, but the public cannot share one opinion unless they physically gather to determine this and appoint someone or something to effect it and be held accountable, face-to-face. Anything else is unverifiable and subject to fabrication, trickery, and the lie. To control things, "public opinion" does not need to be manipulated. Its very existence is a reflection of unaccountable control outmaneuvering every resistance among a plural, powerful, and differing people. The social and managerial order drains away the resisting existence of each and every person and thing, and so the political potential of people in binding combination and assembly. This is possible solely because of the removal of the people's power, and indeed power itself. Did the people assemble on their own, decide, and say what they believe to be so, negotiate it, and ask someone or something they chose to represent their convened opinion on a matter, subject to removal of that person or thing for every and all violations? Not a chance. Public opinion is instead an insult, and a mere part of the larger insult of an ever shifting, disempowering social rule. For this so-called opinion, in fact, has nothing to do with the people in their governing depth and plurality. It is based on the needs of a center to adjust itself, producing realities to undo, disappear, and confuse first principle. There is only a picture of consent, fabricated every day, in votes, in desires, in manufactured reality, when in fact, there is no consent at all.

There is little that can stand in the way of such mendacity except for reality, for reality, existence, and fact remain, even if they cannot appear. The people's power and reality cannot be taken from them, by right or any other means, not merely because they retain power and reality, but because the first compact of the people, in the Declaration of Independence, secured political equality as the foundation of a new body politic, a revolution was fought to secure this, and a body came together to give this enduring legal shape and protections. Struggle after struggle has been

waged to protect these, against all odds, to hold the system to its originary, binding promise. In reality, this promise can only be seized by force, however devious, sophisticated, invisible, and systemic. A century and a half of maneuvering has not affected the fact this reality remains, if only it could be found. It asserts itself every day, against us. For reality is not and cannot be manufactured, in the end. It inherently surpasses every human effort to fabricate and control it.

The New Steerage and the Minorities of One
To imagine, as we do today, that an "information" "economy" might answer this, that somehow the spread and growth of information, data, image, and technological communication could free us from rule by a center caste and its perpetual expropriation of knowledge and power is the continuation of a fairytale, and at worst the logic of its idea. Absolutism has migrated from the apparent, visible, and sensed, to steer from afar, and steer far away, against everything and everyone that is here. The ability to outmaneuver the people reaches an extreme point, as a devious superficiality blocks every traction and interference. It becomes easy to lose out to, for example, someone ten thousand miles away, the moment one acts like a human being with every right. Illusions and fictions are manufactured and organize relentlessly, not because the people do not fight, which they continue to do, but because the people cannot abolish rule and re-launch their own governing. This is how actuality slips from the grasp of those who must endure it. An empire of control, production, and expropriation makes certain the people can never, ever get ahead of it. The only adjustment possible is according to party and cartel procedure, process, and the mass forms the political and economic cartels create and administer. We can generate our own information, material, image, and sound, we can generate things and find the right people, endlessly, even in autonomous spaces here and there for a moment,

but government is out of the people's hands. The result is an ever tighter and more destabilizing flux—of *virtualization*. Manufactured realities, factually unrealities, replace and hide all that is so, replacing what is actually possible with what is only persuasively so. Virtualization, already problematic in the refuge of ideas, becomes the technical domination and neutering of plural political possibility and reality.

The people under such systems become invisible and non-existent to themselves and each other in their full and powerful actuality. The power of persuasion and appearance is expropriated and neutered, though the people continue, against all odds, to assemble for a day, a week, a month, or even years. This cannot rise to the political—that is, as the power of the people in implacable bodies achieving their own governing and holding firm to power. In response to the people's actions and words, where they arise as they will, come command and dissuasion—through agency, communication, need, certainty, desire, psychology, issues, and finally life and the altered structure of DNA itself—aligned, every morning, against us. Each of these mobilize us out of our 'world, to undo the actualization of the people's power and reality. There is only invisible force crushing the space of free self-government, spontaneity, and remedy. The ruling order can finally dispense even with the old fiction of consent.

Virtualization, a kind of universal ungrounding, spreads and affirms what is *not* so, virulently. Instead of what is so appearing to all, in all its unprocessable and resistant face-to-face depth and factuality, answerable by and to and for all—what was once called reality—a void is spread into the world to manage, control, undo, and destroy all non-conforming, non-conformable depths. The result is "organized," but only in a very shallow sense, for it in fact is highly unstable, disorganized, and all-consuming. It disorganizes and destroys reality. The centralization and

accumulation of "power" grows, using the endless chaos it produces to legitimate its expanding growth. This void and unreality, a void and unreality present now even inside us, binds and ties and coerces, draining away interference, resistance, and discovery of what is so—and so any effective human governing of it. Solidarity can be expressed, but is then managed, infiltrated, and outmaneuvered. What is or is not happening inside us and between us is replaced with ever less actually grounded, ever more dissuasive and liquid images, sounds, fabrications, information, and surfaces.

The virtual, unlike previous forms of "public opinion," is based no longer on merely manufactured ideas and opinions but on statistical and coercive perceptions, experiences, sensations, and processes, all of them a "natural" outgrowth of a society of large numbers. Appearance becomes statistical coercion and rule. This is conveyed in the Cold-War-era term "public perception" and the term, born perhaps first during the crisis of the Depression, of "public confidence." We yearn for production of a stable and ongoing experience strong enough to free us from ever more chaotic, un-addressed, unaddressable reality, confident we are actually in reality. Perception is managed, as we well know, but not to control us, which cannot happen. It is managed to hide any reality that might contest fiction and so-called control, enabling us to regain traction and govern. To be out-maneuvered is not at all the same as to be controlled. Unreality and absurd claims are sovereignly inserted into the most microscopic aspects of mind, body, nature, and all relations. Reality is undone by informing— form described, made, inserted, and gathered by others, accepted or challenged indeed, but penetrating anyway. The people are technologically bound under, by being politically severed from, worldliness, from what is unadministered, unprocessed, unique, resistant, and true. The expert who rules and makes rules disappears, replaced by an array of processes with neither apparent human hand, face, or body.

Every political origin is replaced by hidden hands, faces, and bodies.

This new order must be hidden, for these hidden forms remain all too real, human, and illegitimate. The new difficulty is that information and image soften the illegitimacy, making hidden hands seem abstract and fascinating when they are neither abstract nor in the least fascinating. Simulation, dissimulation, and relentless, constant alteration outmaneuver the non-conforming. Simulation, with its total information, material, image, sound, and fabrication, exists to discredit every finding out, with and through each other, of what people themselves truly think, feel, know, sense, are, understand, want, and could be. Ever faster surfaces, severed from, and overlaying, the constituting depths of reality and history, seal off and seek to burn out the depths from address, remembrance, reflection, and response.

That we are mediated by forms controlled from who knows where, that "the president," the Master in the Big House, comes to visit us in our homes and workplaces through our screens, that we can "watch" and "follow" war, slave patrols, and even desperation and conflict, in a foreign country or at home, and cheer or rail, that we can spend each day at our screens and keyboards, the new cotton gins, and that we can "vote" by pushing buttons to re-legitimate an order satisfyingly giving us *feelings* of power, is the point. We are "connected" to the world and each other through the virtual, never the messy problem solving of self-governing assemblies based in every locality, workplace, and realm. There is less and less to assure even elections are real, and certainly no way to demand those we elect reflect what we said we wanted and even voted for. What we voted for vanishes instantaneously, as if it had never even existed. This is crucial to the system's relentless blows. We are thrust deeper into despair, acquiescence, and the chaos that rule over 3/5ths people produces. In reality, we are divided from the world and each other by an abyss

rising and spreading against us each morning when we wake, and before that, even in our sleep.

Information, transmission, production, and technological "communication" are based on a revised, cybernetic model of the 3/5ths human learned from chattel slavery. Virtualization makes it impossible to see the political structure of this rule by real, accountable, and removable people, just as it makes it hard for us to see we remain political, full people with all rights and power to define, resolve, form, bind, and abolish. The world is reduced to information, but really to organizing fiction, manufacturing ungroundedness. This hides whatever is non-conforming, whatever surpasses information, to make the structure of rule only *seem* orderly. This orderliness, of course, is a fiction designed to organize governing. One has no idea of, or way to verify in assembly, in reality, face-to-face, where or who or what is acting and present, and what is so, only what virtual experience and perception tell us is so. We are left to navigate among signs, ever receding mirrors and reflections throwing our passions, thinking, imagination, and finally reality into disarray. These signs, figures, and mirrors derive from a structure of rule by real people making real human decisions. Their devastating effect, however, is to convince us anything is possible, shining promise is everywhere, and progress is inexhaustible and unstoppable. We can learn about everything. We can protest forever. Yet there remains little or no traction for the people themselves in governing conditions. We are lost in warrens of bureaucracies and their knowledge, artifacts, constructions, battles, and so-called facts. This is finally reflected even in language and theory itself, whose ground in actuality can be severed. We become convinced we have no choice but to agree to this and call it real. There simply is no alternative.

The first cybernetic theorists and labs were instruments of the first truly huge, scientific bureaucracies, constructed to wage world war through empirical science and

concentrated "power." This was already unprecedented enough. But their theories rested on the notion of information now gathered, and used, to steer massive force to explode atoms and monitor all things. Unprecedented violence, and finally violation of nature's composition of the world, could be amassed and deployed from a thousand controlled directions. A latent principle in the concept of "information" had been untethered: the violating reduction of world to bits to "control," to eliminate all noise and interference of the world and the people in their plural life, demands, and governing. "Information," as a 19th century technological principle, had already been invented to find out where things and people were located and going, however false this picture was, and however much it violated the principle of the people themselves defining who, what, where, and when they were. In the telegraph and other forms, it then became possible, with the world reduced to bits, to one thing and one form, to transmit this to control, steer, and respond to the unforeseen and unmanageable, to find out what was so, but according to a reductive, single principle said to describe, and relay, the world. This, when joined in the 20th century to unimaginable force and violence, meant such violence could be "used" in a controllable, forceful way to master and target total destruction. Radar, missile, and rocket trajectories were the first world-altering, world-destroying military and technological sign of this, followed by the creation of deadly artificial things renamed as natural, elements like plutonium and all the fabricated elements that followed. The atomic, and then hydrogen, bombs were only the visible part of newly artificial, effectively unified processes unleashed on the earth, signified, for example, in a once basically harmless thing called radiation, that now became "radio-activity." In earthly nature, radiation is minor and effectively manageable. When extracted and assembled in mass, it becomes something quite different. Similarly, "economic" "processes" become

an arena, which, small and manageable on a human scale, on a mass scale, steered by vast bureaucracies, assert every disorganizing and undoing of fact. But finally, and equally consequential, was a theory that the world could indeed be reduced, in reality smashed, to bits, all of which could then be imagined to follow one thing, and be one thing, this thing called information. This in effect brought into nature itself, and the human world, the inherently social principle of one thing organizing everything. This order then entered extraworldly space, to achieve this steering, monitoring, and destruction from invisible satellites and offices, linked by invisible cables and conduits, creating vast networks of data and processing, every machine and algorithm operated from invisible, untraceable sites, round the clock, on the basis of this reduction of the world to completely uniform "bits."

From the start of the so-called "information era," a new kind of destruction of the world's and people's interference and resistance was unleashed. The world, the people, and reality are nothing if not interference and resistance, and hardly uniform, that is, reducible to a single form. World, worldliness, people, and reality must be overthrown scientifically and technically to even have a "substance" that would be masterable by so-called "control." This "control" was, however, and from the start, the espoused and reiterated goal of cybernetics. Information is, nonetheless, only a product of bureaucratization. It destroys plural and resistant reality. It hides, most deviously, the proliferation of mentalities set upon a *political* end: to remove from consideration the interference and resistance of all that is unique, non-conforming, non-behavioral, non-processable, and irreducible. With the new reducibility to bits, force and process can be controlled and deployed massively against actuality, which always remains in the way. Appearance is replaced by information, then information by image, and finally both become subordinated to total, statistical, manufacturable processing, reducing everything to

bits. To focus on information, image, and processing, however, is itself a trick, because what is occurring is bald human and political rule, though it now seems to have no human or political actors involved. The sordid facts of rule can be fully buried, and perhaps most of all, the extraordinary violence now underlying it.

The disappearance of the fractious and real, and their replacement with fabricated information, material, image, and sound, was, from the beginning, a kind of *weapon*, the most forceful mode of replacing actuality with "control," however absurd and ruinous this so-called control is. What it remains is domination, but crucially, now by the very destruction of worldliness. For signs of the world, in the end, through information, material, image, and sound, can be manufactured and managed from the center, according to its needs, producing a sensation of reality when there is little but artifice, claims, and destruction. We can make our own information, material, image, and sound, but the machineries of reduction of the world to bits, and their distribution and dissemination, reassert "control." To get outside them one can only get back inside them, for the center cannot let go of a now fully mutated, expansionist and "lawful" 3/5ths principle, extended from the person into the world itself. The order of a new society born from this, like the older slave society, rests upon a domination that not only does not appear as political, but is able to continually disappear all its political, human, and nonconforming attributes. For, if one looks at their development as commercial and state forms, information, material, image, sound, and their consummation by bureaucracy were almost always, in some form, connected to militarization and violence, enforcing the theft of the people and world's resistant and actual power through an assault on, rather than disclosure of, resistance. Resistance is a kind of source of, and for, appearance. No amount of information, material, image, sound, or bureaucracy can compensate for

the now unleashed theft and destruction of rights, reality, public space, power, appearance, and existence. Each have been, as many of the people were under Slavocracy, effectively reduced to bits.

The people are of course permitted to try to catch up and govern, but they cannot. Forms may seem to be power, as if information, material, image, sound, and bureaucracy could constitute and protect knowledge and power. If this were truly knowledge, of course, it would be power. Unfortunately, it only looks like, and can now appear—because resistance and interference are removed—as knowledge and power. The purpose lies elsewhere—in tools and processes constructed and managed by an "expert"-run, ruling caste, accommodating eddies and nooks where difference flourishes but can never fully rise to reconstitute the people's diverging senses and governing in resistant reality. However personalized processing may be, the frame does not belong to, and cannot be abolished and be reconstituted by the people turning as they do and will to solid ground, that is reality. Things can certainly be reduced to circulating signs and technology, it is true—but only by rendering actuality, which inherently interferes and resists, subordinate, that is into a "substance" that can be monitored and controlled by a single unifying form, that of bits. Plural and resistant actuality has not been, and can never be abolished. It can, however, be steered to the point of vanishing for us, turning every something into nothing through a hamster wheel of virtualities.

Here we encounter, if you will, the founding "sin" of cybernetics, turning the manufacture, control, steering, reduction, and violation of things, people, and first principle into a so-called science. The term cybernetics is derived from the ancient Greek work *kybernos*, or governor. In its very foundation, cybernetics was, contrary to virtually all historical description, designed as political theft of governing for, and to, the center caste and its endless goal

of, and desire for, "control." Its materials were already a simulation, or replacement, of the realm of resistant and interfering, noisy appearance, its "governing" a replacement for grounded government among resisting people in a resisting world. That this rise of domination could become invisible, as such, may well be its most tragic, fatal part. To be able to imagine control by algorithms, for example, one must first be able to *reduce* things to a "substance" algorithms can control. The new "governing" can then be said to not be real, human, and political, but natural, machine-like, and technological, derived from scientific laws and evidence. It was from the start, however, something the people were not to see, apprehend, govern, undo, or abolish. It was built to undo the people, all very much still in an interfering world, precisely as radio-activity undoes and re-orders every cellular structure, invisibly.

Cybernetics is based, as many forms today are that we call "political," on a fiction that organizes. For technology does not steer, *people* do, and images and information do not represent and steer, *people* do. That is the political. The result is to create an order no one can call political, a fiction, and an embodied lie. The order and its constant productivity no longer appear as they are, as a deadly magic show of a caste that cannot be found face-to-face and removed. We very well can see we are steered by manufactured and second order forms, but what we are under no circumstances able or permitted to see and remedy is how this is done by concrete people making political and human decisions, for all too political and human, sometimes even ghoulish reasons. Vast organizations rule and decide, and yet we seem to have no power any more. An intractable illusion is manufactured to disappear the politics of governing. The result is not power, which remains among the people. It is force and theft masked by theories, processes, and people. Information, image, and communication become the means through which bureaucracy reduces interfering ac-

tuality to secondary status, as if it were merely circulating signs. But it is a 3/5ths status that must be adjusted to, and subjugated to, functions in an interconnected, global, war and finance economy, securing a permanent caste. The fractious worldliness of the people—independent, free, plural, unique, self-governing, and not economic or statistical, as they rightfully seek to be again and again—is penetrated and destabilized. The order of society is no longer merely five steps ahead of us. It is fueled, globally, by energy, passions, and hopes. We cannot, of course, catch up to and grasp what we are tricked into pushing beyond our hands each morning.

An economy and society based on this, from the beginning, is a political form. People may be able to assemble, and quickly, because of so-called technology. But who assembled them? Who transmits information and frames its meaning? Where did this information come from? What is information, really? Where does it go to? We have no idea. Who built these systems, and for what? Is the assembly calm, methodical, plural, resistant, and political, face-to-face, for peaceful discovery and establishment of fact, power, and governing among the people? Are we even willing to continue to assemble until fact, self-government, and the governing of conditions are returned to us, not just to some or even many, but to all, in full? Instead, what determines is a virtual communication and process perpetually disguising invisible and all-too-real rule. Tens of thousands of people can be massed and steered this way and that, believing it is they who steer, experiencing and broadcasting this fiction to themselves and others. Buttons can be pushed, screens tinkered with, crowds moved this way and that. Yet the order out of which crowds assembled renders secondary what plural and differing people create, experience, are, verify, and would communicate, as interfering and non-conforming—for themselves and each other, on their terms, lastingly, face-to-face, before every gadget,

process, and hidden command. As long as the "technologi-cal" "governs" and mediates, the physical world and fact can be undone. What actually governs does not appear be-cause it is *nowhere*.

Already latent in nuclear science and chemistry, the destruction of reality finally becomes its own so-called science. Where before manufactured reality merely ruled, now it can destroy anything and anyone that rises to refute it. The turn to the professional and expert, begun in the late 19th century, reaches an apotheosis, as the real, actual, and worldly give way to empty and false representation as an all-consuming process governing all things. The 3/5ths of a person principle attains its universality in the world and nature, with evidence based on depersonalization and the erasibility of fact. Things and even life that lasted for thou-sands or millions of years are turned into facsimiles, then, in shocking finality, are destroyed to free every facsimile from challenge. The world, of course, is no longer fully there for us to check the facsimile against, but is undone by it. Little can be checked, verified, or preserved. It becomes merely possible. What is factually so is not "re-presented," but, as it were, "de-presented." The people, all of them amidst such processes, keep asserting rights, insisting on this or that, trying to preserve this or that, determined to govern, yet full power never returns into their hands. The slightest meeting or thing is tugged this way and that by "communication," "technology," and "promise." What is so is not merely vanishing; what has vanished are the means to find it, sense it, keep it from destruction, to protect, pre-serve, and govern, in challenge and fact. Are we truly con-nected to the person we "communicate" with, the person or policy we assemble to challenge, which might originate only doors away? Is the thing we made or did even real anymore? Or does it come from the other side of the plan-et? Does the otherness of the other side of the planet even register, no less what is under our feet? The technological

doesn't link and relate actuality, it uses manufacturing to unleash force and violation. Is the object, person, or thing the facsimile improved upon and replaced even around to contest? Everything is theorized and technologized to come from ever-newer, more nameless, sourceless regions, there to be returned to nowhere and nothing.

Reality, actuality, and promise remain, but the destruction of real and actual promise and possibility is also real. Bureaucracy, party, cartel, and their instruments are a factory not of order and grounded sense but of the destruction of all that is needed and needs to be addressed. They eliminate, or disappear, what enables anything to *be* addressed, even under the best of circumstances. The people's efforts at self-correction and repair, inside and outside bureaucracies, the very foundation of good government, are perpetually out-maneuvered. Whatever successes bureaucracy and information achieve, filled as they are with real, resistant, and plural people, come not from hierarchy, rationality, knowledge, or data—as professionals and experts lie about endlessly—but from the unspoken ways in which ordinary people, at every step of the way, if ever more desperately, attempt, face-to-face, to assert their right and power to sense and govern, and so remedy and repair. Pockets of self-government in assembly, instances of self-correction and repair, perhaps especially in science, last for a week, two weeks, six months, a year, even a few years, then are wiped clean. They cannot attain lasting power. They exist, did exist, and will exist, but the recognition of the people's sustenance of all reality and power must never be, and virtually can never be, lastingly acknowledged as the ground of things. Anyone inside a bureaucracy and face-to-face with its deeds knows this weird anti-realm, this untraceable destruction of traction, rights, conscience, reality, and the capacity to say and affirm every no. We ultimately have no choice. There is no alternative. We have to go along with unreality, and most of all with what is clearly

not true. If we refuse the choices and fictions handed us, we confront the disappearance of a space through which to achieve lasting rejection, remedy, or justice. The human being is not at all reduced to a cog, but to a thing that can only move forward, and go somewhere, by accepting and obeying a shallow frame that was never theirs and defines and reshapes everything.

In the end, coordination and cooperation become the bizarre signature of an order that nonetheless reduces the world, and the human and natural realm, to chaos. The virtual order, it turns out, is no order at all. A flux of invisible hands steers every which way, in every body, group, gathering, thing, and environment, until things become an untraceable and irremediable mess. Such infinite, global destruction is never accorded factuality as the primary, overarching signature and principle of the so-called "information" era. Instead, further destruction is embraced as a way to generate greater, ever more absolute, evanescent advantage, or sovereignty. Unprecedented alteration and devastation of the human and natural world cannot be located and answered lastingly, by simple and concrete deeds and words of the people assembled. The so-called order cannot be held to account definitively and permanently for its misdeeds and what may well even be crimes. People can try only to catch up, to sue, to block, to challenge, to resist, to protest, but the professional order and its destruction outpaces them. What is left is process and hidden-hand procedures burrowing away. Forms cannot be abolished and law returned to self-government. It isn't merely that some cartel or agency or avant-garde is over "there" destroying and conquering this or that. We have the illusion they are near, but have no way of encountering them as they simply and actually are. It becomes enough to have signs and feelings of connection and power, that is, evidence that, relieved of responsibility, hides and drains every resistance of premise, deed, word, doer, and world.

Relief from responsibility is the final, devastating payoff for such shallowness and destruction. In such an "economy" and "science," we try to find out what is happening in its density, factuality, and depth, in all its resistance, plurality, interference, and responsibility—in government, in the economy, in the world, in our lives, in nature, abroad, at home, and face-to-face. But it takes enormous and finally exhausting effort. Instead, information, molecules, processes, and trends seem to steer events and experiences through what is only probable. The realm of statistical and automatic functioning grows. The moment anything comes from people to show what is said to be so is blatantly not so, it is answered by a near-climatological hurricane of unreality. Evidence which lastingly runs counter— the evidence we need to govern and correct—is neutralized and destroyed precisely because it *interferes*. Why did that happen? What is going on? Oh, well. The people convene to fix and remedy some disaster, then another one arrives in its wake like clockwork. Someone or some gathering emerges that dares to challenge and be grounded in reality. But it can only give way. The smashing of reality and a differing, plural people becomes the engine of society and its ever-growing, out of control expropriation and automatism.

This is why the "end of the political" and the "end of history"—the triumph of what Hannah Arendt called, in *The Human Condition*, "the social"—become a mortuary of the real and actual. The people attempt to keep things working, to fix them, to repair the disaster of systems constantly, yet to no enduring result fully capable of appearing and lasting. In spite of centuries of struggle for concrete rights, power, accountability, traction, and reality for all the people, in the virtualized order, it becomes difficult to figure out how people have been outmaneuvered, against their will, to become, yet again, *subjects*. Each is poised, by process and vote, against a mass of billions, each transformed into a minority of one. Seeking enduring coalition

against this endless flux, its abjection, and its legions of expert defenders is worse than difficult. The experience necessary for governing cannot accumulate and last, in the world, face-to-face, because conditions shift and progress forever beyond us. Indeed who even knows if we ourselves are who and what and where we think we are? The mind itself is reduced to a cognitive processing of flux. The people can see a policy or entity is ruining everything, but science, the ruling order, and all its avant-gardes say this is not so, that the lie must continue, even if we can all see it is bald and ruinous fairytale. The experts tell us there's always a silver lining. We, as people, different, constituting, and unique, cannot say no, sorry, that's not the point. The ancient fact that experience is the heart of power, that it can defy everything we are told is so, is smashed.

It is with this destruction that virtual and manufactured reality achieve a decisive step beyond prior forms of visible dominion. Where the priesthood and divine orders expropriated power and representation to themselves, now the expert caste can do something similar. But it is more far-reaching, in the name of world-altering science. We are offered the only thing left: a last, false domain of freedom in fictions of autonomy, as if we could be free of everything and at last become sovereign in some new, otherworldly space. The virtual order disempowers and dematerializes our mutual, and messy, efforts to concern ourselves with preserving, to respond to what has been and is bound by a web of relation, fact, and law. We escape, assured in the end that the destruction of the world is finally not even real. What matters becomes, literally, unthinkable. It cannot be answered by thinking, and so is cast into an abyss.

The circulation of ungrounded, unreal, and collectivized signification was never a semiotic matter or the problem of the organization of signs. It is an abyss. It has always been about the loss of, and alienation from, our conditions and their grounding in stable actuality, in the

world as it is. The first principle that guided the frame and foundation of a people's law in a governing body politic has been cast into an archaic, impossible, pre-technological, and pre-modern past, where the people and self-government can be dismissed as the first problem, and first principle, of a real, secure existence. An abyss is brought into, and manufactured for the ruinous conquest of, the world and its plural, always differing, people.

The Existentialists and Others Make a Go of Responding

The consequences of manufactured reality, or unreality, are widespread and existential, regardless of the professional skill, origin, or intent of its many creators and sustainers. These consequences, in their premise and effect, leave the ground of existence, for those who must experience and inhabit it, undone, on a global basis. The difficulties this poses for thinking, imagining, judging, action, and finally politics are serious, and only partly because the "order" that results is so infernally shallow. Its superficiality disguises the abyss opening up between actuality and society. To break through this, one must begin to think, and try, however one can, to get back to the depths between us in the world, and finally what moves these depths perpetually beyond our reach. The mind and senses cannot work together in an abyss, but their connection remains, even if every "power" on earth requires their connection to be severed. How to get out of this steady descent into an all-too-human hell? What, one might say, happened to existence?

An attempt to address the European version of this began in the mid-20th century, and with great philosophical intensity, in Europe. WWI had made it obvious everywhere outside the United States, that people and the world had been outmaneuvered to their ruin by new events and possibilities. The Depression originating in the United States, and that then spread, made answering this harder still. An existential line had been crossed, but by whom, and what

to do? With the first truly total world war, then world depression, then a second, even more total world war, destruction of human solidarity and experience reached a new level, decimating and smashing the problematic legitimacy of traditions in every direction. The order of the political, expert, and bureaucratic had revealed its capacity to manufacture destruction of people, communities, things, and relations to an unimaginably general, even universal extent. A kind of absolute groundlessness, or rootlessness, had become a condition.

European thinkers were among the first to try to understand the shape of this, following, to a great degree, the lead of thinkers willing and able to begin to face this ruin, using words like "being," "nothingness," the "absurd," "authenticity," "meaninglessness," "the abyss" "death," "time," and so on. What *was* real? What was *being*? What was *nothing*? What is *mortal*? What is *action*? What is the *imagination*? Who *are* we? What is *despair*? What is *meaninglessness*? These words were an attempt to grapple with new conditions. One beginning for this was unquestionably the brilliant work of German philosopher Martin Heidegger and those influenced by him, French thinkers like Jean-Paul Sartre, others like Albert Camus, and more. While never a unified group, and rejecting the group label, the existentialists used philosophy, literature, and even poetry to try to repair understanding and put it on solid, thinking ground. Prior knowledge, philosophy, culture, and tradition had failed; new foundations and ways of using language were needed even if Americans, a people quintessentially concerned with foundations, remained unaware of their part in the problem. Heidegger, before WWII, began pursuing this from a metaphysical, abstract, and poetic direction, using words to point to the depths of what the philosopher called "being" and "nothingness," the latter the absence encircling being. He located the threat to being in "the they," the realm of those over there who chatter away thoughtlessly,

who lack "Being," and later, after the second world war, in the ungrounding threat from "technics."

The problem of authenticity, or what was truly real, was central but, while existentially posed, was framed by Heidegger in a way that proved empty. The so-called "authenticity" he posed as an anchor was shallow and very tenuous. During Nazi rule, Heidegger revealed how. Philosophically and administratively embracing the Nazi movement, the philosopher showed a jarring incapacity and, after the Nazi defeat, rank unwillingness to name or address blatant consequence, not the least of it the philosopher's own conduct. What Heidegger formulated as bracing response, the metaphysical "encounter with death" as the precipitant to "thinking," proved farcical. When corpse factories and moral collapse had become undeniable, Heidegger used the term "processing" to get at this, implicitly comparing corpse factories to industrialized farming. However outrageous, this pointed to a genuine problem of the industrialization of new processes, as well as, in a roundabout way, the totalizing violence of manufacturing reality itself. More consequentially, it showed how to disappear the fact of vast numbers of real and different people, not at all "the they," eager and willing to coordinate, as he had, with shocking criminality. The abstraction of metaphysics allowed the philosopher to disappear his role in legitimating non-thinking. Nothingness and non-existence could be discussed conceptually, but their worldliness and unworldliness, and their construction by deliberate, political humans escaped Heidegger, raising the question of whether such thinking was even real. The depths the philosopher found, while captivating and brilliant, were entirely free of the extra-conceptual aspects of both the world and all-too-human political conduct and consequence. Heidegger would argue, remarkably tendentiously, in several texts, that the abyss was actually the ground. This was self-contradiction, a trick, and impossible. One cannot find

ground in an abyss by definition. One can, however, sink into a bottomless hole.

Like Heidegger, Sartre used metaphysical terms, but also fiction and plays, to get at such new conditions. Following Heidegger, Sartre argued "nothingness" could serve as the beginning for "consciousness." This made sense, in a roundabout way, pointing in a new way to a truth. How else could one grasp the world if one did not wrestle with the abyss that arises to dissolve and disgust us? Might not thinking arise if confronted, face-to-face, with such nothingness and disgust? The reliance on the philosophical and metaphysical had consequences here too. Sartre, following Heidegger, located nothingness not in how our relations to others and reality are shaped and steered by the political and historical order, not as the result of factual, political governing in history, but again as a kind of metaphysics, now only slightly more existential because it spilled into our relations with each other. Sartre's notion of *bad faith*, or the presence of the inauthentic and false in how we are, relate, and deceive ourselves and each other, rested on a philosophical sense rather than an historical, political sense. Nothingness was not a means of conquest but rather, simply, a "hole in being." As Sartre put it crisply near the end of his first great work *Being and Nothingness*, advancing beyond Heidegger, it "appears the world has a sort of drain hole in the middle of its being and it is perpetually flowing off through this hole." That actual people had vanished into this hole, and on multiple continents, remained beyond thinking. Freedom and consciousness, Sartre argued, arose out of our encounter with nothingness, not in the political and historical realm of equals governing, but in negation of all that is so, indeed, in its very draining away. The imagination was born there. This described something unprecedented for experience; unfortunately, it was only philosophical experience. The "drain hole," abyss, and encounter with nothingness were all too

real. They were placed, however, beyond political experi-
ence and repair by living, breathing, plural people, and so
beyond the potential for a truly existential politics.

While some of the vocabulary and concerns moved
for the first time towards a reckoning with conditions,
what underlay this, and those who worked from its formu-
lations, was the contemplative bias against the political and
non-conceptual depths of reality, that ineluctable realm
where nothingness and being play out for us every day.
For Sartre, as for Heidegger, others were alien, reinforcing,
rather than remedying, in Sartre's case affirming, decep-
tion, self-deception, and alienation. The problem of the
people, though addressed more in Sartre's late writings,
could not take on concrete, historical, democratic, or plu-
ral ballast. Heidegger had spoken of the people, called the
volk, as part of a gruesome Nazi ideology. Sartre, far more
engaged in public life, did little better, reading the people
as masses, with alienation a part of massed subjectivity,
working from Marxist and finally Maoist rubrics. The de-
struction of a plural and free public realm, so obvious in
the widespread collaboration and coordination under to-
talitarianism, confronted everyone with total subjugation,
that is, total subject-hood. It could be answered only by
the subject. That subjects could mass together as a kind
of universal, materialist *abstract* subject still left subjectiv-
ity, whether concrete or abstract, and eventually multiple
subjectivities, forged into a kind of resistant bloc or blocs.
Public life could not be seen as, or become, plural, the fully
plural people as the beginning for an *objective* realm able to
address and answer every manufactured abyss.

The 20th century existentialists, though they tried,
for the first time, to address human experience amidst the
rise of nothingness and unreality to power, could not an-
swer them. For what had come under attack was precisely
the plural, hardly subjective, people. Sartre, who fore-
fronted nothingness as a condition, avoided it as the con-

cretely political problem of our time. Anti-colonial think-ers attempted to resolve this, but the limitation inherent in the existentialist framing of subjectivity, even with count-less, different massed subjectivities, could not overcome the reliance on the self and mass as the bases for freedom and "being." Thinking, built on philosophical, and social, rather than political foundations, was bereft. While it is as if being drains away into nothing through some kind of hole, *why*, and *how*? *Where*? Who *created* such an abyss, and why? One of the foremost facts of our lives was posed but hidden: that what matters is beings, persons and things in their full, differing existence, in plurality, political history, and actuality, that is, in political realities which precede, shape, and steer every concept and thought.

Those who built from the existentialists, and sought to formulate notions of "the other" and our relatedness as "others," focusing on the "inter-subjective," or later, in the post-structuralist period, through ideas of "heterogeneous" subjectivities and "assemblages" of them, could not escape this turning away from ordinary, non-conceptual, shared, and diverse, non-conforming political experience of stable history and fact, something that is hardly only subjective. Philosophical concepts could not grasp the uniqueness and inviolability of non-machinic and non-collectivized, non-subjugated persons, thereby hiding the potential of expe-rience as defiant, more than conceptual, and in particular more than subjective, that is, as the beginning of a ground in the political and confirmably real. Ideas and thoughts, as Nietzsche put it so well already in 1885—examining what is revealed when we try to think into the past—are con-structed on "rainbow-bridges of concepts." The bridges, the philosopher noted, are not actually there.

The problem of being and nothingness, while fore-fronted, failed to get a human and real answer. This re-mained true in the anti-colonial thinking building on this work, forced, by unremitting colonial violence, to wrestle

with the misleading problem of subjectivity as "conscious-ness." What was still left was the single person philoso-phizing alone in an irremediable encounter with the po-litical world and its violations, the only apparent salvation the repetition of violence. What the existentialists and their successors' philosophical prejudice attempted to raise but obscured was, nonetheless, a fact: politics determines whether there is or can be being, freedom, or authentic-ity, and whether the people, in their plurality and rights, have secure reality and the power to assemble and resolve things, rather than none. This *cul de sac* was summarized in the devastating line from Sartre's play *No Exit*. Nameless forces, now human, determine things. The result, stated by one of the play's characters, was "Hell is other people," or in a more accurate translation, "Hell, it's the others." This sarcastic, dark, and despairing sense, present but hidden in Heidegger's notion of "the they," permeated Sartre's works. The result was to crystallize in thought the tyranny, internal and external, that emerged fully in the 20th centu-ry. The new ruling orders of society and politics had disap-peared responsibility, human redress, solidarity, thinking, and lasting political structures to protect these. They had done so by claiming our shared realm, where remedy and repair can and do arise, as an endless hell. It is, as it were, as if hell had been raised to govern and could be manu-factured now in the world for that. If existence preceded essence, as Sartre famously held, it was never existence among political equals who are helpful or harmful to this, and either way, needed for thinking to grasp what is so—in *politics*. Instead, the result is a singularized, alienated, a-historical, a-political flux of abstraction and, finally, what one can only call the retreat into the philosophical and the-oretical—however born of real and worldly desperation.

People and world are not concepts or theories, nor can they be reduced to philosophy. A void had been insert-ed into the world that was hardly merely conceptual, phil-

osophical, or psychological, just as our relations with each other are hardly only conceptual, philosophical, or psychological. Ordaining man as free, saying that what matters is choice and that man is "condemned to be free," as Sartre soberingly argued, left untouched an unaccountable, anti-human, political machinery that placed political freedom and traction in the world, and worldliness, out of reach. Sartre's displacement of hell onto "the others," then conceiving the people as inert or activated masses, was mirrored in his adherence to Cold War polarities, supporting for a while the Soviet Communist Party as the answer to "capitalism" and U.S. hegemony, and after that, full-scale anti-colonial murder and violence—the latter arising, devastatingly, through a refusal to hear the doubts and concerns in Frantz Fanon's work, a refusal repeated tragically among some American radicals of the 1960s, and German and Italian ones after this.

This latter turn, in Europe and America, proved fatal to rediscovery of any ground powerful enough to renew the people's self-government, everywhere. It was a trap that the *pied-noir* Camus, less openly ideological and more human in his descriptions, fiction, and philosophical texts, fell into from the opposite direction, remaining firmly within the pro-French colonialist camp during the Algerian war. He, like both Heidegger and Sartre, described the abyss without historical or political ground, now reframing it as an impasse understandable through metaphor, in which violence simply arose. Our condition, Camus argued, is indeed unremitting. We are left, like the ancient Sisyphus, to roll a boulder uphill forever, precisely so it will roll back down. This described well the reality we do not, and seemingly cannot govern, that has taken our governing off the table. The Black American writer W.E.B. Dubois described something like this scathingly as the "Sisyphus syndrome." Camus named something real, but made no account for the possibility that its reality might be

manufactured. This limit reached gruesome expression in Camus' abject relations to the "other" of North African Arabs, who, as "others," could only be seen and felt from a stance of self-alienation and worse—something indigenous North Africans were horrified by, given how much they had been reduced to nothingness by savage, unremitting, European colonial domination.

Both Sartre and Camus, and even anti-colonial existentialist thinking, struggled with public problems, but the philosophical prejudice, however close it came to taking the side of experience and the people, lacked a plural and political model of the human and communities. Alienation, angst, and a subject tricked by internalizations could be described, but not the fact power and reality had been seized from the people, making angst, despair, fracture, nothingness, and even machinic objectification into political and historical effects. The one thing existentialists had pointed to, for the first time—that we live under conditions of despair, angst, void, and the irremediable—failed to gain a fully political response. Nothingness can be grasped existentially, but it must be answered politically. The problem is not metaphysical. It only confronts us with the frightening, all-too-20th-century "choice" between obedience and being manufactured out of existence.

One European tale-teller, though he did not address imperialism abroad, managed to get at the problem at home. Though he died shortly after WWI, in 1924, Franz Kafka—likely from working as a bureaucrat in the Prague Workers Accident Insurance Company—was keenly tuned to the terror rolling down everywhere. In books like *Amerika*, *The Trial*, and *The Castle*, and in numerous short stories, Kafka described, in literary terms, the rise to rule of, and conquest by, nothingness. Though it might manifest metaphysically, it was hardly metaphysical. Nothingness, as Kafka described it, had become the condition of people rendered, somehow, no longer full persons, and so no lon-

ger able to come together, in answer and remedy, or, for that matter, able even to conceive that they could. Kafka's central character K., in all his varied forms, was perpetually wrestling, to no avail, with a genuine and all-too-real 3/5ths status. This was human—however strange, alienated, and mutated the results. A nameless, shapeless, and impersonal rule had spread until no one would or could take responsibility, and, reduced to effective non-person status, all became complicit. Each person became a rubber stamp, an effective minority of one, for an order no one could, or would, answer. Violence had disappeared into abstraction and universality. We could *try* to find who did what, but it was hopeless, for there was no full person left to address.

Kafka's insight, expressed poetically, was to show this new force was procedural and removed all human, plural traction. His language conveyed this in aching detail. One is swamped by rules and protocols that have lost all human and political roots. No roots are left, and so no remedy or answering is possible. Everything is neutral and marches on to a depthless and shallow end. Ground is found, then vanishes, and so one is forced to keep moving, accommodating an infernal order. K. in *The Castle*, as in *The Trial*, chooses and decides over and over, taking him further into a labyrinth of nobodies and nothing, aided at each step by piece after piece of new information. As K. says of the Castle, "each person had come there for some purpose." K. moves and maneuvers with purpose, but when he finds people, he finds only further nothings and nobodies, face-to-face with the novel's most purposeful nobody of all—*K. himself*. This was truly a comedy. So in more human and familiar form, with the protagonist of Kafka's groundbreaking first novel, *Amerika*.

A worldless world, for Kafka, was the shape of total domination. It was exacted by people without political power, unable to think or build a shared sense to answer worldly conditions. That there once was a transformation of persons into nothing, into nobodies, into 3/5ths people,

was obvious, but a history permitting political thinking and response was neither available nor possible. Reality, as "K." continually experiences, is all that is *against* him. Who knows when or how or why something happened. Who knows who did what, or why they did it. But one thing was clear. Here, Kafka's insight took on its most scathing form. For there was a vast supply of possibilities, choices, becomings, and decisions to be made in ending up nowhere. There was, at the same time, no responsibility or traction whatsoever in *governing conditions*. Conditions had moved on to become a new type of rule—the rule of *nobody*. All that was left was machinery and procedure, protocol, administration, and information, creating a nameless, faceless, perpetual, and untraceable violence against us all—the crucial driver, the dream and nightmare of new possibilities. Anything might be so, but what was certain was one would end up nowhere and as nothing. Existence was transformed into a state of total possibility, which is to say, it had become *virtual*. Becoming was not a way out, as some have cruelly argued Kafka proposed, but the infernal manufacture of dead ends.

With Kafka, in the early years of the 20th century, we enter what French thinker Jean Baudrillard called, describing the later, technological form of this strange, unstable, and wobbling condition, *the perfect crime*. Baudrillard ascribed this to a condition of total simulation, information, imagery, and dissuasion. There is only a small degree of difference, however, between the realm Baudrillard described and the new type of rule Kafka sensed, in its full comedy and tragedy, decades before, when it was still visibly bureaucratic. We are insensate before a violation that no longer appears as, or can even recognize itself as, violation. With Baudrillard, the human and accountable governing of things now no longer even appears as nothing and nobody, but as the simulation of something and somebody. It offers no traction at all in reality, and so the result is that

no one *cares*. If a society is lawless, so what? Law is rigged, everything is rigged, everything can be made up whole cloth. To care politically only makes things *unbearable*. The abyss has entered the world to govern. Some can exploit its lawlessness and disappearance for advantage. One can, building on Baudrillard, reverse simulation to disclose, by simulation, all too real human actors and lies. But the form that undergirds lawlessness and the virtual can only be poked and prodded in a never-ending game of catch. The underlying governing condition of an abyss cannot be answered, retrieved for redress, or governed by those falling into it, even though this can, as Baudrillard sometimes did, be thought of as a game. The problem, as Kafka demonstrated, is that, under such an order, existence is hardly a game. It remains a matter of life and death, even if it is fascinating. Baudrillard suggested, in more recognizable terms, how a functionalized and bureaucratic existence—with self-enclosure, image, and information broadcast to every horizon, saturating us all—makes politics inaccessible and unworkable. Propaganda lies, already hard to detect, turn into metaphysical, material, and psychological realities. Wars do not "take place." Reality itself does not "take place." Finally, because political question has become inaccessible, it is *rejected*. Office, job, self, career, psychology, opportunism, and furtive, temporary associations, producing fleeting, temporary autonomy—all things Kafka detailed thoroughly—cannot answer conditions. We can only go along, for in resisting our conditions, we only strengthen the irremediable. Our power has vanished, but we are compensated for this. A little dignity can be recovered in navigating the simulation. This, to a great extent, recapitulated Heidegger's tendentious description of the abyss as the ground. It described an experience, not a reality. It was Kafka, however, who accurately named its all-too-human reality, and detailed its truly deadly consequences.

The realm of others, of all that is human, political,

differing, powerful, real, and free is not hell, a game for advantage, or an abyss, nor can it be thrust into oblivion, even by the virtual, by endless bureaucracy, or by an ever-more captivating, soothing, and convincing lie. An endless red-tape existence is what faces a people and world robbed of first principle. We cannot find and do not actualize first principle because we no longer believe it exists, ever existed, or could. The worldly—the intractably factual and plural, the realm of everything resistant and unadjustable—may become depressing. It may exceed every effort to opportunistically answer it. But if it seems we are broken, even shattered, if it seems reality has been pushed beyond our reach, throwing all governing into an abyss, this is only seemingly so. Politics is not a dead end. We face it, as we face differing others, in the smallest of ways, in our neighborhoods, in our workplaces, in everyday interactions. This is our ground. Our veil of illusion may end up a vale of tears, we may seem to traverse the world in delirious, moving capsules lit by screens, finding others we need through this. We can even dissolve into a collectivizing flux that arranges and disarranges our lives. The world's disappearance may feel entirely aesthetic, the abyss of signs and machineries loudly telling us it is home. But we do not have to give up the fact each of us, and all of us together, retain the right to disagree, to say no, and to convene and do things differently.

In every permutation, K. was isolated, part of a universal condition, a minority of one facing untraceable domination. But that is not our only choice. The world is never, and we cannot afford it to be, beyond capacities for redress and repair. We retain the right to self-government, to address our world and each other and what is so. This is a beginning of real objectivity and ground. It can answer the abyss of manufactured realities and their nothingness. The conflict faced every day between obedience and non-existence merely hides the real conflict between self-gov-

ernment and manufactured, or false, reality. This brings us back to the contest over first principle where we rediscover an old lesson.

The Ancient Contest

The link of first principle to a governing order may be dissolved in an abyss, and its link to the people obscured, but it is the people who retain this link in fact, in history, in remembrance, and by right, everywhere. If a form, or forms, are there to outmaneuver the people, to keep people wherever they are off balance, this simply needs to be called finally what it is: a new kind of *slavery*. As Abraham Lincoln, one of the greatest fighters contending with the modern gulf between what we sense and are told, and actuality, often stated, the master is fully as ruined as the slave under this modern form: self-government and freedom do not exist, though they may appear to exist and are even called slavery's root. Lincoln, quite simply, with many others, called such arguments and such a society falsehood. Modern slavery rests on a kind of simulation, and Lincoln understood very well its gravity and hold on political space. It rests on the claim and usage, in words and rhetoric, in propaganda lies, of founding and widely applicable freedom principles, thereby not merely voiding them, but confusing everything. The slave, as the master, is handed and agrees to signs whose function is to destroy their reality and ground. They are handed what they may embrace and experience as a spectacle, as it were, but it is political slavery. This rests on a basic fact Lincoln argued again and again: none can be free if *all* are not free. This is the realm of real signs.

It turns out one cannot, as so many have shown again and again, escape the contest between freedom and slavery. In the United States of the 19th century, the slave power as a whole, and its infernal society, expropriated and destroyed the people's power and freedom, using signs to

hide their destruction in fact. This is what has happened under its successor, though in a far more sophisticated and total way. Only first principle can penetrate through this morasse to signify and make clear what is real. It can be fought for, and it can guide us back to fact and to actual freedom and power. It marks and discloses the contest. For the construction of mass society and mass propaganda, which evolved in America before Europe, had a precursor. As we know far less well, it faced those who fought it to the ground as a bald lie, acting, thinking, and assembling to defend first principle.

The 19th century American chattel form, which we understand was monstrous, is framed as primitive and obvious when it was neither. We think we can address our conditions now in terms of contemporary forms, as technology, processing, and signs, even in pockets of protest and "activism," but the question of our existence and whether or not we are free has not changed so much or lost its elemental gravity. It is not by chance total domination consolidated and took on modern form, though brief, in the first eighty years of United States' Constitutional history, and that an answer to it arose most tenaciously out of New England. This domination was profoundly new, and disappeared itself, precisely because founding compacts had established a new kind of power for the people to prevent all tyranny. Tight plantation control over proto-mass forms, exercising an early form of mass reach and penetration, was an American invention—to confuse and crush the real and practiced, factual and revolutionary conceivability and practice of self-government.

To fail to understand that the Confederacy, in its last days, was in fact the first totalitarian form, based on the 3/5ths principle taking direct aim at, while invoking, self-government, and so was more dangerous even than its European and Asian successors, leaves us unprepared to understand, and answer, the forms we are now under. If

we look to Kafka to grasp our new world, one need only try to imagine a form ten times more devious. The political form of chattel rule in the United States eliminated from consideration the capacity and responsibility of all those inhabiting and benefitting from it to grasp, answer, and govern. Its method was a deliberate, theorized counter to self-government as political equality, in principle, structure, and law, turning self-government, impossibly, into the origin of political *inequality*. The world itself, and especially people, were property to be dominated and used. Bondage was not merely physical but profoundly political. It was, as politics' foremost modern effect, mental. Frustrated organizers trying to emancipate Southern slaves, by the mid-19th century in America, lamented, in the great words of Harriet Tubman, that so many more could have been freed "if only they'd known they were slaves." This usually dismissed, strange statement, describing a problem different from pre- and non-American forms of slavery, is buried by all who say slavery, and the political form expanding and protecting it, was obvious because of its terrible brutality, that of course everyone, especially the slaves, *knew*. But it was precisely those reduced to a 3/5ths existence, rendered nullities and nothing, who had the hardest time imagining, and risking answer and abolition. Countless agitators and fighters for freedom in the mid-19th century were aware the destruction of capacities, power, and personhood was extreme, and so a political and moral problem for an *entire* society, indeed the whole world. Frederick Douglass devoted great energies to this warning, as did, in particular, and as a political example, Lincoln, for all his flaws, even before he rose to the presidency. There were many others as well. Psychological and physical destruction of the full, unique person was a tool of mental and political conquest. It undergirded productivity. Why, if a door was opened, would someone not walk through it? How could someone forcibly reduced to an animal unit in a trans-continental productive

economy *not* see they were something more than what they were taught, and were allowed to learn, was so?

The question was clear for those agitators for political freedom: how to revive political capacities among those convinced, through near-military, and finally fully military force and discipline, to remain imprisoned in a desperate, horrific 3/5ths existence, supporting a productive society based on that 3/5ths principle inherently. The Southern Confederacy, forever under-estimated, had figured out how to reduce people to a partial, debilitated existence, to slaves, to bits, and keep them productive, so the economy could grow and perpetually expand and spread the slave power. Political rule, totalitarian in nature by the end, made this organization complete, shattering every capacity. The source of a mentality of superiority over the behaving majority who learn to accept non-person status may have been secured by unimaginable violence and humiliation before the American Civil War. Yet when open violence and humiliation of the majority were removed, replaced with hidden violence and humiliation, the political order of total supremacy lived on to expand. This points to a terrible truth. Freedom fighters against slavery had a ferociously difficult time because the attack was on self-government and reality itself. The chattel slave could not imagine their existence as a full, political person with other full, political persons because of a political—and mental—order history books disappear or refuse to see in its contemporary implications. Unrelenting physical brutality was merely half, and the far easier half, of a political problem—the conquest of people's capacity to think, imagine, act, come together, and to convene and bind for power and self-government.

Making a majority unable to conceive and realize their full, resistant political capacities, not merely physical bondage and terror, was the solution, by the Confederacy, to the possibility and founding premise of a continuing revolution, and all its verifying evidence, in self-government.

Every means was used to hide this New England-born answer. Its defeat in New England had been attempted and failed; thus it spread in the South, where New England forms had never fully taken root. Slave rebellions, resistance, revolt, and flight continued, in countless forms. But political freedom as the answer to slavery ran aground, practically, on the destruction of people's capacities, white and black. Overnight, freed of this *political* form by Radical Republicans, following Lincoln's program, formerly enslaved blacks instantly began self-governing, taking up office, and overturning the slave mentality in fact and reality. This happened, to the people of the time, with stunning swiftness. But the forces determined to crush self-government never let go. Culture, family life, endless laboring for an absolutist order, and all the religious and psychological tricks keeping this in place had achieved something unprecedented: they had made first principle inconceivable. This dead end, and *nothingness*, would be re-established again, within only a few years, once the old political form was restored and black power was crushed, resuming supremacy's expansion.

Some blacks would remain free, tilling their own land and building an independent life, filling the ranks of the Populist movement in the South in the years after the Civil War, as would their descendants, retaining deep memory of their freedom, in the Civil Rights movement decades later. But the order that retained control was ferocious and would not relent. Conquest and invisible empire were bound together to become inextricable. So it has become now with its new, less overt, depersonalized form of rulers and ruled, managers and managed, machines and machined, conquerors and conquered, in a bureaucratic, two-, rather than one-party society. It is now hard to imagine the people could or would *ever* govern themselves. It is nearly impossible to imagine we are all full, different, non-enslaved, politically equal human beings *by right*. As a

result, it is hard to see and counter each theft of power and being, each theft of our existence, from before birth and at every point in our lives.

Successor colonial and totalitarian orders were merely updated versions of Slavocracy's intensive destruction of political capacities, for Slavocracy was always an imperial form. The modern, bureaucratic, information-controlled society has only perfected this destruction and raised it to a higher, more sophisticated technological level. The slave was alive to produce, for an economy whose garish profits enabled expansion and control across the world. So it is now, with plantations and a society expanding inexorably, picked up by ever new societies trapped in ancient categories and misunderstandings of freedom and power. To the chattel slave, reality was crushing, horrific, and irremediable, the slightest attempt at freedom met by unimaginably brutal force. This seems alien to more liberal, multi-racial societies with so-called modern economies. But is it? Are not the questions of those desperate and brutalized everywhere our questions? Who knows how to be truly literate, who is even permitted to be literate, not in the sense of knowing the alphabet and calculation, but with every tool and knowledge, in history, philosophy, ethics, politics, and critique, from every country and time, necessary to govern? We think no one needs to be literate in such a way. The modern reign of the virtual is easier, more elemental, more productive, and far more stimulating. Who can fight such a system, especially when it has spread so far and so fast? No one can, in any lasting way, that's clear, so why try? How would we even begin? What happened to that person who stood up, or that assembly downtown, or that massive gathering in a far-away square, eight months or even ten years ago? Where did they go? What happened? Oh well. The life we have may be awful, but if we break free, we will be consigned to only crueler and more savage conditions. If we venture to call our conditions degrading, this only makes life

harder. It leads to problems. It is safer to not resist or attempt to govern. As for the slaves in the American South, it finally isn't *safe* to come together to reassert freedom and power.

The Southern Confederacy's barbaric, modern answer, its solution, perfected North and South in the Progressive era by rational and bureaucratic administration, was to figure out how to destroy the conceivability of the people's self-government. It is the modernization of this, in a more depersonalized, psychological, and materially productive form, that destruction of the people's realm and rights has advanced, even with rebellions and massive unhappiness, across the planet. The American context makes this progression clearest, as well as a history of response ready to be carried forward into new conditions. Today, it is true the lash and whip are not at all physically and visibly intense. There are all kinds of routes to imagine we have escaped our conditions mentally and physically. Compared to the chattel slave, our lives, no matter how precarious, are vastly better and freer, and to compare our situation to a chattel existence is to genuinely insult those that endured the horrors of it. The new political order remains uncontested, however, and one crucial thing remains the same: we cannot govern our conditions, nor conceive we might and can and must. We cannot imagine ourselves except as we have been imagined to be by those who rule, precisely because we are eager for the benefits obedience assures, protecting us, we presume, from non-existence.

Compacts of self-government were, the New Englanders learned in abolishing the early American plantations, slavery, and indentured labor in their region, the only way to overcome a domination able to destroy persons and community from the inside and out. For the New Englanders, the plantations were not merely an economic monstrosity; they were a political, moral, and psychological *obscenity*. Many New Englanders had indeed arrived as imported and indentured labor. Their answer was to assert

the incontestable fact that each person has the right to assemble with others to govern—and govern all corporate and party forms—with every means visible and accessible to do this. The principle was to see power where it is, among the people, and to bring into appearance whoever pursued its theft. The revolutionary solution, as Emerson summed it up in Concord, Massachusetts, in 1835, was to "give every individual his fair weight in the government." The New Englanders devised a form and a law for this: governing conditions, face-to-face, in the town meeting, where all that is political was made to appear. As they sensed, the plantation—just as the eternal, so-called "corporation" that followed it would be—was, and remained, in permanent conflict with rights, political equality, and appearance, from the start. It is a lie of historians, the social and political sciences, philosophy, and virtually every academic and cultural field to hide the frightening meaning for the present of a form *able* to neutralize self-government and eliminate its conceivability, thereby reducing the people to a 3/5ths existence that no one dares answer.

The Southern Confederate form established a hostile and outrageous counter to self-government—specifically to erase the continuation of revolution and first principle. It was as advanced as any form invented since. It did so in a concrete and practical way. It was self-government and its law that had to be, and was, systematically destroyed. What we face today in America, and so the world, is its successor. While no one can be dragged around in public in chains, they and their partners sold, in public, to a visible and obvious succession of political, economic, and even sexual owners and predators, we have extreme difficulty imagining there is more to reality than what we have, or that the predatory realm may have expanded far beyond any participant's capacity to imagine it. Today, as then, we have great difficulty imagining ourselves able to face and answer the sanctions that arise when we seek to

become free. The narrowing of reality and appearance, for us, eludes understanding or remedy. Each of us becomes, inexorably, a minority of one. While we are more comfortable, our humiliations milder and even manageable, we cannot imagine ourselves every morning as an assembly of differing people with the right to convene, secure all rights, govern, and dissolve anything that threatens our full dignity and full existence.

The lessons of the first great, concentrated contest over first principle that occurred in the United States in the 19th century have been undone, as if the contest over first principle never existed, and did not still matter, as such, for everyone. We choose this economic route or that; we choose this job and social status or that, and fight furiously against others to rise in one or another pecking order; we choose this cybernetic invention or that, we follow this or that piece of information, we gather in this or that assembly and feel freedom for a moment, yet it all seemingly evaporates. We try to say no, but we have a life and others to support. The economic and social order is not so bad after all, if only we agree to look at things in economic and social terms, doing what we need to survive and prosper. We too live, as the slaves did, under a scientifically justified economistic and animal model of human beings, now totalized by an order of control, simulation, surveillance, and raw, if mostly hidden and unimaginable, force. Our very forms of knowledge and practice re-assert this. The transformation of plantation reality into manufactured reality continues, reducing and voiding the political possibility of a free and full, rights-bearing, non-conforming, resistant, self-governing existence together. There is little protected space and time in which to experience and learn how to govern our conditions, lastingly. What would a free man and woman even be? Who would know, or *care*? Somehow, mysteriously, we cannot take back that 2/5ths of our person that is *political* freedom and reality—the full right to a full existence,

with others, in all our depth, difference, breadth, memory, and human possibility, governing all that concerns us.

The greatest invention of the American chattel form, as modern as the latest totalitarian adaptations, was to convince the slave he or she must remain a slave, was never anything but a slave, and would always be a slave. This was so ingenious that a person handed an open door really would, unbelievably, turn it down. Whether this is achieved through fear, terror, or the lure of endless provisions and glittering possibilities, this mental and political form of domination remains so advanced our stories about the rise and nature of our political systems, in America and elsewhere, need to begin over from scratch. Large portions of the people in America, and elsewhere, have been brought to rights only the few had not very long ago, yet at the same time, something with roots stretching far back has advanced effectively to counter this and render a full political existence unimaginable.

Philosophy and theory are no match for this lying rule of manufactured reality, or unreality. This is why Baudrillard bothered to argue, controversially, persistently, and often, that we are *no longer real*. Those with new rights will rightly protest. Why then did Baudrillard, who understood the virtual almost better than anyone, glory in his refusal to propose a political response? For him, there needed to seem no response, for to imagine an answer was to miss the gravity of the hour. In a sense, he was right. The problem is grave, for we have permitted conditions to outstrip us to an extreme and nearly fatal degree, precisely with all our so-called rights. The abyss between society and actuality is grave. In another, deeper sense, however, the philosopher was, one might say, a bit too *comfortable*. There must be response. What has been disappeared exists. The human and political realm has not been and can never be superseded. The abyss that has opened up, with nothingness pouring through, must be answered and closed. The past, history,

and reality have not been, and cannot be erased by virtuality, even if virtuality is everywhere. They linger, stirring beneath a glittering, fictional surface working every morning to burn out our resisting depths.

The world and differing others remain. They are not hell, or games, or machines, or genetic assemblages of molecules, or identities triumphing, or flickers on a screen, or projections floating in space. There is no perfect crime in reality. Something that is much more than nothing is left, and the turnkey virtual realm is precisely that: there remains a key to turn. Crimes may extend to the horizon, though never permitted to appear fully, and they may seem irremediable. They may swamp our very existence, awareness, and memory, they may seek to erase from appearance our every depth and factuality. But they can be answered if we take back the power to say no, to join together, to respond, to appear, to exist, and to govern. Even if reality is hard to determine, things become clearer when we learn to start over from first principle.

The rise of the virtual to "power," or the lie, follows the rise of a single argument and all the many who survive well, and prosper, within it: that self-government of all the people is neither possible nor necessary, and to call for it is naive. It is neither impossible *nor* naive, and to call for it is precisely what would ground us, and close the abyss, as it has for so many over time. First principle is the guide. It is true we are happy in ever-expanding theoretical and dream-like possibilities. It is true it is inconceivable we might answer our chains, govern, and reclaim power, especially when the chains seem only of signs and do not weigh so much. But the chains would appear as quite heavy the moment we grasped our right to the security of governing all our conditions, rather than merely the few manageable ones. The chains would feel harsh because they are harsh. The disasters around us are their true signs. This is why so many prefer not to walk through the door when the chains

are off. To imagine freedom makes the chains one adjusts to heavier. Rewards we can identify come instead with acceptance. We know these, and cherish them. But the rewards of political freedom and self-government are greater still.

Facts may slowly, inexorably have been reduced to non-significance, but it is the people, all of us, who experience things as they are, who keep things going, and who could end this. We, all of us, meeting together now and then, in assertion of our right to power, can put together a picture of what is so, support each other, recognize actuality, and proceed. The managerial and intellectual strata will continue to develop pictures, proposals, theories, concepts, and technologies for who we are and what is right, and why one more new solution or theory is always better. But the return to first principle is there, to dig us out from such relentless, eviscerating speculation. To the mind swept this way and that by the tugging and pushing of the virtual, a return to first principle constitutes a pathway through and out. Our retreat, and the march of institutions forcing this retreat upon us, is answerable: by the first, and forever revolutionary principle that *self-government is our only security.*

There is no question thinking from first principle is hard at first. But it is easier by far than navigating a welter of complexity and precariousness perpetuating a genuine and real unhappiness. It means simply to re-orient our minds to a starting point, and to recognize that complexity is constructed for reasons of rule, for political reasons, by real people, and it has a real, if unknown political history. The test is existential, but the response is political and historical. Self-government discloses a power and reality that cannot be manufactured away. Nothing can diminish or destroy the right to be secure in experience and fact. We have the right not merely to representation, but to *govern* representation. We are not *units*. We are not data or image or numbers, we are not machines or processes, we are not merely psychologies or masses or anything else, even if

3/5ths of our body and perceptions may be artificial, fabricated, and steered. Interference and noise are real. Actuality is real. Limits and facts remain, implacable and real.

The virtual and its defenders try to propose a frictionless realm where we do not need to govern, where we can avoid the mess around us and retreat into glittering possibility. But experience each day tells us this is not so and can never be so. Ordinary, commonplace fact is there. It comes in disturbance and friction. As Lincoln said, facing a prior and more primitive form of totalizing falsehood, we need only "disenthrall ourselves." With first principle, old questions become new, and can be thought out. What is government? What is a republic? What is a democracy? What is a democratic republic, for us? Who are we? What do we want? What is right? What is just? How might we govern? What is identity, really? Answers will come. They will be decent. They will certainly be *better*. This, not any new concept, not any new theory, not any new technology, will generate the words and images, the sounds and textures, the ideas, thoughts, actions, and relations that would enable us to turn away those who tell us we are powerless when we are not, that elections inherently dig our troubles deeper, and that in the end, we deserve a miserable 3/5ths existence, and need to get down to business and make the best of a bad situation.

We cannot know what is happening, we cannot regain reality and traction, until we enact and honor what we experience. We can organize everything differently. Who knows what repair might look like? We can find out. We have the right to find out. We can *take* time. We are not bound to the lash. There is evidence. There is thinking. There are courageous examples and predecessors. There are caring ones, peaceful ones, to help, in numbers so large we might well be quite surprised. One thing is certain: it is possible to catch up to conditions, to answer, and to govern them, and this is always simpler. We need only give up the

explanations, descriptions, and concepts handed to us. The people have not and cannot be conquered in reality. What was taken from us can be taken back, if we just begin to learn what has been taken from us: *our reality*.

The existential problem of manufactured reality is global now, and has been spread systematically, just as the Confederacy sought to do so primitively and tenaciously, through its nominally pre-industrial but super-modern political form. Issues, policies, and complaints mount to the sky, as does the rubble. But fundamental political questions can still be asked. Americans have, for themselves at the least, a tradition of struggle for freedom, against slavery, with a core principle to steer. Just as the attack on the conceivability of self-government began here, so did the power of self-government as the answer. Thinking can catch up. We are not the social, animal 3/5ths of a person Slavocracy needed and that was refuted. It can be answered, again, but thinking, too, must contend with a serious, decades-long organizational crisis. The contention that the professional and advanced classes can solve the problems of our world and the people has run its course. Its decimation of the world stands all around us. Deeper traditions and realities beckon. The legacy of the modern and postmodern era can be untangled, stand clear, and be answered.

The theft of the people's existence, and the highly modern barbarism that drives and secures this, rooted in alien concepts and principles, requires only that we begin convening, perhaps not even as often as we might think we need to, to sense the world we are in, to mark and respond to what each of us knows to be so, talking to each other in reality, and governing from our vantages on it. It requires only that we interrupt what is automatic, and begin thinking, imagining, acting, and coming together, not for protest or lobbying, but for governing conditions, however tiny and seemingly inconsequential the first steps. Understanding that governing is the foundation of every body politic

establishes the first, and hardly difficult fact. Self-governing by the full body politic is merely the next step, and it is neither impossible nor naive. As a first principle, when applied, it reveals, more quickly than anyone could ever imagine, the governing we are up against and how to answer it with our own. It shows us what the world is and could be, and who we are and could be. It builds a door. First principle needs only to be recovered and applied, firmly, steadily, again and again. This is what it means to follow it. A door can be built by this, one that it is not at all hard to walk through, if, only for a fleeting moment, we permit ourselves to hear, at last, what is calling out to us, with mercy and open arms, from the other side.

I love my native city more than the salvation of my own soul.
Nicolo Machiavelli to Francesco Vettori, April
16, 1527

2.

Debates following the L.A. acquittal and subsequent riots, and efforts to answer these events, were fierce, with diagnoses of all kinds. The political dimension received little or no attention. My thoughts on "first principle," nonetheless, collided with actual conditions, for something entirely unexpected and improbable happened. In early 1993, months after my piece came out in Framework, I came upon, by chance, a short article in a new alternative paper. It described people beginning a political, and to my lights, real response. A diverse group of Angelenos, the paper said, had begun exploring the principle of "neighborhood councils." Was this possible? At the end of the article, there was a location listed for the next meeting. I found my way to a school auditorium in central L.A., by the Hollywood freeway, and sat at the back. There, around twenty-five people were discussing how disempowered people felt, how the city was harmed by this, and what might be done to change things from the ground up. The group had met once or twice. A couple participants had political experience, but most were people active in their neighborhoods. The whole thing was, for me, a miracle. I had found a political home.

Some later told me the council effort began with a member of California politician Jerry Brown's 1992 presidential campaign, others that famed activist and State Senator Tom Hayden, flirting with a run for mayor of Los Angeles, had been part of it, wanting to use councils as a campaign issue. At the meeting I came to, Hayden was not present, but a former Jerry Brown staffer was. By the second meeting I went to, she too was gone, and the group had shrunk by more than half. This left a small group of around eight to ten of us whom anyone in city politics, no less the art, culture, and academic worlds, would surely call "nobodies." I remember painful debate over our very small numbers, why no "important" people were interested, and wrenching doubt. But the ones who had returned were undeterred. That they were not indeed players of any kind struck me as a huge plus. It felt quite real. The experience of the riots was foremost, political ideologies

ranged widely, and they did not interfere. A structural principle was at stake, and it crossed all political lines.

The group had just begun a one-sheet bulletin calling this gathering the Neighborhood Council Movement, or N.C.M., to provide minutes of meetings and announce forthcoming meeting locations. At my second meeting, I offered to help by keeping minutes.

I could not help telling everyone I knew, all in the cultural realm, about this extraordinary development. I usually did so only once. Eyes glazed over. This was my first shock, echoing the silence after my Framework manifesto. Over the next months, as we tried to reach others, my education deepened. The lack of interest among professionals—among urban planners, left scholars, activists in labor and immigrant rights, movie people, academics, and artists—was glaring. In repeated encounters, I could feel condescension, even contempt, especially from those who identified themselves as concerned with the new, the very ones I thought would be most interested. For this was indeed new. In actuality, I did not fully believe even the critique I myself had formed. It is one thing to critique something in thought to provoke; it is different to find it demonstrated in reality. Those with a strong professional career focus were now indeed the very ones who had no interest in trying, however imperfectly, to rebuild self-government among the people. Efforts were made to reach out to unions, teacher organizations, and political party people. Nothing. I couldn't understand it, and grappling with this led to no good answer.

One notion I'd proposed, however, had been surprisingly confirmed: with no echo, commitment to first principle was everything. It wasn't until I started attending N.C.M. meetings that I could see how this worked in reality. Principle was an anchor and lens. Abandoned in the very reality I had described, first principle was able to hold me up. As long as a few of us in this strange group of ordinary, hardly fashionable, not at all avant-garde people kept meeting, publishing the bulletin, and pushing, that was enough. Indeed, it was more than enough. It was amazing.

Supporters inside the city government would emerge, but they did not come to our meetings. As we expanded our mail-

ings, nobody new showed up. Apart from the newspaper article I'd come upon, there was no press coverage of these efforts at all, ever. Why would there be? We were a handful of people with no social status whatsoever. The wider public realm, even with our efforts, had no means of finding out we existed, and there was, for quite some time, no confirmation that what we wanted had any purchase at all. What we faced was silence. My discovery of N.C.M. had been a fluke. The article I had come upon, by chance, was the only public mention I recall until the last moments, and I had found it only because I grab every newspaper and local publication I can find. The good, and only truly alternative paper that had clued me into the new "movement" did no follow-up and was closed down a year or so later. Fortuna, it could be said, had smiled on me.

Because I technically lived outside the City of Los Angeles, in Santa Monica, I was in the peculiar position of pushing for councils in a different city, albeit the megalopolis surrounding mine on three sides, the ocean being the fourth. But a principle was at stake. Further, because I was not at the first gatherings, I was not truly a founder of N.C.M. In another sense, given the work I would do, I consider myself, at least, as a "co-founder" of the effort. In reality, all but one of the actual founders dropped out. By the end, even he did not show up at the crucial moment. While this was in the future, one could feel a brutal wind blowing down upon us. Was it from the past, or the future? How could any of us have known? We were beginners, and that saved us.

After a couple more meetings, and discussions about outreach and other topics, we decided our newsletter, however limited, needed to go beyond announcing meetings and minutes to discussions of substance. We needed to figure out what we were doing, because we actually had no idea. Perhaps "substance" might draw in new people and build a real movement. What were we proposing? We began to think of "opinion" pieces, reprinting articles, and ways to elaborate anything that might encourage people to join us and create a real movement.

In the wake of the acquittal and riots, the White and Asian communities, media, and existing neighborhood leaders

still regarded the meaning of security, that notion I had addressed in my Framework piece, as policing and "law and order." The police, to these groups, were allies under siege, and the solution was more Neighborhood Watch patrols, in effect self-appointed, roving groups of volunteer cops. By contrast, in communities of "color," primarily Black and Latino, security meant something entirely different: getting justice, for they had none. For them, "law and order" was absurd. "Minorities," as is usually the case, had a clearer sense of political reality, but they were locked out of resources, embittered, and cynical. As a result, I believed the city, such as it was, would divide precisely over this matter of "security." This was hopeless for any broad change. Later, massive demonstrations by poor immigrants from Central America would emerge. Yet "minority" communities would prove the hardest to convince local councils stood a chance, and we failed to solicit even minor interest from them; they were unreachable. Getting power down to all local communities remained beyond imagining. For me, this was the reason to push. The first principle I'd outlined months earlier, apparently without any impact whatsoever, became grounded in real conditions.

The angle I took in my first pieces was not shared by many in our tiny group. In particular, my briefly expressed outrage in the following piece, over mere owning and consuming, bothered our newsletter editor, Jim Churchill, who said it would alienate our constituency. I wasn't sure we had a constituency. But I was pitching in, he did not make me take it out, and we were, in a manner of speaking, equals.

The newsletter in its initial stages followed a standard, bare bones, 8 1/2 by 11 inch form. It would end up as a folded-in-half, vertically narrow shape, xeroxed, hand-folded, and hand-stapled. I do not think it ever reached more than about forty people.

The series I would write was titled "Notes on First Principles," in the plural. I have, as with the first intervention that opens the book, retitled the series, appearing here in slightly edited form, as "Notes" on a single first principle. For the texts I would write, and that follow, were indeed concerned with first principle.

Though it might seem strange, following first principle—to carry it, apply it, and push for it, regardless of lack of any echo—was, for me, the only way I could live with myself. I was frustrated with conditions, in the academy, the cultural realm, and in politics, and had no idea what to do. I had no organizing background, and no interest in what "activist organizing" meant whatsoever. In first principle, though, I saw a way through all this and was willing to stake everything on that. The city had an enormous distance to traverse to begin to restore the people to their own power and knowledge. I had found a way and a place to begin.

The following text, my first for the so-called "neighbor-hood councils movement," appeared in July 1993, approximately eight months after the short, rough version of the preceding piece landed nowhere.

Notes on First Principle #1: What is Security?

The meaning of the word security for us is *expansion of self-government*. Everything that is worthwhile springs from this. We cannot gain freedom by standing still.

It is tragic that the reality of self-government for all the people does not exist. Its *reality* must be experienced, and experienced by all. Meaning is only safe when we are secure, and we are only secure when we govern. That would be meaning. That would give proper meaning to the ancient phrase "Don't tread on me."

It is a sinister achievement, indeed a sign of veritable sinister work, that freedom could be experienced, in principle, as *insecurity*. Only a devil could devise such an axiom. The entire edifice aligned against us seeks to make this axiom the rule of daily life: that freedom means insecurity. It is absurd that "Don't tread on me" is the preserve of working class and middle class whites. Because the next statement to the people is almost always this: to have security, you must have *less* freedom. We say no!

The undoing of sensible axioms accelerates. There is no need to see, as Orwell asked us to, a boot stomping on our face forever. We would be luckier if we could all see the boot. But some can certainly see it, and clearly. The 19th century Frenchman de Tocqueville suggested that if tyranny came to us it would be "absolute, minute, regular," "provident, and mild." It is definitely minute and regular. But it is neither provident nor mild.

This is why we are insecure—not because of freedom but because our freedom is missing. When we say we are for security, we do not mean what "government" and media say. Self-government is our only security. Seen through that lens, it is clear our government and media are not very concerned about security.

What do the people say? When they say they want security, and safety, what do they mean? Property-owners cry out for police and safety. But what do they mean? Property is merely a secure stake in the world. What do they fear, then? If they do not feel safe, why? It seems we barely know what property and safety are. Too many crying out on this subject are not heard. Why are only some allowed to have a stake in the world? Is not a stake in the world, like freedom, everyone's right?

It may be scandalous, but we will say it: freedom is not owning and consuming! Consuming, buying, owning, securing the self—these produce *insecurity* if that is all that matters. These are not freedom. Many have this so-called freedom, but many more do not have even that. That is why one must have freedom and power first. That would be a stake in the world. Everything follows from this. If those "with" have property and money, but do not feel secure, what is their property? They might ask this. We certainly do. Only self-government for all secures each person's stake in the world. That is security and safety. Only control over our lives, in every community, that is, self-government for all of us, can end everyone's insecurity.

Looking deeper into the dark, shallow concepts have taught us to fear each other. We have not tended to self-government. There are many now who are even hostile to that notion. Can they imagine self-government for all? No! They imagine more real estate, more gated enclaves, more police, and better positions for themselves. But the light of free, self-government for everyone, in all our lives? It is inconceivable.

A falling or non-existent standard of living, racism, and police violence instill fear. Fear exists for those who do not have a stake in their world. Our answer is more freedom, not less. We need an end to insecurity. Not, as is now the case, only for the "haves," for the privileged, and most of all not only for our so-called great and noble leaders.

Those who follow us may look back and curse us for greed, for short-sightedness, for blind pursuit of self-interest. Why? Because these are narrow and ruinous. To fight for freedom is to fight for self-government in all our communities. In all communities—in Black communities, Hispanic communities, Asian communities, as well as in White communities. How could memory be so weak? How could we have forgotten we as a people, as a city, can never be *partially* free, when so many have no freedom at all?

Our fight is for expansion of self-government to all. Without that, security and freedom are a lie. Ensuing generations will turn to ask: How could freedom and security have been lost? They are lost when some call themselves free when most are not. We ask, instead: How could we have forgotten that source from which all our happiness, security, and independence flows?

It became clear, quickly, that neighborhood councils were a non-issue—not just for the parties, the political and economic center, the media, and the professionals, but also for the two so-called alternative papers. We were a non-issue because no one saw us as a possibility, or more likely, as a threat. It was very hard to disagree. It was as if a handful of people were living and gathering on the dark side of the moon.

In talk after the riots, the concept of "civil society" became the new term through which to debate things. Everyone said it was "civil society" that was missing. But the concept, born of resistance to Soviet occupation in Central Europe in the 1980s, when imported into the States, took on a peculiar cast. Something was wrong with this, but what? Angelenos had glimpsed, everyone was told, the opposite of "civility," that civil society was what had broken down. And so everyone in the media, press, and official order dedicated themselves to calling for civil society.

For income, I had been doing a small university research project in a desperately poor, African-American section of South Los Angeles. I was struck how one or two specific streets and their sidewalks looked well-cared for, surrounded by endless blocks in every direction that were utterly barren and dead. I found out indirectly, through the interviews I was doing among residents, that it was usually the work of a particular person who, regardless of their neighbors, had begun caring for their block. One in particular, because of this—I liked her a lot because she cared so—had begun colliding seriously with police. Her phone was tapped and cops would park in front of her house, shining spotlights into it, all because she was out and about, fixing things on her street, and would not work for the police who were harassing youth daily and managing street trade. This pointed to something. I remember pitching the idea of neighborhood councils to her, and she laughed. That pointed to something else.

The original version of the following piece ran in N.C.M.'s November 1993 newsletter. It used the idea of percentages, so often

used by statisticians, and that would also be used, years later, by Occupy. This piece, my second, was the first mention of a new kind of school.

Notes on First Principle #2: What is Civil?

What positive principle are we seeking through neighborhood councils? To rediscover our humanity by re-opening the school of the people.

In Los Angeles, education in humanity—differing people interacting, caring for things, expressing concern and power over crucial matters—has been replaced by education in petty despotisms, private life, and material gain. People pursue careers, tenaciously trying to protect their jobs, turf, and even cliques, worrying about the access and approach of strangers, newcomers, and *others*. Paranoia may be a wound, but tyranny is the knife that creates it. In cutting away others, we wound only ourselves.

The concern over a decline in civility is hardly limited to the West Coast and Los Angeles, as a recent mid-October article in the *New York Times*, "Looking for Civility," revealed. Rodney King's famous "Can't we all just get along" was answered by Willie D., an East Coast rapper: "No, Rodney, we can't get along." Calls for civility, calls for people to be "nice" to each other, to be polite, to obey the law, ring hollow for a reason. Honestly, for many, there is no sense of fairness or justice in their lives. No one, it seems, is civil to *them*. One must ask, seriously, who are the ones not being civil?

People work hard, try hard, and are seeing less and less back. Inequality is mounting, and benefits from work and community life are dwindling. Crime was an issue in recent mayoral races across the country, replacing every other issue. But what crime was discussed? Rarely do media or officials, when they use this word civility, consider where

this is actually absent. Society is not working for everyone. Is the problem what some call a lack of law and order, or might this oft-asserted claim reflect something more ominous?

What many do not want to admit is that the "decline in civility" represents growing, indeed geometrically accelerating, *inequality*. The ones who've made out okay are not civil. Inequality is not aimed only at the long-disenfranchised. It is aimed at nearly everyone now under the top five percent. This is *injustice*. More and more are subject to fear at the hands of those secure, comfortable, and doing okay, especially those with "authority." More and more, people experience incivility from the "haves." This was the import of the chant that arose, for the first time, during our recent riots: "No justice, no peace!" Is this not understandable? Does not the insecurity this points to produce fury? Who, truly, is experiencing lack of law and order? To talk about a lack of politeness is insulting. But in another sense it is quite right. For the society that considers itself so very polite is hardly polite.

Perhaps society could be more polite.

Civil society and civility do not mean obedience to law if the laws, and society, are unjust. One could ask now, indeed, if laws that exist are enforced concerning the top five percent. What has happened to law and order *there*? The foundation of civil society, and law, means the respect of those who have for those who do not, those with power for those without, and finally, the deference of those who rise in society for those who are unable to. The status-obsession of the Reagan years, spread into every realm, has *corrupted* civil society. We saw the views of some on this problem recently. Their rioting is only the result of years of one group feeling no hesitation in crushing the rest, of rising to stay above, feeling superior to the people they see as hardly equal. There is no greater sign of civil society's decay than this. The loss of principles starts not at the bottom, but at the top. A person with even only a little power and

wealth who crushes another violates their political equality, in principle.

Civil society is peaceful not because everyone obeys the law. It is peaceful because law is just and enforced for all, and so can be respected by all. How can laws which harm so many be respected? In Eastern Europe before 1989, everyone obeyed the law, was "civil," yet something was utterly missing. The law and the society had become a lie. The people needed a civil realm on *their* terms, and so sought to create a "parallel" realm. Why? Because civil society could only be real if it was free from state, party, officials, society, and media. The Eastern Europeans began, as Vaclav Havel put it, to attempt to "live in the truth." The public realm, and especially the law, was a snake's nest of falsehood. A parallel realm was the only security. There, people could experience each other humanly, not turning each other in, not trying to one up each other or incur favor by those with "authority" in society. Always, always, keeping clear about the lie. Justice begins in decency and dignity. It begins in truth. If the powerless cannot expect justice, and the powerful, however little power they may have, don't know how to practice justice, civility is hopeless. Yet this is what officials and society call for. "Liberal" interpretations of justice enforce this. They want the state to enforce peace. But what is their peace? It is the same among so-called "conservatives" who want the police to enforce law and order. How is what we have law and order?

What we want is a realm apart from office, society, center, *and* the margins. Not a realm of obedience or disobedience, but a realm to practice political equality. In our neighborhoods. It is there that civil society could begin. No one has the right to crush another, no one has the right to wield wealth or power, however small, over others, driving them into obscurity and misery. Fairness and a shake at the good life are everyone's right, not just for the few or even the many. Respect for law is not obedience. It is the

acceptance of just rules that all obey because they are just. If society breaks down, it is not because desperate, unrecognized people disobey, but because the "powerful" make up rules and break even them. Increasingly, it has become obvious the "powerful" and those with "authority" have no respect. They do not understand civility. Rappers who invoke gangster life and insist we cannot get along only mirror this. They too want to be immune from an existence crushing us all.

As long as those with power and wealth, however small, regard those without power and wealth with lack of respect, there can be no civility. It starts at the top. Civil society has been destroyed not by lack of obedience but by lack of respect and deference from those who run things.

Turning in new, yet old directions
The shallowness of our thinking, reducing everything to "left" or "right," "liberal" or "conservative," hides the full dimensions of the problem. There is indeed a corruption of "values." We live in a world of crush or be crushed, not of equals governing their lives politically. People struggle long hours in voluntary associations, against bureaucracy and misfortune, and in jobs. They try to improve their neighborhood, yet the society as a whole shows them no respect. There is no fabric rewarding such work, leaving us with either "insider" or "outsider" status. This is not good enough! We lack experience in the school of tolerance, compromise, equality, and power. Many people keep pursuing this, practicing it as they can, and often alone. But not the five percent. Where better to address this than in a city where celebrity runs rampant, ruining every political equality? Of course there is fury. The people have no peace. They have no justice. They have no political equality.

The civic must be rebuilt—not just as opportunity, infrastructure, jobs, or local industry. Civil society is where people work things out, in that old cliché of "Little League"

sports for kids, in helping a friend, in volunteering to help a neighbor in distress, in cleaning up a sidewalk or moving trash cans for pick-up, in solving a problem on the block, in trimming a tree or bush, in admitting in a gathering, yes, perhaps I did make a mistake, or no, I didn't know that was the case. This is the beginning of civility. It should be honored, and those few who dare to do this should be praised. They are a model. For it is individual-oriented in a forgotten sense: one discovers and learns how the other is crucial, and so one finds *oneself*. Neighborhood can build that. So many fight for their neighborhood, and those one would positively least expect. The roles of teacher and student need to be upended, prejudices confronted and overcome. Those who do care should be rewarded. That is civility. That is the discipline of practical civility. That is the discipline of political equality.

The principle behind our pursuit of local self-government through councils, behind our attempt to find working models in the past and around the country, is this: by taking back the power that is ours, by discovering with each other the space and time for this, we can begin to be civil to each other, no matter someone's vaulted status or claims to authority. We cannot overcome the unfairness and destruction in this city all at once. But we will never know what direction to go in if we do not have the space and time to learn, at a simple level, how to protect, support, and learn from each other. That is the meaning of "Don't tread on me." Without self-government among the people, without a school for the people to see they are political equals, there can be no justice. Without justice, there can be *no peace*.

4.

Tom Hayden, a fellow Santa Monican, supposed early participant in N.C.M., and a famous '60s activist, had become a California State Senator under the Democratic party. Hayden published an editorial strongly endorsing neighborhood councils in the city's leading alternative paper, the L.A. Weekly. N.C.M. reprinted it, and we sent him the newsletter with a cover note. Hayden did not respond. Known for his participation decades earlier in Students for a Democratic Society, and for writing its founding document, The Port Huron Statement, Hayden had weighed in on issues over the years. He was visible, had some power, and was the only person I was ever aware of on the left to come out publicly for neighborhood councils.

One summer evening, totally by chance, I ran into him in a local supermarket check-out line. I introduced myself and spoke with him for a minute, inviting him to a "town meeting" I was organizing on our effort at a poetry institution I'd begun attending, Beyond Baroque, in Venice. He was in a rush, but expressed interest, and gave me his office number. When I followed up, the staff-member in charge of scheduling said he was busy with budget issues. I insisted, and got nowhere. By the time I composed this following appeal some months later, Hayden had made no further public gestures on the subject of councils. He had still not communicated with us. It was time for outreach. I proposed a letter to him to remind him we existed, and decided to try the added lure of calling for a space for councils in the City of Santa Monica, where we both lived, and where such a thing was even more unimaginable than in L.A.

Hayden had apparently decided his public editorial endorsing councils was sufficient on his part. Whatever the reasons, after I composed the letter, the group decided any further communication with him was pointless. There was, beneath the surface, stiff resistance to what a couple called his "celebrity." My neighborly letter never went out. Hayden, the famed activist, and famous student advocate for "a democratic society," never weighed in on the issue again, and vanished. Though the letter was never sent, I feel the gesture, and moment, deserve a marker.

Fred Dewey
[Address]
November 29, 1993

State Senator Tom Hayden
California State Legislature
Sacramento, CA.

Dear Senator Hayden,

You may remember we met in the grocery line at Lucky's
on Lincoln and Ocean Park this past summer. We spoke. I
invited you to speak at a town meeting I was organizing at
Beyond Baroque, in Venice, to discuss building neighbor-
hood councils. You expressed interest, but your scheduling
assistant said you were tied up in state budget negotiations
and could not come.

The evening went well—with Mike Davis, the noted au-
thor of *City of Quartz* and critic; Bill Christopher, head of
P.L.A.N.-L.A.; H.R. Shapiro, a political historian and orga-
nizer for community control back East, whose historical
research has been cited by Gore Vidal; Jon Shaughnessey
and Sharon Molander from the Neighborhood Councils
Movement, or N.C.M., and myself, also from N.C.M., as or-
ganizer of the event and moderator. The discussion was very
lively, and at times even fierce. Davis dismissed the councils
out of hand, as a move by racist and right-wing homeown-
ers; Christopher remained neutral; Shapiro praised council
democracy from a historical perspective; and N.C.M was
their firm advocate. Your contribution, and perspective,
were missed.

We are grateful to have reprinted your excellent *L.A. Weekly*
article supporting councils. We'd like to pursue common
ground. The New England town meeting is one compass

point. Another is the issue, more generally, of public space. I published a (severely-edited) piece on sites called "public spaces" in Los Angeles in the *L.A. Weekly* in October, noting they were actually only crowd spaces. I suggested, as you have, that our discourse on public space is too narrow, nationally and in L.A. I have enclosed those thoughts, to be reprinted as I wrote them, this winter, by the L.A. Forum for Architecture and Urban Design.

We recognize you have been active on a number of crucial issues and are respected. That is why your advocacy of neighborhood councils is so crucial, and why we are reaching out to you now.

For Santa Monica where you and I both live, there is surely a local component. A Civic Center Design Plan is under discussion, missing any space for community-wide meetings or councils. I agree with you about the threat of Santa Monica becoming "an elite suburb." One solution is local councils here too, and near the City's political buildings. Santa Monica could become a beacon locally, rather than merely "Tammany by the Sea," as it has been called.

I, and N.C.M., believe, as we believe you do too, that Los Angeles can become a beacon for the whole country. I am writing you on behalf of N.C.M., and as a fellow Santa Monican. We would like to get your thoughts on direction and approach, and to explore ways to advance together the cause of councils in the region. We look forward to a chance to talk in whatever capacity you feel comfortable with. We ask only for a few minutes of your time.

Respectfully yours,
Fred Dewey
For N.C.M.
[Encl.]

5.

By mid-1994, our "neighborhood councils movement," or N.C.M., had dropped down to a meager four people: one concerned with is- sues of communication and branding in the newsletter; another the possibility of local experimentation in eco-village life; Jon Shaugh- nessy, our new newsletter editor, and one of the original found- ers, now a petition organizer; and myself, the only one not at the initial meetings. The first, and excellent editor of our newsletter, Jim Churchill, and his partner Lisa Breneis, moved to Ventura County to work on their farm. Two down. Shaughnessy and I went out periodically to advocate at community meetings, neigh- borhood groups, umbrella organizations, and to pursue conversa- tions with a City Council staff member, Greg Nelson, in L.A. City Councilman Joel Wachs' office. We had, spurred by Churchill and Breneis when they were still with us, gone to various regional "neighborhood" conferences, studying systems where councils had succeeded, in much smaller cities like Portland, Oregon and Minneapolis / St. Paul. Greg Nelson, on Wachs' behalf, had been studying these systems from a legal perspective and had begun looking at what was needed to revise City law.

The cities where councils had taken root used non-profit boards functioning in an advisory role. N.C.M.'s role, as I saw it, was to keep the core principle—of local self-government for all—percolating wherever we could. We were not policy experts, and trying to become that was too steep a mountain. I knew I could defend first principle, amidst the welter of facts, political realities, and doubters. This would prove crucial, as complicated policy questions and demoralization grew, thinning our meager ranks. The impossibility of the quest, and the silence, were indeed overwhelming.

At this strange and lonely stage, I vividly remember an example of the clash between proposal and reality. We participat- ed periodically in the only cross-neighborhood organizing group created to address city-wide neighborhood matters, P.L.A.N./L.A., a group of homeowner-group leaders convening one Saturday a

month at L.A. City College. It was chaired by Bill Christopher, an architect and urban designer, whom I'd invited—for his work at P.L.A.N./L.A.—to my prior "town meeting" at Beyond Baroque. These were hardened and practical people, and debate over principle was, to them, a waste of time. This to me reflected a problem. They had been sent our newsletter, and the following piece. And one Saturday, we got on the agenda.

After a vigorous discussion of a garbage landfill the City wanted to place in a canyon against vociferous neighborhood objections, we got our ten minutes. I outlined the principle of the New England town meeting and Jefferson's phrase "divide the county into wards" from a late letter to Samuel Kercheval, showing charts outlining a self-governing community model created by my friend—also at the earlier "town meeting"—the political historian H.R. Shapiro. He'd devised this with his friend the artist Donald Judd, for their 1970s New York group Citizens for Local Democracy—a group that at various points included Judd, his wife Julie, and "advisors" Lewis Mumford, Hannah Arendt, Noam Chomsky, and other luminaries. Shapiro was not supportive of my work for neighborhood councils, arguing they were not political and so irrelevant. All I could say was, hey, this is not an ideal world. I brought his arguments with me. In my talk, I linked the Declaration of Independence again to neighborhood councils, as I do in the piece. The response of the homeowner leaders was uproarious laughter, then total silence. This was how pushing first principle among existing groups, and among most of my friends, went.

At the time, a Chamber of Commerce group, "Rebuild L.A.," was defending business interests as the heart of reform, complaining business was suffering "death by a thousand cuts," in other words too much regulation. This center group had momentum and was outside public challenge. Unhappiness among the people had no traction. All of this needed to be addressed.

The initial version of my text was published in the May 1994 N.C.M. newsletter. My reference to "we" in the piece was absurd, considering "we" was by now a shrinking handful of people, in reality only two, Shaughnessy and myself. And this only

a year after getting going. I was determined to keep the principle alive, acting as if we were indeed a full-fledged "movement." I believed, in spite of the silence, that first principle matched the public's actual, if unexpressed and unheard, questions.

The piece marked my first use of the phrase "the school of public life" in my writing and thinking.

Notes on First Principle #3: On Political Reality

It is fitting that a movement born of political and social strife, as N.C.M. was, would make as its purpose the health of the city and, as for every city, town, and countryside, the people's birthright of self-government. We feel ever more single-minded, as we and others are wrestling with political reality that was never defined by the people, all of us, that live here. The problem of political reality conveyed in Jon Shaughnessy's comments at the March *P.L.A.N./L.A.* meeting—included here in the newsletter, addressing a series of practical issues discussed then—needs to be addressed. This can only be done, however, by putting aside the self-elating clichés favored by those with a vested interest—though loudly denied, perhaps most of all to themselves—in the status quo.

Claims about political reality are always used to reinforce the way things already are. For us, this is not political reality. Political reality, for us, means self-government, asserted in congregation and assembly, coming together to decide our affairs. Public space is the space of reality. It can arise any place—from the Declaration of Independence to a neighborhood group meeting on some topic, in communities facing crushing poverty, lack of rights, and decaying, roach-infested buildings, or those walled off in arrogance. Public space arises wherever people and their claims congregate to define and govern. Public space is a political form. It is the *public* thing. That, not policy meetings in the

halls of government and business, is political reality for us. If political reality is decided only by professionals and activists in backrooms, as John Locke wrote about impediments to "civil government," peace will be impossible, and more importantly, meaningless.

Today, we are fortunate that our ancestors, even with their flaws, conquered the divine right of politicians. What we now face is bureaucratic right, legitimated by a popery of science, technocracy, and efficiency. That is why one question is seldom asked and never answered: who is the good life *for*? Real politics remains hidden under a barrage of protocols and information. No wonder many experience death by a thousand invisible cuts. Those trapped by this are hardly only executives and businesses. For the public as a whole, the thousand cuts are clear. We face a snake that knows only to slither out of the public space, hiding its work in back rooms and chambers.

We need politics taken out of the private realm, so we can address those who see themselves as acting so responsibly. What if responsibility were instead in the public's hands? What if it were a joyous, rather than a burdensome thing? Power is having a stake in our world. It is a new kind of birth, just like being born again. Not as religion claims it, but as we demand it, politically. That is reality.

Some speak of the loss of place, of alienation. We agree these are problems. But the means to solve this cannot come from professionals, further development, and the center. It can only come from neighborhood power in place. This is attacked by planners, academics, and official after official as an *impediment*, as irrational, as *reaction*. But, we ask, how are box stores, jammed streets, and endless development—fostered by unaccountable politicians and tax structures—rational? Efficient for what? For *whom*? How is the political structure we have rational? When there is no public space, reason is controlled by bureaucrats and the ambitious. *This* is irrational. We are subjects of an extrem-

ism overturning self-government each day. That is political reality! Of course geniality and trust turn to rage and suspicion. Bureaucrats against no-growthers is no option. Why? Because bureaucrats and business win every time!

What is checked, balanced, and undone, in the end, is the people's space. That is political reality. This is what undoes every neighborhood. Singled-out activists and planners go through the motions of public appeal but see only the rabble behind them. Center officials eat at the public trough, serving donors who couldn't care less about the citizenry that permits them to exist. This is obscured by a rats nest, a Sodom and Gomorrah, of rationality with no reason, science with no empirics, polls with no public, and democracy with no representation.

We seek, instead, a federation of neighborhood councils, a glorious parliament of the people *born again in freedom*. Out of this, a new city, a real city, will surely come. We need renovation and rebuilding, yes, but of neighborhoods and all that makes neighborhoods strong. People say local governing is impossible with so many moving in and out of our neighborhoods. It is true, parts of Los Angeles are this way. But why? We have a solution: imagine a neighborhood that when a person moves in, whoever they are, they are welcomed into a self-governing structure. This would give place real meaning and substance.

Los Angeles is cursed by privacy. It is time the ones who benefit from this are forced to say in public all they whisper in private. Let's hash that out, face-to-face. We need structures to do this. That would be political reality. We feel there is nothing more important than place, but what do we face? A landscape of scars. Buildings, like people, are there one day, gone the next. Outsize buildings go up, replacing buildings with a history that people have long oriented themselves around. The people protest such "development," to no effect. Who permitted this? We need anchors in place. We need self-government in place. The

vastness of the city is the alienation of *no-place*. It is the alienation of a people without a voice. We can stop that, here, in a city that has perpetuated this for too long, spreading its model everywhere. We can build and strengthen regional and local relationships. We can invest ourselves in communities. We have one of the greatest array of universities, workshops, libraries, thinking people, and cultural and artistic experience anywhere. But who would know? Who can see this, and make use of this, except those in the private, ruling dens of government, academia, and business? The people must be able draw on this. We need to meet. We need to govern. Civic life and enterprise are not at odds. They belong together, and they belong among the people.

Today, self-government is our endangered species. It is the first habitat in need of conservation and restoration. Self-sufficiency, independence, dignity, opportunity, meaning, and preservation can be achieved only by those grounded where they are. This would be a real communion. We need local economies, locally-scaled industry and creativity, to invest in spaces made safe by political equality. We need spaces in order to think locally. Each person has something to contribute. In self-government, everyone's skills are needed. We can only achieve this through a stable, regular space which rewards the arts and education of a *polis*. That would be a city. That would be *the school of public life*.

The old, hoped-for FDR stand-by of government investment and programs, even with its idealism and help, is blocked from every direction. The bureaucracies do not care. Bureaucracy is a curse. It is no longer even *credible*. How can we expect a Sodom and Gomorrah of procedures to deliver for us? Might there be investment? Sure, but rebuilding the *old* system, for the *old ways*? By the same people? What we had before was not just inadequate, it was all wrong!

With a rich cross-section of experiences, Los Angeles has everything to draw on. We can study capitals of the past, American communities, cities all over the world.

Imagine the now-ancient New England township, without its clerics, homogeneity, and Puritanism, infused with the richness of cultures and backgrounds we have here, in a climate ideal for gathering year-round! But instead of turning to "Rebuild L.A.," let's start with a fact. Los Angeles has mistakes to correct. We need a *new* life where local collaboration, born of local strengths, is supported, rather than blocked, by banks, big business, finance, politicians, and media. We need start-ups which build neighborhood linkages and cross-fertilization, which support neighborliness, we need *access* to resources and communication. We can have farms. We can make things. Strong neighborhoods are not created by patrolling for crime, not by last ditch, failing efforts to stop a development that goes through anyway. We need to build in a different direction. We need neighborhood councils to find out what is planned ahead of time, not, as now, when it is always too late. Knowledge needs to spread, conversations need to become regular, public, and local, with neighborhood commitment and work rewarded, embraced, and shared. With people of differing backgrounds, from different experiences, not with those who only think alike. We do not think alike. We know that is a strength.

The old days when opportunity was offered by the system seem to be over. Why? Because government and business are blocking it. Why would they ever rebuild for us? We must start from scratch, and build our communities together. We can no longer afford neighborhoods as barren vacuums. We can build the self-assertion and dignity of the people. We must become independent—individually, federationally, a city of people supporting each other, learning in the school of public life. *That* is what we are fighting for.

6.

I had been writing and publishing cultural and political criti-
cism since I moved to L.A. a decade earlier, and though I had
at one point written experimental prose, it was never published
and I had given it up. When I met the poet, editor, publisher, and
dean of a local art school Paul Vangelisti—I'd become director of
the literary/arts center in Venice, Beyond Baroque, in 1996—we
immediately fell into wide-ranging discussions about poetry, his-
tory, politics, the lack of funding for culture, and his own experi-
ences at the institution I'd taken on. Vangelisti had published
many L.A. poets, including the first major, and for a long time
only book by the extraordinary Venice poet John Thomas, whom
he loved. He had done the only book up to that point by the leg-
endary and long-gone Venice beat, Stuart Perkoff, who, at the
end of his life, had been with Thomas' now wife, Philomene Long.
Vangelisti did not hesitate to show me his scars from his time
at Beyond Baroque. He had gone through nearly every experi-
ence I was now facing, and even with some of the same people,
especially a space-grabbing, vastly better connected organization
in the building whom we'd given a small desk to long ago and
that now was after our top floor and our theater. Vangelisti con-
firmed much that I sensed, and was a friendly and seasoned ear.
He invited me to contribute something to the next issue of his
magazine, Ribot, on the theme "History." I wrote this very short
experiment in spontaneous prose for him, the first experimental
text of mine published outside my high-school yearbook and a
small magazine I'd done with friends in New York years earlier.
It invoked a number of people, places, and themes I was thinking
about, to appear later in my thinking. It was published in 1997,
just as Beyond Baroque was beginning to really hum. I wanted to
conjoin the poetic with signals from my city and a wider history.
It was a critical intervention into memory, and dedicated to the
muse of history.

Mnemosyne

How does an American place erase all that interrupts the movement of daily life? Can one make something lasting of remembrance? Bluebells. Who can come and find the world? Desert Canyons. How many years of being driven by fictions, blocking the world from sense and understanding? Woodrow Wilson. When realities are private, knowledge of how to aim, how to judge, evaporates, and with it, beauty. Thaddeus Stevens and forty acres and a mule. Accounts, narratives, tales, stories of what has happened slipping, replaced with dreams. Rosa Luxemburg, warning everyone, unheeded. Events no longer recorded, recordings as artifacts of automatisms. A great wind, churning the sky. Frederick Douglass asking: whose independence is it? Deeds forgotten, replaced with the probable. On Little Roundtop, an event, improbable. The more tilted to catastrophe, the more miraculous the unforeseen. Bob LaFollette nearly made it. What is past exists. The future is a wind, pushing us back. René Char, in the hills of the Maquis. The house down the street. Neighbors, friends—immortal! Tumbleweeds in the sky. Crows in dead trees. You and I, deaf to the land beneath our feet, trying to work our way back to remembrance. No, this is not a city yet. It is barely even human.

7.

By 1997 and 1998, through the efforts of many, Beyond Baroque, which had been in shambles when I came onto the board in 1995, then stepped in as director to help rebuild, was on its feet and thriving. After two years, I was beginning to take a little salary and see my labors bear fruit. Grants were coming in, and I'd found new donors. I had begun bringing in national and international poets and writers again, after years, had begun rebuilding the archive, had started a publishing imprint for the center, which had never happened, and was reaching out to New York and abroad. The battles were growing, but I barely noticed them. For me, merging the political and cultural were crucial, and where possible, to get things moving in a city whose only truly ancient feature left is a famous tar pit. My spirit for this was enhanced by meeting and working with freelance journalist, editor, and activist Michael Simmons. Together we put on events bringing in the legendary musician, activist, former Detroit White Panther, Sun Ra producer, and manager of the MC5 John Sinclair. We would stage the only reunion that ever happened—or will happen now that members are gone—of his long-departed, Detroit collective of artists and activists. Michael, I, and Sinclair shared a deep passion for poetry and freedom. We became friends.

After publishing criticism in the local alternative papers, that world was closing. I was getting nowhere in the theory world, mainly because I wanted to talk about reality, events, and real politics. So I began writing a column for an art world, newsprint 'zine, Coagula, which could be gossipy, was not always nice, but was widely read in the art world, if in secret. At Coagula, I found a platform, and I pushed it to the max. I lambasted national politics, discussed history, and even went after President Clinton for shocking comments at a White House arts ceremony I'd been invited to for my position in the literary world, making my tenure at the prominent, widely recognized arts center a bit problematic. For a rancid political and cultural situation, I combined founding principles with critique of contemporary events, art, and political and cultural policy. I called this column "Letter from Freedom X."

Freedom X was an "avatar," or persona, I had created for a long-abandoned experimental prose piece. My avatar had a history: appearing first as graffiti during the Civil Rights movement's Freedom Summer, "Freedom X" was picked up by Miles Davis as the title for a composition on his album On The Corner. I loved the album. That's where I got the name. In L.A., I put it on my car's license plate. This led to an interaction with, as Simmons called them, "the Fuzz." At one point, downtown, I was pulled over by the L.A.P.D. When I asked if I'd done anything wrong, they said "No," but added, with a pregnant pause, "We know..... about you." The cops looked at each other, weighing their words' probable effect on me. I sat politely, silent. As things grew tenser, I asked, warmly, what the problem might be. "Your car was spotted driving around downtown late at night recently, pretty fast. Your license plate is, well, pretty......memorable." They asked me where the "Freedom X" on the plate came from and I told them—the Civil Rights struggle—adding, accurately, "I've been out of town, so I am surprised, officers. But thank you very much. I'll look into it." I pondered if my mechanic had gone on a spree. I'd been East for a long break, and stored my car with him. But that of course was not at all the issue. The L.A.P.D. officers added ambiguously, "Well, we thought you should.......know." The cops got into their car, and in my rear-view mirror, I could see they were laughing.

Simmons was a fan of my Coagula column and its vociferous arguments, and would greet me with a perennial and rousing shout: "It's......F-R-E-E-D-O-M X-X!!!!" He was the only one I knew who expressed real appreciation for my concept, and this cheered me up. Others thought it was amusing, as the police had. So I decided to bring my avatar fully into public, using it to begin a 1997 event I organized at Beyond Baroque to honor July 4th and the Declaration of Independence. I'd assembled people from different parts of the city, racially and culturally, from poetry, politics, music, art, and law, to reflect on and respond to the meaning of the day and the increasingly confusing political situation under President Bill Clinton. Simmons, who was at the event, kindly asked me to write for his magazine collective, the

Saturday Afternoon Journal, for its next issue on *"flashback."* I offered him the following text, seeing it as akin to flashbacks experienced, in trauma and loss, by returning war vets. The effort was to summon, in an incantatory, public, and experimental way, a new type of agent or actor, not quite a super-hero, but similar. The piece had refrains, one of them from Frederick Douglass in the prior text, paraphrased from a talk in 1852, the day after July 4th, the same talk that supplies one of the opening quotes for my first intervention in the book.

My aim was unquestionably intervention, but of a new kind. Freedom X was a debt repaid to William Burroughs' work on the *"word and image virus."* It seemed to me, as Burroughs had done, that things might be turned around by a fiction—my avatar—but that, as a fiction, it could engage wider fictions—fiction battling fiction on its own turf, as it were, to ground a different kind of political imagination. The idea was, as Burroughs described the cut-up he pioneered with Brion Gysin, to *"let the future in."*

July 4

I am a public space virus.

I am Freedom X.

I am a persona. I am someone who. I am someone that. I make mistakes. I ask you in. I ask you stay. You are different from me you allow me to be who I am. Without you I cannot be. Without me you cannot be.

That is independence.

That is public space.

That is what this day is about. To mark a day and say no further!!

The flag is a symbol not of state or states not of genocide slavery murder but of people assembling to create their own government. July 4th a text a principle to protect all deeds and speech to protect each other support respect learn deal enact

The people's freedom.

Our flag is stolen bloodied every day we do not come together to protect each other we burn in slavery.

I say, this far and no further!!

Whose independence is it?

I am Freedom X. I am born of people who loved liberty those who did not. I am born of those who made body mind a mix who stood up and fought for freedom those who did not.

I am a half-breed mixed and mongrel.

I am a virus in dead spaces standing here.

I differentiate. I say nothing. I say something. I do and do not. I can and cannot. Those who brand me brand you. I am neither right nor left straight nor queer a person who has color because history I am not ice I am fire a flame that burns never consumes a flame burning to be free.

This is the fire we share.

Whose independence is it?

Our names are ruined we see them hear them do not know them.

To escape the darkness where word means its opposite darkness we do not understand.

I am born of mud and air of people who mixed with doctors freedom fighters slaves natives the unschooled schooled those who did not know who they were I stand behind those who did know who they were who nonetheless stood free.

I am born of this contest I am the parties in it yes.

Slavery those who take independence take freedom leaving no choice giving everything away force the end of those burning to be free.

I choose liberty or death, not both.

Death is a closed door.

I choose liberty.

History says some have more. Today says so. No one can have freedom if freedom is divided it is immeasur-

able it cannot be calculated freedom is indivisible yes!

So long as one person is not free freedom is divided ceases to be freedom.

But we are blind and slaves.

I break this forge a *new* path. I break links to the plantation return to a different line I will have none of this monstrous form born of parties.

We cannot stand clear we must.

I stand at Lexington I stand at Harper's Ferry I stand on Little Round Top I stand at the front of the bus I stand wherever I can.

Whose independence is it?

There is history.

There is Malcolm Little. Separated out from a family name that mixed up history marked him by a name drove him deep! Touched the depths began a journey our journey from prison our prison each morning for others affirming difference self-government of the people our self-government yes.

This X was a great transition! X, the mark of slaves lineage stolen literacy stolen lives stolen future stolen.

So Little to live Great in glory only an American could go from Little to Detroit Red to X to El Maliq Shabazz to light the world dignity majesty never give up educate be strong stand get up demand.

I join you to make an X that is a principle.

Whose independence is it?

I give birth to this my name is foundation shattered reassembled in mourning yes.

My name this name scrawled on walls during Freedom Summer to New York title of a song on a platter from Miles take this cosmic music I am sound I am space.

Freedom X word image ephemeral and floating answer a legacy stolen to take an X see it hear it say

Freedom is riven its people robbed its name is now X too.

To become an X to acknowledge this part of all races born of and mixed with the master and slave manager and managed back to New England my father the South my mother to principles places willing to go to where all went wrong face it deal with it memory is real.

I am parties in the contest I am sorrow I am sin.

I am a persona cast in transition.

Freedom X a mark not a person a counter-measure a persona.

Freedom X to New England to town meetings there I'm home.

Freedom X to Virginia my mother's birthplace Richmond in flames the Confederacy rocked and falling back further to South Carolina beginning of this damned thing this sin this horror yes I'm going there I am taking you come with me deal.

To stand up we are in chains this is the price it circles back cast them off it was not all of us but we are still

Responsible.

Give birth to a new name start over remake this day a new day a new compact.

I will be neither slave nor master will not rely upon name of blood possession all that is made and not free.

I think imagine find reap the fruits am capacious take a new name declare

I am Freedom X.

Whose independence is it?

I am someone who. I am someone that. I make mistakes. I ask you in. I ask you stay. You are different from me you allow me to be who I am. Without you I cannot be without me you cannot be. That is independence. That is what this day these words that are a trace a residue a new beginning are.

To mark a day and say no further!!

For those who hate this day this sign of slavery and murder I am sorry it must be remade a day of assembly

declaration let's talk.

 Okay?
 This day of beginnings a day to ask
 Whose independence is it?
 Question is a party I can join.
 A party for the republic for freedom.
 The *only* party I will join.
 A party of one.

8.

*In 1996, after I'd taken on the directorship of Beyond Baroque,
Jon Shaughnessy, the only other active N.C.M. member remaining, had said to me, concerning our cause, "You know, Fred, this
will take a hundred years." I agreed in no uncertain terms. That's
sure how it looked. But if there is one thing that can be learned, it
is that events do not follow the shape of the past, and to think so
harms every capacity for the political. For something utterly improbable happened. It happened because, in 1997, massive parts
of the City of Los Angeles—the San Fernando Valley, San Pedro,
and Hollywood—threw in the towel, as it were, and began threatening to secede. The City establishment, which had resisted the
people for a century, faced a sudden loss of revenue, prestige, and
national power. A crisis had arrived for the political and economic
center caste. Presto! "Charter Reform" appeared on every official
and center member's tongue. And there, miraculously—one cannot emphasize this enough—right at the center of the debate, and
official proposals, were our "neighborhood councils." To my astonishment, neighborhood councils became the solution to defuse
a potentially serious problem for politicians' unrivaled power.
What our "movement" had been calling for, to no effect since
1993, and was being pushed, equally futilely, from the inside, by
City Councilman Joel Wachs and aide Greg Nelson, went from
being impossible by every measure—one hundred years seemed
a conservative estimate—to the only way to halt break-up of the
second biggest city in the United States. Our hypothetical call,
heard by so few, had been transformed, overnight, into potential
reality. Here, the lesson of the unexpected, and being prepared
for it with a principle even when nothing whatsoever confirms
it, cannot be exaggerated. Events had moved in our favor, if we
could grab the moment for something no one in the system, I
was certain, really wanted. In other words, the call for councils
by the system did not mean the kind of councils we were calling
for were what was meant, or that our invisible position in the
city had changed in the slightest. We had been nobody, and we*

were still nobody. But it was also true, in its way, that nothing, nobody, and nowhere had now turned, however briefly, to being something, somebody, and somewhere.

To answer the secessionists and create the perception of reform being pursued, two "commissions" were created by the center: one appointed, the other "elected." Who chose their members was never clear. The commissions were tasked with coming up with, and evaluating proposals, language, and law for a new City Charter. The whole thing had a strange aroma. Nothing had come from the public. Though neighborhood councils, thanks a little to our efforts and the work of Nelson, Wachs, and others, were now "on the table," this masked serious, unaddressed problems. There was no debate among the people, and whatever made it into the public eye was thoroughly controlled. What was the insiders' agenda? What was going on? If the people as a whole were hardly calling for councils, where was it coming from?

I felt a sense of vertigo, for while we now had a slight chance for the first time, I did not trust it. Lending further unreality to the moment, N.C.M. was now only two people, Jon Shaughnessy and myself. Neither of us knew what to do except keep meeting, and sending out—more and more infrequently, and more and more absurdly—our newsletter calling ourselves a "movement." The other two members of N.C.M., no longer doing anything, were willing to sign off on whatever we crafted, if we could even find them. The entire enterprise had finally taken on a completely hypothetical air. It didn't matter. The City, now, after five years, was beginning to move, and faster than Jon or I, or anyone else in fact, ever expected. This was, of course, a quiet and imperceptible warning. It was too fast. But there we were. The unexpected had, as Arendt continually predicted, arrived. Jon and I were two Sancho Panzas carrying on the fight when Quixote had vanished, but our windmills had turned from fictional dragons into real tigers.

The initial version of this intervention was written for the October 1998 N.C.M. newsletter, which would, it turned out, be our last. My angry, skeptical tone was akin to that of a mouse

outside the Castle walls, desperately, if squeakily, calling out to the people beyond the Castle to enter the hall where a group of insiders, only slightly larger than our group, were going to decide the fate of the second biggest city in the United States. If the effort had even a trace of reality, I felt, pushing hard on principle at this point was crucial. I do not know if anyone ever read this short text, as there was, as usual, not a single response. The only sign of life or recognition whatsoever was Greg Nelson's friendly smile at gatherings, rooting with us for the improbable.

Notes on First Principle #4: A Plea To The People

Insiders have designed Charter Reform to shut the body politic out. Why? Who chose these people? Is this new ritual to repair the *fiction* of representation, the *fiction* of the people, to merely bring the establishment machines closer to the people to more safely disenfranchise them?

City government and its bureaucracies are responding to discontent and the threat of secession and break-up by ignoring, once again, the people. Discouragement and silence are crucial. There is no better means to discourage the people than a city lacking *civitas*, lacking *care*. Politicians show they don't care, over and over, and most crucially of all, especially when they pretend to care. We know this well. It is contempt—for history, for civic tradition, and most of all, for the people.

Secrecy, exclusivity, invisibility, and pretense are the principles of so-called "public" life in Los Angeles. The signal "charter reform" sends is very familiar: the people do not matter, they deserve crumbs, they need to be steered by that old trick, *commissions*. We need *two* commissions in fact. *To finish off reform!* And so officials of every stripe line up to steer the process again from the people. Why? Because defeat of the people is the signal that must be sent, from backroom to backroom, in a drumbeat turning steadily into a symphony.

We say those who have "power," or seek it, do *not* want Los Angeles to develop a public, civic, neighborhood life. They do not want neighborhood councils. This might seem strange, given they're now *calling* for them. But this is the dilemma we face. Media, economics, party, and bureaucracy only rebuild the walls to keep the people out. The ham-fisted and oppressive thing we call government in Los Angeles has never been politics. It is private. It is hidden. It is a farce.

So we ask: how could the City Council and City bosses be doing something that is not real politics? Because politics, were it to exist, would be the life of the people. It is not the life of activists, so-called representatives, commission members, or the Chamber of Commerce. At its best, that is *service*. Real politics is the space where place, neighborhood, and power come together and are secured. Real politics is the antithesis of bureaucracy and office. Politics only arises when it holds these *accountable*. That is not what "commissions" do. Commissions are there to bury and kill us.

What the "political" establishment, the City Council, the commissions, the mayor and so on do not grasp is that the people aren't interested in taking power from them—*we never gave it to them in the first place*! That is why politics in Los Angeles is a fiction. The people don't hand over power. If there are elections, our power is only exercised, and barely then. The people know it is contempt that is destroying plurality, enterprise, wealth, neighborhoods, and the city's viability. This is the heart of rule here, and has been since the city began. No coalition of insiders can change this, or *would*. No. Commissions are a way to build a coalition against us. Only the people can establish government and its policies. Anything else is *non-representation*.

We know neighborhood councils and public life are a threat to control by officials, parties, bureaucrats, activists, and media. We know that. For the people to get even a little of the power that is theirs would only *encourage* the

people, and this cannot be permitted. That would encourage *real* politics. But it is the people, fortunately, who have every place's interests at heart. Managers and intellectuals try to convince us this is not so, indeed was never so. They try to convince us that we, the people, cannot take care of our own city. That is why, if charter reform is to mean anything, it must re-establish the people where they live, in a public, political space. And the people retain the right to dissolve anything that blocks this.

Only a charter able to protect the people stands a remote chance of passing. Government's legitimacy rests in the public's space—not a space for the few, for managers, not even for the many, and definitely not only for our so-called "representatives." There is no representation without the life of people present and governing. We may have representation, but we are not permitted to exist as *the people*. That is why debate is absent. The people want their right to govern acknowledged and secured. They want the space for it to unfold. Then a real debate could begin. Where is that debate? Where are the people? Los Angeles now faces a watershed. Will the people receive the honor they are due, or be silenced yet again, by another trick?

The wolf's dictionary has been repudiated.

> *Abraham Lincoln, Address at the Sanitary*
> *Fair, Baltimore, Maryland, April 18, 1864*

What predicament? Who are "we"?
Any appropriate shore bird can say,
"Hu-ar-wee-Hu-ar-wee."

> *Jimmie Durham, "The Voyage, Or, Poetry*
> *Has Probably Lost its Past Power," Poems That*
> *Do Not Go Together, 2013*

9.

The Moment Arrives

The exercise in "charter reform" seemed more and more the center caste spinning in space. The Appointed Commission was quickly discredited for its blatant non-reform proposals and was dissolved as mysteriously as it had been set up. The process then moved to the "Elected" Commission, filled with academics and lower-level politicos, with a shy constitutional scholar, Erwin Chemerinsky, as its chair. By all visible measures, the "elected" commission was far more progressive and sympathetic to the people than the commission that had been mysteriously dissolved. But at a pivotal meeting, held at the Department of Water and Power, the Elected Commission was to vote on a question we all thought had been resolved: whether to give councils real power and make them a policy-establishing part of the city, an idea that had now suddenly gained momentum out of nowhere, or to make them advisory only, as they were in Portland, Oregon and Minneapolis / St. Paul, and as we and Greg Nelson had proposed them, fully taking into account "political realities."

The proposal for councils with political power, at first sight, was vastly more attractive. Neighborhood councils making city policy would certainly have far more power than those merely "giving advice." And power was, in every respect, what I'd been agitating for, in my small way, for the people, for years. It seemed a huge step. But it had not been put forward by the people, who remained completely uninvolved, if not precisely uninterested. This was a center-established group that was, on the spot, now considering a very attractive proposal.

Things become more grounded in political reality if one walks principle backwards. If neighborhood councils were to fully govern policy, and so have real power, the existing City Council would become irrelevant. Because of law, any proposed referendum for the city had to go before the City Council before going on the ballot. And proposing policy power, real power, for neighborhood

councils would pose a direct, implacable threat to the existence and power of Los Angeles City Council, one of the most "powerful" city bodies in the country, and in whose hands the shape and fate of the reform proposal rested.

Because of experience meeting with insiders and groups through N.C.M., I'd learned to watch carefully. Particularly a fellow from the City employee unions who'd taken on for himself the role of covering "Charter Reform" through a city-wide newsletter. This man identified himself as "progressive," and worked with the unions. But he had proven cagey on crucial matters, at crucial moments. I remembered vaguely at one point, at a lunch at a downtown diner, that he'd openly rejected the principle the people and neighborhoods should have power at all. Indeed, he had certainly, in all the times I'd met him, never, ever come out in support of neighborhood councils. I even dimly remembered him saying, at some point, in passing, that the City Council was where power belonged. He was a human calculator and never revealed his hand. This, of course, was a sign. Faint, to be sure, and better to ignore if one prefers happy face reality. Now, he was, at this crucial meeting, on this crucial vote, contrary to everything I had learned to expect from him, not only strongly pushing for councils, but councils with real power. At first I thought, great! But then I started to wonder. I needed to think this through, and fast.

Walking first principle backwards through the confusing reality in front of me, sense built on fact: the existing City Council would never, in a million years, allow elected, powerful, governing neighborhood councils to replace it, as the Elected Commission was now actually considering proposing. This contravened all known facts of politics through the ages. When the union fellow stated he was suddenly now, for the first time, at this crucial vote, in favor of councils with real power, I smelled a rat. The super-attractive proposal was precisely that: super-attractive. How could anyone in their right mind reject it? But it was much, much more than attractive. In fact, if it were put forward, it would provide the City Council with a very good reason to get very involved in rewriting the proposal, handing power back to

the establishment and out of the hands of those who, in calling for secession, threatened the whole game. The push for councils had barely registered; secession was the real threat, for it meant the break-up of the City bureaucracy and its endless, if usually masked, century-long rule over the people of Los Angeles.

To take power out of the hands of the people is the function of what is called "power" in America. And in political discussion and debate, or discourse, contrary to what people think, the point is rarely the merits of any proposal. The point is preserving "power" where it is, and now, I suspected, following tradition, the point was to disappear the new pests and crush reform. For me, and for many others, what mattered was that more power at the neighborhood level get approved and be put into City law, through that old, and trusted, progressive reform of public referendum. If final ballot revisions were put into the hands of the City Council to revise, however, and if neighborhood councils with real power were proposed by the "Elected" Commission, the City Council would step in, stop it, block it, redo it, and so on. Advisory councils were no threat, being "only advisory." That's why we and Greg Nelson had pushed for them. This was, I and Shaughnessy were quite certain, and no doubt Nelson as well, the reason they had been able to get into law in other cities with their own City Councils and their own "political realities."

I quickly deduced that, if all went as had apparently been planned, the Elected Commission would indeed vote to propose, "naively," policy-making, political power for the councils. Victory, everyone would cry. This would then, by the usual means, be caught up in who knows what nest of meetings, debates, and proposals, and would never go into the referendum for the new law, precisely when no one was looking. The City Council would, by any means necessary, behind the scenes, block councils threatening them with irrelevance: delays, further committees, a dozen other solutions would arise. Questions would be raised, officials would deliberate, and a new ballot would come forward from the City Council: to propose a delay in the creation of councils until after the referendum, with their shape to be determined by the

august hands of the City Council. The City Council no doubt would make councils conform to their unbelievably gerrymandered (that is, non-neighborhood-based) Council districts. Self-appointed neighborhood leaders we knew so well would back this, or something like it, because they already had an "in" with the establishment. Perhaps some neutered variant would even be put into the referendum itself. The original proposed Charter's architects, we, and Nelson would complain loudly, but to no avail, because "power" would have shifted back decisively to the City Council. The proposed independence of the neighborhoods from the City establishment, to have the councils actually based in real neighborhoods, would evaporate.

This was the central, hidden goal, I was sure, of this elaborate theater play. The ensuing mess would hide the crucial maneuver—an independent say, grounded in neighborhoods, not City Council districts, would be blocked. NO one would be able to figure out how this went down except those on the inside used to, and expert at, this old game. This is what the Elected Commission was going to achieve by proposing the very thing the City Council would never, ever permit. I knew if councils did not get into the new charter and law, now, that is, legally establishing and protecting them as the proposal held, conforming to real neighborhoods, the neighborhoods, and the call for localized government, would be lost, for a long time. Councils with real power stood no chance. New types of councils would magically emerge as arms of the City Council machines, as sub-machines, appointed or in some other way. It would be a very, very subtle revision of the simulation that had ruled Los Angeles from its beginning, and most importantly, it would get rid of the secessionists, and could be called "reform." Secession would be halted, the crisis for the establishment ended, and guess what? Like magic, the City establishment and existing system would come out the winner, with a very nice and happy new face.

The time was now. The problem was, I had to reject all my own arguments for real power to see this. I had to step back, and keep my eye on shifting power back to the people, in fact and

reality, by following first principle. Councils had to come in a form acceptable to the "power" structure, after which, neighborhoods, accustomed to a little power, would surely seek more. In time, I was fairly sure, advisory councils free of the city council would become even more local and powerful. Of course all this might have been wrong. Perhaps the City Council would approve its self-dissolution. I doubted it. No. The proposed law had to protect the neighborhoods from the power structure that had ill-served them, and neutralized them, for a century. Then we, the people, could re-evaluate, not politicians, bosses, and business leaders promising the moon and screwing us in the dark, ingeniously, for their own ends, yet again.

The first clue my thinking was correct was the location of the vote: the Department of Water and Power. For decades this was regarded—and shown brilliantly by the "fiction" film Chinatown, by Roman Polanski and screenwriter Robert Towne—as the Satanic body secretly ruling the city. Symbols matter, if not in the way we think. Clue two: the room at Water and Power was filled with insiders, few if any members of the public, and certainly no, or any that I could see, members of the neighborhood groups I had met. It was a sea of suits. There was not a casually dressed person, pocket protector, or issue-button anywhere to be seen. How, for the most important decision concerning the second largest city in the United States, could this be?

I was, by this crucial meeting, the only member of N.C.M. there. N.C.M. had shrunk to Shaughnessy and myself, and Jon said he was busy and could not come. He did, it must be said, call me about the meeting, and for this I am grateful. I wonder to this day why he even told me. I nearly didn't go. I really nearly didn't go.

The meeting droned on until the crucial and climactic vote on advisory vs. political power loomed. By then the momentum on the Commission was indeed for the stronger, far more attractive option of power to the councils, judging by nearly all Commissioners' comments. They were poised to unanimously approve, and move forward, a fabulous recommendation everyone

would celebrate and that would die a torturous, utterly confusing death. I figured just enough members of the "Elected" Commission had been placed there precisely to play this game that has gone on through nearly all recorded history. For commissions, like the political system itself, are, like so much else, about manufacturing reality under the guise of mollification, repairing a breach, and so forth. They seem to be on the side of the people when they are decisively not, and are crafted because some scandal or horror has finally appeared. Being politicians and academics eager to rise, commissioners would be swayed by whoever had the loudest voice, and the center establishment always has the loudest voice.

The most puzzling fact was also a real clue. Not a single, living person, during endless discussion in that room, brought up the single most important and glaring truth: that full, political councils would be rejected outright by the City Council in the ballot review stage, and that to propose this would hand power back to the City Council. Not a single soul on the so-called "elected" body brought this up. This, to me, was my evidence. The most obvious and important thing wasn't even mentioned for this proposal that now, out of nowhere, had unstoppable momentum. In all of human history, there have been few, usually only extraordinary characters, who have given up power on their own and handed it over to the people. The City Council was no body of saints, and the establishment was there in force to make sure that remained the case.

The final clue was my union fellow, so opposed to power to the people, now suddenly sharing the majority of the Commission's noble view of power to the people. It was a sham. Proposing policy and governing power for the councils was a trick from the inside to kill councils as we had envisioned them and as those pushing for them had proposed them. A clever trap had been prepared and was about to spring. We were going to lose independent and neighborhood-based councils, but no one looking back would ever be able to figure out how it had been done.

The chair asked if there were any final comments. A couple continued pondering the wonderful, newly possible idea

of policy-making power to the councils. The chair began preparing the vote. Desperate to stop this—contradicting my arguing only if you accept politics is right side up in America—I began running back and forth across the rear of the room, out of sight of the Commission and hidden by the sea of suits, working in every pause to simulate outraged members of the public. Shouting in a variety of voices, pitches, and volumes, doing my best to convey a people, I moved back and forth, from one side of the rear to the other, dodging the suits facing forward. It was absurd. "No!" I screamed from one side. "Not a chance," I said in a neutral, academic voice from the other side. Then from the middle, yelling, then bounding back, in a quiet voice "A terrible idea." I even shouted out, crouching very low, a truly nasty epithet at the poor, gentle, scholarly chair of the Commission, Mr. Chemerinsky, who, being soft-spoken and shy, was put quite off-stride. But the mass of insiders between me and the Commission blocked the Commission's view of the "public" I was working so hard to produce all by my lonesome.

At the precise moment the vote was being put forward, I was still running across the back of the room. The City employee union fellow appeared out of nowhere and stretched out his leg to trip me. I jumped over it. PROOF!! Filled with a burst of renewed confidence in my principle, however battered, I shouted, with every last ounce of energy I could possibly muster: "THIS ISN'T A PUBLIC PROCESS, THIS IS RAILROADING!!!!"

I stopped. I could not believe what I'd just said. I had said giving real power to the neighborhoods, at last, was railroading. Of course, I suspected, the proposal was a fraud. But to hear this coming from "the public" was the last thing the insider crowd, and the Commission, expected and had worked so carefully to prevent. I am hardly a good actor, perhaps not even a mediocre one. But the full Commission, unable to see the reality of the commotion at the back of the room—precisely because of the army of suits blocking their view—assumed there really was a public firmly and angrily against giving councils power. It was ridiculous. Why would the people not want more power?

The Commission, up at the front of the room, stopped and debated, in a state of embarrassed and growing confusion, responding in puzzlement to what one member, actually a conservative, called the "anger and outrage at the back of the room." "YOU BETCHA!!!" I screamed, at full volume, putting a tidy bow on my package.

The Commission then did what I never expected. Taking their vote, they approved LESS power for the neighborhood councils.

That meant we'd won.

I cannot say for certain this would not have happened without me. Whether I was even right or not I will never know, and history books will likely never tell. But a final clue stood out, in retrospect, in a glaring way. Not one person came up to me afterwards and said, "Whoever you are, you are horrible, you lied and faked this to take away the people's one chance for power, you should be ashamed of yourself. You are a thug." Not a single soul confronted me with this. And certainly not my union opponent who had been "pushing," for the first time ever, at this meeting, for power to the people. He vanished. My hunch is anyone who had seen me in action knew quite well what the game was, and that is precisely why no one said a single word when it was all over. The trick, rather than our councils, died what I would guess was an entirely unexpected death. And here, of course, is where political reality enters in. All the suits and insiders, embodying the sentiment of the establishment, no doubt said to themselves, well, the people got less power, and this is absolutely fine with us. This was precisely what the small body of us pushing for councils hoped would happen with our "advisory only" proposal, one that had now very narrowly avoided a catastrophic, brilliantly devised defeat. I had experienced this Alice-in-Wonderland world where politics in America is completely upside down.

Charter Reform, proposing neighborhood councils with "advisory only" power, separate from Council districts, went forward from the Commission, was passed easily by the City Council, and was approved by the voters with a huge margin in a citywide referendum vote in 1999, putting more grass-roots, neighborhood bodies, separate from Council districts, into City

law. Los Angeles overnight became the largest city in the United States, by a vast margin, to have a neighborhood council system.

The Charter called for around one hundred and ten councils. Each neighborhood had to define itself and the councils had to, and now could, self-select as to their make-up. Our friend Greg Nelson knew neighborhood self-definition and self-selection—each council constituted by each real neighborhood, deciding what and who would be in it, how to conduct things, who could run, the number of members and so on—was the only way to keep the evolution organic, however chaotic, assuring ordinary people would stay involved and that real, not City Council, neighborhoods would define and steer. Each local council, once formed, was protected by law and could not be subordinated to a Council member. How the people built them was up to the people, not the City and its political and economic center. Additionally, the new Charter established a city agency, the Department of Neighborhood Empowerment, to oversee the system's construction, assist with organizational matters, funding, by-laws formation, and so on. It would be headed by Greg Nelson. This would be supervised by a Board of Neighborhood Commissioners, or B.O.N.C., an acronym appropriately invoking, from old cartoon balloons, the sound of one cartoon character banging the other over the head.

The councils as voted into law were in no way the town meeting form I had argued for since I began writing and agitating in 1992. Effectively quasi-public, they would be non-profit corporations with neighborhood-elected "board" members. This did not open up a true, public space for government where every person had their fair weight in power and governing. But it made representation and participation more local, and though "advisory," as I and others anticipated, the advisory councils' decisions would be hard for City Council members, officials, and business types to ignore. Power would begin to shift onto its proper foundation. The councils and their federation would grow in power. It was enough the councils could not become City Council arms, though each Council member would of course strive to "reform" this. There were many such solid requirements, crafted by Nelson

and others, and finally, perhaps most strikingly of all, by the notorious office of the City Attorney, put on the case after the "Elected" Commission "vote" pushed forward a structure that threatened absolutely no one.

Before the councils, the only local political control possible was to show up every few years and, along with those able to, vote for or against a single representative to the City Council representing two-hundred thousand Angelenos. This "vote," in an unfortunate but well-grooved custom, was always for one of two or three center-selected candidates. The people had been a rubber stamp for each center-chosen representative, governing two-hundred thousand people. This obscenity had been the people's choice. Not any more.

Thomas Jefferson toward the end of his life argued in a series of letters to friends and colleagues that the base principle was for no hundred people to be without a political representative, and that the larger order needed to build upwards, or downwards, depending on one's view, from this. This was a very solid proposal of Jefferson's, and wise. What we got in Los Angeles was hardly this, but it was getting there. The neighborhood council base was set around thirty thousand residents, a completely different situation by all measures; each "board" could have a dozen or more neighborhood members, to represent a neighborhood of thirty thousand people. At even twelve representatives, that would be a representative for every 2,500 people in Los Angeles, dramatically down from two-hundred thousand.

All told, my constant writing, testing, and, at the end, action had taught me something. I had begun to understand system politics in reality, and while this would have been impossible without study of party-political history—and for sure if my soul was no longer clean—I'd stayed outside, to witness, experience, and act, driven solely by an inchoate sense embodied in a first principle. It was here, in this vote, that I saw, in no uncertain terms, the power of such a thing to steer one through sophisticated lies and truly ingenious trickery. My study with Shapiro and on my own had born fruit, even if my mentor in real politi-

cal history thought my efforts were a waste. First principle, as I had argued, barely believing it, in 1992, had indeed enabled me to see and hear through the politicians' clever fog, precisely when everything pointed the wrong way and the crucial moment unexpectedly arrived. And most of all, when a very attractive idea came forward to bewitch and ensnare everyone, even me. Following principle meant paying attention, and pushing, but more importantly, being able to follow, uncluttered by any idea, a real event, and succession of them, unfolding in real time and space. The point was getting more self-governing down to the silenced and crushed people, not to carry in my satchel, years after, a much better idea so nobly defeated and twisted, as ideas are and always will be, by that mysterious and devious dissolution of our senses called "political reality" in America.

Principle may, it is true, have blinded me, as the council network may be neutered or, in time, like so much, become a farce. But law guaranteed it was no farce at the founding. While the public may not have gotten the school of public life they were entitled to, and that I had long pushed for, the city unquestionably had something much closer. And this was the best chance I knew of for birthing its actuality. I, meanwhile, had done my share in a very big city, one of the most ingeniously hostile to real, actual public life in the U.S.A.

The "movement," by the end, at the crucial meeting, had dwindled to one person—me. That it was ever a movement was not precisely a lie, for there were a good number that shared its sense by the end, even if they had no space to appear. Telling the truth, as most of the time in real, and very dirty, politics—in this case concerning the paltry size of our "movement"—would have done little good. Only principle could guide. It held fast and illuminated in the darkest, most demoralizing moments of a steep uphill fight, precisely when it counted. What the people could and should have was the compass star, and where reality and idea came up short, principle stood upright. The structure would now be there for the people to shape a bit, whatever that was, and that, more than anything, was the beginning of a little more power

and memory in a realm where neither had a chance. There would be different voices, and different bodies, and they would disagree on some things and agree on others. But they would be heard, even if it was only in fixing potholes. For the first time in my experience, apple pie won.

For the councils, progress was instant and messy. A huge number sprang up instantly, while for a number of communities, the process was contested, difficult, and drawn out. Minority and poor communities had been incapacitated for decades, and were highly skeptical. Some of them, with councils built before the new Charter, had been created as Council sub-machines, rendered, to use that Sartrean term, "inert." But the process of neighborhood self-formation as a new political fact was under way, was enshrined in law, and would, in the years ahead, resonate, deepen, and spread.

In 2002, three years after neighborhood councils were placed into City law, Jon Shaughnessy approached me to revive the N.C.M. newsletter and begin pushing again. It was clear that, while councils had taken root, City politicians, the new Latino mayor—a former progressive, and hardly that now—members of the Chamber of Commerce, and police, were set, usually through some tiny proposed change, on slowing the councils and neutralizing them however they could. The new Charter made this difficult, as those of us fighting for it knew it would. But devices can be found by professionals working 24/7, while the people foolishly catch up on their sleep. Things like funding procedures and California "Brown Act" stipulations—in particular against conflicts of interest, demanding reporting requirements for candidates—were discouraging ordinary people from running. While the Brown Act, a solid progressive reform, was created to expose candidates backed only by private interests—developers and Chamber of Commerce types especially—the law had been turned to Swiss cheese in the state capital, Sacramento, by center politicians. That they turned around now to use it as a weapon to block and confuse the councils was beyond outrageous. In addition, councils were of irregular size and even legitimacy. Factions were jockeying for control, and procedures and processes were, as will happen in anything so new, hardly worked out. To our lights, this meant the councils as an evolving, freer space faced a danger. To my now better-tuned ear, there was a strange demand percolating around the city: that different points of view on councils were undesirable, and what was needed was "unity."

My proposed text, written in August 2002, in response to Shaughnessy's claimed intent to restart our newsletter and "movement," sought to address this and push back against the politicians. Shaughnessy's call, however, was part of a larger agenda he never disclosed. Through a series of accommodations and attached matters, I felt myself, strangely, and in what direction I could never tell, being strong-armed. Perhaps Jon had

second thoughts about the return of my vociferousness. Or per-
haps he had some other purpose in mind. I will never know. The
newsletter, my text, and a revived N.C.M. never happened, and
Jon and I, after this unfortunate experience, parted ways, only to
reconnect years later to survey a baby we had helped birth. This
was, in a real sense, the end of N.C.M. But we had helped, finally,
to give the people at least a little room to move under the colossus
called the L.A. City government.

I have included this final council intervention, from lit-
erally the last days of our "movement," as it was an effort to
assess the first steps of a development unprecedented by any mea-
sure for Los Angeles and the U.S.A.

Notes on First Principle #5: Union Not Unity

We are very happy neighborhood councils are now in the
Los Angeles City Charter, knowing this will protect them a
bit from politicians' efforts to cripple, end, or control them.
Politicians do seem to embody what one might call—as a
shortcut—*corruption*. They are skilled at building a veil to
hide their scheming against the people. That the citizenry
continues to support this—that is, to fund it, work in cam-
paigns for it, and accept it—is extraordinary enough. Given
how things are organized, though, it is understandable. But
a question remains:

How is it politicians are so incredibly good at un-
doing the people?

It is a mistake to say corporations or business are
the ones behind this. The politicians and parties take the
money, and while they nearly always do what corporations
and business want, this suits *their* purposes. Politicians
aren't interested in money, they are interested in *power*.
They take the money to make sure the people never get a
leg up. If the people said no, the whole rotten edifice would
topple in an instant. That such a system does *not* topple,

and that mendacity does *not* appear, remain a sign of the politicians' wiliness, but also how many elements help them to disguise the rotten truth. The people's demands are, the center always says, born of ignorance, lack of expertise, in need of correction, in need of better rules and procedures. But if you dig deep, which is hard with politicians, you will find they, as party men and women, do not respect the people, never will, and until a form can be built to counter this, will act from their hatred for us. They hate us because we, the people, are their *rival*.

This is why the people must never get what they say they want and need, and especially not what they *voted for*. When the people are permitted to vote, it is usually only to re-install center factions and their factotums. No, the point is for the people to never get what they voted for or what they want. That's what parties and center factions are for. That's why *they are there*. And that's why we pushed for neighborhood-based councils.

At some point, the new council system will have to address this. For city policy is crafted to protect fake elections, party funding, ballot control, and an endless array of straight jackets for the people. Only a few voters in reality are needed to legitimate this—to vote for those who have no intention of carrying out the people's wishes. But power, contrary to what politicians and experts argue amongst themselves and to us, increases the more people have it. The more power the people have, the more power there is, even for politicians. Who would have guessed.

Here, a more subtle problem arises. It is a fatal mistake to think unity and power are the same. This notion drives society and media. It leads to rigged elections and force. The politicians and society are bent on producing a unity the people do not have, do not want, and would never express in assembly or governing. We say well and good, *that* is reality. Americans are becoming more and more familiar with a society imposed on them. We say well and

good. Let it be known at last that society is the opposite of plurality. We can live with that if we have to, but only if we can govern. It is plurality that constitutes our actuality and power. It teaches. That is what we want: not rigged votes, but plurality and power—not in rallies and protests, which do little and, at their best, are made only of crowds. "The people united can never be defeated." So we hear, anyway: unity is what really matters. This old slogan, revived for the L.A. riots, is fine as a slogan, but it has proven, again and again, to have nothing to do with reality. The people can never be united. Who would unite them? A leader? Stronger parties? The slogan is misleading. If the people are defeated, as they are, it is not because of lack of unity, which cannot be achieved. To *say* this is to be defeated, and very cleverly. The people can be united only in fiction and unreality. The phrase we like is: The *union* of the people can never be defeated. Only when we are a union, which is to say, we are *not* unified, but working together from our differences, can we take back the power that is ours. *The union makes us strong.* This is a good phrase, it's got a good history in Los Angeles and in the U.S.A. Let's revive it.

Locally-rooted councils expanding in every direction and place are how we can build a union for all the people. Yes, the first steps have been small. Bigger steps will follow. The people now have a *better* space to bring officials, parties, and the power-hungry to heel. When you put these spaces together, you have a beginning. That is why we fought for councils to not be subsumed into gerrymandered political districts, but to be devised by *real* neighborhoods. We were adamant. They are not there as machines for the City Council, the mayor, the Chamber of Commerce, the police, or all the big-shots who have dictated for so long behind the curtain. The more broken from, and safe from, the center and *its* needs, the more the people and city stand a real chance.

Contrary to what the center, activists, and political

science say, politics is not participation. One can participate in fraud, in fiction, in deceit, in political gangs, in cliques, in corruption, and worse. One can participate, most importantly of all, in legitimating one's own loss of power. Representation has a similar problem. Representation is not enough by itself. We can be represented by liars and lying images. Only in our plurality, securely protected in law, can we hash things out and protect each other from such fictions. Participation means for us to assemble to conduct, bit by bit, our affairs. Then representation will improve. In time, maybe even the non-profit council boards will evolve into a federation of spaces where reality can be at last addressed. We believe it will come.

We're beginning to hear about "improvements," though. They are emanating like swamp gas from the center. The City wants to put new rules on us. The result is a return of that distinct fever Los Angeles is so good at—*unreality*. The city has created a lot of that over the decades. Because what does the center say? The councils are *service* organizations. We are hearing this a bit too much, really. The people are not a *service* organization! Most of what matters is decided in secret. People are told ahead of time they will not be represented and can do nothing about it. So who serves who? City officials, activists, professionals, Chamber groups, and parties still see the people as servants, as service organizations for *them*, that is, as *inferior*. And so they are working hard to make the brand-new councils into a new rubber stamp. We say no!

We can think of a couple things to address, for starters. If councils were to truly evolve into a space for the people—unlike the Neighborhood Watch groups that are a volunteer arm of the police—they might put pressure on police stations across the city to end intimidation of the poor, non-white, homeless, immigrant, protesting, and non-conforming. What if councils went after, for example, the un-Constitutional "permitting" process for protests, for

example? This is an outrage, an insult, and it is used again and again to show who's boss. The people do not need permission to assemble and seek redress of grievances. But the problem goes deeper. Who, frankly, is watched, and who is watching? Can we even conduct our affairs freely? We doubt it. The machines are watching us, very closely, and we want things the other way round. It is time we began watching them, and closely. That's what the councils are for.

We see the new councils overtaken by secret co-alitions, some, it is true, well-meaning, but that override the range of opinions in a neighborhood. The problem is not merely their decision-making. Our still-developing councils have blocked voices from being recognized and we have heard, and seen, people harassed. Cronies with hidden links to the center pursue a non-public, or at best, pseudo-public agenda. Even "potluck" suppers and infor-mal gatherings can become a way to build secret coalitions outside the public space, on issue after issue. That's why we have ended up with party slates, and factions, arising to rule the councils.

This is why first principle remains our compass. What is the purpose of councils? The purpose is to give voice and power to all the people, not just the few or even the many. The neighborhood councils are not an arena for schemes of politicians and factions, bureaucrats, experts, parties, *or* activists—all those quite sure they "know bet-ter." They don't. Neighborhood councils, to have meaning, must lead, step by step, towards power for *all* the people. As we argued in 1993, at the beginning of a long fight, what matters is *expansion* of self-government. We cannot be still. We cannot be half-free if we want to be free.

It is difficult with the destruction of memory in L.A. to see how much this place resembles a city of the deep South, with more high technology, ethnic diversity, better communication skills, and money. It isn't called the Southland, that old term for the Confederacy, for nothing.

But that is only its social form. The center cannot be contested. Its brutality beats through the happy face again and again. Even with the first, crucial steps achieved, resistance by the center in Los Angeles remains as strong as anywhere on earth. The landscape of the city still defies free assembly and contact between strangers. That is why we need expansion of public space, not in parks, but in politics, in transportation, in civic life. How can we govern if we do not encounter those different from us, who are near as well as far across town, on a regular basis?

N.C.M. worked hard, from 1993 on, to push for councils in law, in the Charter, to build a secure space that could not be taken away. There is work to do to expand that. Before we get to that, though, it's worth looking back. N.C.M. was laughed at by the "realists" in city politics, in the city unions, among existing neighborhood leaders and activists, by academic and technical professionals, and so on. We don't need more democracy, they all said, we can get the deals we want, that is reality. N.C.M. was dismissed by progressives and those on the left calling homeowners right-wing, fearing loss of *their* status and power. We were dismissed by business interests and those on the right calling those supporting the people left-wing, fearing loss of *their* status and power. Nobody who protects the status quo ever wants a space for the people. Why? Because the people are close to reality and know how things are really being run. The center, the right, and the left all see themselves as superior. That's their *function*. But political freedom is a fount of miracles. Events transpired in all our favor. Events will transpire in our favor again.

We believe, as we have from the beginning in 1992 and 1993, that a renaissance of the public, were it to flourish here, would have an impact far beyond Los Angeles. Los Angeles has always been a laboratory for the country, even the world. What we see now, in fits and starts, is the emergence of a realm where people really can appear and care

for their city, one of the biggest in the country. Things can be contested a bit more—not a lot, it is true, but more, and hopefully, over time, a lot more. Communities are coming to life, boulevards are coming to life, neighborhoods are able to care a little more for, and preserve their history, character, stability, and uniqueness. And eventually, neighborhoods will begin to talk to each other. But there is still no space for this. The yearly Congress of Neighborhood Councils is a beginning, but it has a very long way to go. It's basically experts telling us how to do things, and, now, that we are only service organizations, and that they, the experts, will help us. Clever. *Service organizations*! No doubt there will be a big battle there.

But let's appreciate what we achieved. Neighborhoods have begun to throw off that toxic mist, that swamp gas hanging over us all. We are on the lookout for this gas rising again. And there it is! We do not serve the politicians or the commercial order, we are not mere consumers and job-holders, we are *not* service organizations! We are not tricked by the center, the media, or the professional caste. We are residents and citizens of a city with the right to self-government and power. Our differences are the beginning. Education in public life means protecting those differences, to learn about *actuality*. The society serves us! Plurality is the only way to learn this, and union is the only way to protect it. Power, to be power, must be visible. It cannot come from lobbying and organizing in the dark by those seeking "unity," trying hard to impose rule through some image and information of who we are, telling us fairytales. Poisonously telling us unity is the issue so that, when there is no unity, professional politicos can say, at last, "See, the councils are failing because they cannot show unity!"

We believe those who call for unity secretly want to be, and become, the center, to *rule*. That's why center and activists call for unity. What's wrong with us, we just can't seem to get unified. *What's wrong with us?* But parties

and factions are the ones striving for unity, that's how they keep their rule. They do not expand the people's power, which is plural, or help the people find out reality, which is plural. They produce fiction to every horizon. How wise the opponents of party- and faction-rule over the last four centuries in this country have been! Parties and factions are inherently the rival of the people. Unity is a trick used again and again to discourage and arrest our union, the people's union in all its differences, to keep us in unreality. Only union can negotiate shared interest and understanding. That's what we seek. *That* is what we are fighting for. *That* is power.

The councils are here to challenge. They will build the union of the people, not unity, and certainly not parties. And we are here to defend them. The public space is our only protection, our only security, our only hope. That is why we say, now, ready to serve: *In our plurality is our power, in our power is our plurality!*

My friend and teacher, the political historian H.R. Shapiro, had slowly cut himself off, pre-occupied with ever more telegraphed, furious email barrages to faculty lists across the country and world, delivered in a fusillade basically from the moon. Growing weaker and more defiant, Shapiro was, on one wheelchair excursion, on an Ocean Park Boulevard hill near his Santa Monica home, struck by a speeding van that then fled. After receiving poor Veteran Service care, Shapiro, rallying, tried to fight Santa Monica in court and lost. I continued visiting and reading with him, but his wife had walked out and a son by his first wife was back East. I tried to offer news of the councils' success, for the principal of councils was Shapiro's abiding passion. But he was determined to wrestle the tiger alone, in the only realm he had left, this argot of private text I kept receiving, addressed to "Professor Dewey." I finally received a call from his wife, with no number to call back, and no details. On October 22, 2002, some time after my prior piece was penned, and not having seen Shapiro in months, the "unrelieved" devoured one of the democratic republic's most tenacious, if fully underground and unheard, chroniclers.

To most, Shapiro seemed crazy, his work incomprehensible. For me, it was the mind of America that no longer worked properly. What can one say, then, about this final turn of events for such an unrelenting fighter for the Republic? That it was inevitable, given a flawed life? This is the increasingly short-sighted and cruel calculation now called reasoning in America. For horror, suffering, and lies, as survivors will say if they are still able to speak, render everyone blind, numb, confused, and alone. This is the prison America has devised for those who dare to probe beneath the fictions, and in particular, to remember the Republic, in public. Shapiro had been abandoned by his own language, retreating into the four walls of a cave. One could say that Plato, and organized fiction, had claimed one of their most formidable opponents.

Unable to deal with this, and dragged in its wake, I

threw myself into Venice, my work community, to regain my footing. Poetry offered solace, but I wanted to see, as a stakeholder through Beyond Baroque, how the now Charter-protected council was doing. I had hosted its pre-Charter forms at the center, but these were creations of the City Council member, were bitter and acrimonious, and did not last. Now, broken by law from those chains, Venice had a new problem, and one Shapiro had taught me to look for. At a meeting in a neighborhood church in the early 2000s, with about seventy people in the room, I encountered what had appeared, in full view, on the national level, but that I had never experienced face-to-face. This was the rigging of a vote by a faction in control. When some issue, I do not remember which, came up for a vote, the newly dominant bloc, in an old children's school device, lined people up at the front of the room to be counted. They then, however, over-counted the side supporting their proposal and under-counted the opponents by at least a dozen votes, voiding the actual vote, to "win." This demonstrated that great modern axiom of ruling: "It's not the votes that count, but the one who counts the votes." Something more amazing, however, lacked any axiom. No one dared to speak up against this obvious falsehood. No one in the room dared address, on principle, what was right before them. This is something never addressed in political science: how unfamiliar people are with speaking up when someone, or something, with "power," tells them what is not at all so, when they can very well tell, but dare not.

So I stood up. I went to the mike and expressed my objection, pointing out the blatant vote-rigging, and, over a growing din of attacks, and finally needing to shout, asked those packing the room behind me to make the count themselves. No one would. I was stunned. Those "representing"—and faking the vote count, so in fact not representing at all—radiated confidence and cheer. The din grew, I refused to give up the mike, as some tried to grab it from me. I demanded, again, that the room behind me make the count themselves. Chaos, boos, and jeers. The vote-riggers refused to yield. No one dared challenge them, or wanted to, in a vote first graders would have done far more honestly.

I expressed, over the din, my rejection of the vote, and that I, as a stakeholder, could not support the council, turned to the back of the church, and headed out. As I reached the back, a beefy, long-time member of the controlling faction, guarding the door, added with a sneer: "Don't let the door hit you on the way out, buddy..."

What comes to mind here is the Richard Pryor "joke." A wife finds her beloved husband in bed with another woman. As the wife stands at the bedroom door, the man firmly declares he's not cheating on her, that what she sees is not real, and adds: "Who are you going to believe?Me....or your lying eyes?" I, like the wife would be in the face of such confident authority, was thrown into confusion. In politics, this is precisely how factions overturn the people, annulling appearance by use of confidence and bald unreality as a weapon. This is how people are convinced to disregard what they actually can quite well see and hear, and that is right in front of them. And so they tell themselves this is okay, because it is how things are always done, because those with "power" define what is real. This is how the theft of reality and power corrupts.

Stepping outside the church, I was in disarray, for I was, in fact, actually uncertain whether I had seen what I'd seen. After a few moments, a long-haired younger man came out, approached me, and thanked me. He confirmed that what I had seen had indeed happened. After some banter, we began laughing, for the whole scene was outrageous. The fellow's name was Dante Cacace. This was his first involvement in politics of any kind, and because he cared for his neighborhood, he had come out. He was now ready to quit. No! He was exactly the sort of person I had dreamed would appear in local councils: an ordinary, honest, non-system person. A brief, productive friendship began that night, one which, a while later—when face-to-face with the same practice from a new vote-rigging bunch, a "progressive" faction who took the council from the first gang—led to our crafting the petition below, against slate, or party-line ballots.

Slate ballots are a standard faction or party device: one can vote only for a list of candidates, they get in, and then rig

things their way. This was how this bunch had taken over, then filled the room with like-minded residents, and how a second group then did the same to them. This tactic has proven the object of revolts, most recently in Madrid in 2013, and in sites all over the world learning the sordid facts of center and party rule over elections, and how it destroys the people's space and reality.

Some time after, Dante and I went out to meet with others from Venice who shared our outrage. On their behalf, we spent time crafting our petition, trying to make it simple and friendly. We did not have to gather a single signature. A body had been thrown into motion in Venice by people confirming each other. The issue crossed all lines. The neighborhood had now encountered two vote-rigging factions in a row, and so our stand against slate, or "party" ballots was taken up by the council and put into rules for the next election. Some version of the Venice body had preceded the Charter in many forms, and had been turbulent for a very long time. Now things became more peaceful. The act of two people coming together, strengthening each other's vantage, meeting with others who confirmed a shared sense and so established reality— spurred at the start only by one person daring to stand up and another saying yes, what you saw did take place—helped set the council on a stable course that holds to this day.

I saw Dante only a couple more times. When I ran into him later, he had transformed. He was developing transparency procedures for the young council, and was fully involved. The council had moved to bigger and bigger rooms. It was succeeding, and I had backed up a new kind of actor in my own community. If another vantage had not weighed in to confirm mine, however, I would have remained alone, he would have quit, and political power, arising between multiple vantages, would never have emerged. Dissenters by themselves are never enough, but if they find confirmation of truth in someone else and are willing to join in action, everything can change. If Dante had not come outside that night to introduce himself, and thank me, the social, and unity, would have won. A single person's passion, indeed action, requires others. The space of appearance rests on this. And action

born of it can answer conditions even when our senses, and the world, are turned upside down by what is called "politics" and "history" in America. This is the petition we wrote, and it never needed to be used:

We are a gathering of Venice stakeholders committed to good faith, reconciliation, and to assuring a fair and transparent neighborhood council where different points of view are safe and single factions and slates cannot dominate.

Dante Cacace Fred Dewey

Your signature here, please:

Date:

This unprofessional, unexpressed question is the one worth answering.

John Berger, "Why We Look At Animals"

12.

By the seven year mark, or mid-point, of my tenure at Beyond Baroque, in 2003, the work of administering and programming the poetry and culture center had taken over my life. The following text began as an effort to answer that, and begin thinking out some of the efforts I'd made culturally. I originally put together very unconnected elements—thoughts on questions of site, on experiences from years before, on the programs I'd developed, and finally on a later text by the writer, artist, and critic John Berger that had inspired me. The first version of my piece juxtaposed the elements, more as a cut-up. The context for the piece, and its opening, was the launch of the second Iraq war, and now occupation, based on forged documents and fiction. Rights were being eviscerated, and old forms that had given voice to criticism and fostering alternatives in the public realm seemed to have given way. Most venues and institutions had offered little real resistance to a strange, ever-shifting system consensus, but instead reinforced it, explicitly not answering, or giving space to, massive public unhappiness. The alternative local press was neutered and the academy seemed lost in theory-land. I was struggling to build a meaningful counter-space in the public realm, and think out what this would be. The culture we had seemed to me to have become deeply problematic, and culture's role needed to be rethought. My first run at this, at that moment, with its four disconnected pieces, was like trying to keep a tiger at bay with only the legs of a stool, but no stool. The old cartoon image of keeping a big cat's jaw open with a stick is just that—a child's entertainment. One is going to get mauled.

The argument I'd made to myself in taking on Beyond Baroque was that the cultural arena, and specifically a public space like Beyond Baroque, could build something new in a locked, total state. This was in debt to Havel's arguments for a "parallel realm" for truth and "living" it. It seemed it might be possible to start something and turn things back to their proper foundation culturally. But how? The real, albeit tiny, change in

- 176 -

the political realm, helping to establish councils in L.A., did not extend to the larger culture, which had not altered in the least. The cultural realm was not interested in serious challenge. While protests were massive before the Iraq invasion, after, there were no cultural shutdowns, no strikes, and shockingly no further protests. Culture and society seemed dead. A silence taking form in the late-1990s under Clinton had become serious. I'd tried to answer this in a local way by curating and hosting events with poets, international journalists, filmmakers, activists, lawyers, artists, musicians, and more, but while these boosted local spirits, they seemed only to reiterate what everyone already felt and knew. There was no wider impact. The many I brought to the center were fantastic. But the "parallel realm" never could get beyond the protective four walls of the center. Frustrated and uncertain, I tried in this piece to write my way out of this, just as I had tried with programming at the center to work a way out. The idea was to build a principle of culture able to address what I called a "crisis in appearance." I believed then, and believe now, that protests and opposition are no answer to a society that kills truth precisely by unresponsiveness to its people as a full, political body. The people can't find themselves in it. Trying to push demands and truth on a locked system is like trying to reach the tiger through its better nature. This is its better nature. It is a tiger.

The piece was my effort to step to the side of that hopeless battle and see what the cultural realm might be able to enact and strengthen. My initial 2003 version was rough. Its opening, with its phrase "a total assault on reality," proved too strong for some friends I submitted the text to for publication, and with the piece disjointed, it was rejected. I went at it again in 2006, going further into my efforts, but once again, the struggles running the center brought writing about the work there to a halt. Six years later, having left Beyond Baroque, my efforts to secure the center's second, 25-year free lease successful, I decided to revisit my non-stool stool. Like some other pieces in this book, this is really only a marker. While it has been reworked significantly, the original form, gesture, and moment, from 2003, animate the piece. A

new way of thinking about culture and its relation to public space is more necessary than ever. As with the cut-up, the idea was that unrelated things put together might allow an unseen possible future to emerge to remedy the irremediable.

A Cultural Response to the Crisis in Appearance

What are artists and writers to do when, all around them, a total assault on reality, and our capacity to learn from and respond to that, is being waged? Can cultural institutions and practices stand up to this and answer? What would they respond to? What would a cultural response to conditions be? Events and structures have left the space of appearance, and the people's capacity for spontaneous response weakened, suggesting our existing models of culture and cultural practice, theory, and critique are utterly inadequate. The senses of the people as a whole are under attack, and new thinking and practice to respond to this are called for. What would a culture be, when society strikes to the very roots, burning them out? What are the roots that are in danger? Something more than discourse, description, and dissemination would seem to be needed.

Culture, when it is firm, can protect the artist and writer's free capacity to speak to all that matters, however they might see it, along with the people's ability to experience this, safe from force, command, open disruption, or dissuasion. Culture's concern with thought-things and imagined-things, with the people who make them and most importantly that they can, demands a space to take care of, preserve, and protect artistic and critical life and its artifacts and contributions. We need refuge for the depths of worldliness, to secure our capacities to answer the world we are in. Under favorable conditions, art and politics, though distinct, would support this. Art, at its best, fills a space, to materialize our full possibility to understand, hold, and re-

flect on our depths, to help them appear and be thought, imagined, and judged. Politics, in its proper form, would protect such a space, so all of us, a people who have the right to conduct and govern all our affairs, could indeed understand and think what is happening. But our concepts and principles of culture seem unable to foster this in any lasting way. It is as if we would have to unlearn everything we have been taught about culture, and start anew, for it to ever regain its crucial potential.

Culture, were it solid, would mediate and arbitrate between art and politics, helping us build up our understanding and protect response. When art and politics are undone, however—and in ways we still barely understand—culture has little to safely mediate and arbitrate. It is overwhelmed, and cannot offer resistance to the ungrounding of our senses and world that is such a signature of our times. Writers, artists, and institutions, if they basically go along with society and try merely to make the best of a deadly situation, end up unable to communicate and protect facts, cannot lend them significance, and cannot establish, no less protect, truths in the public realm. In the end, something occurs that no one considered could ever happen. Culture, or what we are told is culture, is unable to give us what we need to understand and respond, in thinking and imagination, to the world we are in. The life of the people loses its capacity to answer conditions. Culture, concerned only with objects and activities and our relation to them, cannot build this capacity. It becomes a handmaiden of regimes, distracting people from conditions and making the steering of the people from facts its goal. Culture becomes a thing to consume, rather than something that helps us to understand and respond. It has less and less to do with who, what, where, and when we are, and what might bear on and clarify this. It ends up as one of the prime collaborators in regimes, helping enlist the people in, and convince them of, ever-shallower representations. The only choice is to join in on the general assault on reality.

In culture, as everywhere, institutions have their own history and bias in presentation and activity. But whether the institution is established or "alternative," cultural institutions and practices in the U.S.A. have been battered by an accelerating, three-decade assault—first from the right, in defunding and demonizing anything controversial or testing, paving the way for domination of so-called "market" forms and calculations, then from a left that argues, again and again, as if sealing the deal, that economics and the social can protect us. The result is demographic, statistical, economic, and social reductions of every kind. The cultural realm no longer is allowed to mediate and arbitrate but is, as it were, over-ruled. Culture is reduced and neutralized, using terms and descriptions that buttress the attack on our non-conforming senses and capacities. Falsehoods and miseries are no longer answered and almost can no longer even be thought or grasped. Mere production continues to grow and expand, as thinking, imagining, and judging give way under it.

This points to a conjoint cultural and political question. How might the artist and writer be safe enough so they can challenge society, with all its prejudices and reductions, in a far-reaching way? Is this only a matter of free expression, or something deeper and more consequential? How might such challenge be embodied, be given life, remain grounded, and be protected? What would the culture of such a space look like? To think of culture only as objects and the people making and disseminating, and worse, as things, images, and sounds to consume, hides the concerted assault on appearance and reality. Production can grow and expand, but cannot fundamentally challenge. For objects and people to be safe in their full freedom, to answer and respond, demands a culture concerned with something other than mere reproduction and society. Culture is distinct from social activity and reproduction. On a certain level, to have enduring meaning, culture may need

to *resist* the social and reproduction. It may need to openly challenge the automatic character of production, dissemination, and categorization, to resist the reduction of our world to bits and functions. And here, our theories of what culture is are little help. We can only ask questions. Would not a real culture hold out, for all of us, the possibility there is more than what we are handed and make? Would it not need to answer the assault on reality, on appearance, and on the capacity to learn about this? Culture, if it is to mediate between art and politics—if it is to answer and make sense of things and answer our real conditions—must go into the world, help it to appear, and protect appearance as it is, so that response to what is so can be real. Society cannot do this, for it rests precisely on disconnecting us from our reality, on reducing us to social functions and positions. Society, in the end, without a strong challenge from culture, becomes the motor of the assault on reality and our capacity to answer that assault.

II

One of the surprising forms from recent history that, in some respects, poses a frame for this is the 1970s art "movement" of "site" work. Its answer was not at all what we would conventionally call political. Among its better-known American practitioners, Gordon Matta-Clark and Robert Smithson showed one could disclose the limits of our habitual and customary senses, and what society tells us these are and mean, by acting physically into the world, and grounding us in that. Site work, in its early years, took place firmly outside normalized social strictures, rejecting the use of artistic technique, form, and content for any activity concerned with buying, selling, and navigating a commercial art "world." Using physical intervention in the wider architecture and landscape we share—with Matta-Clark, conical sections cut through abandoned buildings,

along with his artist-run support structure and restaurant, FOOD, created with Carol Gooden in Manhattan's Soho, and with Smithson, in countless practices, his best known the Spiral Jetty of boulders built out into the Great Salt Lake—artists began posing an answer and challenge to society's dematerialization of our senses and what one might call the realm of conventional artistic objects and their objectivity. Their works established a practice of creating and intervening whose documentation recorded and disseminated physical interventions, even after the works, and the gatherings that produced and supported them, had passed. While brief reference to these two people and their works remains cursory, the point here is that they revealed, albeit in a brief glimpse, how much the actual world we are in could be sensed and seen in a new and grounded way. Though this world they pointed to was not really political, their actions nonetheless pointed to the actual realm where our senses and our lives happen every day.

In my first years running the literary and cultural institution Beyond Baroque, in Los Angeles, I had not encountered a literary equivalent to this. Words and texts alone seemed somehow unable to restore worldliness and its potentials in this way, digging into things as site artists had, physically and experientially. Since the period after Vietnam, writers in the United States have had a very difficult time imagining a path outside the social, and in particular, actions into the world. Just as it would eventually do to art, the social has tended to swallow up writing and text, turning it into another factor in endless production. This was possible no doubt partly because writing is a more private process, but also because writing, like art, whatever its hopes, depends on dissemination of objects and recognition, and this is usually forced to follow the rules of political economy. Acting into the world, for the writer, seems to have little enduring, material, and physical capacity to restore public space. Underground publishing, chapbooks, and some small

presses have tried to resist a general ungrounding, creating objects in a different way, but they tend to be constrained, again, by society, and the lesser reach of their experimental, small-scale efforts. Why have writers and literary texts had a harder time acting into the world, and leaving a record of that? Books are able to challenge every social process, certainly, but in people's minds, rather than through physical, concrete alterations and interventions in the physical and palpable world. Books last, to be seen and thought and felt, but even in this they are under ever-more concerted assault. One can read texts and words in public, out in the world, in venues and even outdoors, but the work seldom physically "cuts into" the physical sense of the world enduringly, the way boulders in a lake do. They are able to enrich the life of the reader and bring into that a wider world, fully implicating the reader in that. But the written object generally does not, and does not aspire to, intervene in the landscape and architecturally, as American artists acting into a site and place began to in the 1970s. Texts can point to a new form, they can bring people together, they can describe all that matters, they can challenge society fundamentally, but in the object that is a work of art, the writer generally does not physically "cut into" or "cut through" what is so, constituting a challenge that is registered and remembered physically in the world. The only residue of this is sculptures, made by artists, that memorialize those people who have changed every constellation, or that help concretize events and facts, the way Maya Lin's memorial to the American dead in Vietnam continues to do.

One of the influences on non-social, site-based artistic activity, and the general sensibility that Matta-Clark and Smithson began, may well have been an array of Beat writers, reaching out in books and writings from the 1950s, 1960s, and even into the 1970s—writers like Kerouac, Ginsberg, Corso, Burroughs, Perkoff, di Prima, Baraka, and others. In spite of how they have come to be framed, the

Beats—along with those who had been Beats but moved into new terrain—made alienation from society and mass society, and by implication, its political system, central to their positions and work. By means of an increasing focus on lifestyle and demographic concerns, American society has worked hard to neutralize their example—of a fully lived and embodied assertion of unhappiness with, and challenge to, how things are organized at the level of daily life. By the 1970s, cutting-edge writing experiments began focusing on the realm of textual space, academic discourse, and theory, driven by a tacit sense that society was inevitable and was too big a problem. One can find strong, resisting elements in the textual mechanics of writers in particular like Kathy Acker and Burroughs, making clear experiment can be an embodied resistance to every facet of the social. But few text makers have followed their example of overt resistance, and friction. What they critiqued in their practice was a burgeoning tendency: to see new and avant-garde forms of composition, productivity, and social activity as enough on their own. Burroughs' and Acker's texts, characteristically, bear little relation to intervention in site and site action, and so remain remote from site work's capacity to intervene in the sensed and shared world. They do suggest something, however, for the stand-alone object.

While it is of course unfair to pin culture's subordination to the social on a single person, there is no question that New York artist Andy Warhol, nearly single-handedly, and lastingly for the art world and culture, made social success and recognition into the sign of the challenger. In endless ways, from his early Factory days to his later full-bore embrace of society and celebrity, Warhol reframed resistance as fashion, taking things and even people and remaking them to be bought and sold, mostly for his own ever-expanding position. The larger effect was to reframe works and people that rejected the social, and pursuit of social status altogether, as a kind of school for losers. Warhol

was hardly alone in this. But it was certainly he, with his acute deployment of irony and constant mass-cultural re-invention, that gave disaffected and alienated artists and writers a model of how to join the social without hesitation or second thoughts. The result was a model of subversive-ness that could scarcely answer, and even downplayed, the attacks that began to gather under Carter, Reagan, and Bush I. For a brief moment in the late 1970s and 1980s, art and literature were able to ignore this aspiration to soci-ety, however ironic, reviving direct contest with the social on a broad scale. The window was brief, however, as the so-called, and ever more vicious, "culture wars," really po-litical wars, joined with growing dissemination of so-called market arguments to exhaust every alternative.

What seemed buried and shut off by the end of the first Bush era, by the end of the 1980s, was full-fledged, concerted opposition to the cost of mass society and in-deed of society as a whole, a deepening collusion the writer James Baldwin identified vividly, and often, as "the price of the ticket." Society, and the social, are by now widely considered the only possible arena in which writing and art can be sited, recognized, and endure. This is what cul-ture has become. The social result was a new kind of subtle, but ever-more-present snob value, for both challenger and maker. What few protections existed for the practice of artists and writers railing against society and its unreality were undone. This led to acceptance of a narrowed realm that could be called a public life and culture, but was in fact only a social realm, its instrumental, monetary, and status forms enforcing regimentation with payoffs. The social has proved in no uncertain terms it can accept and assimilate everything, especially, and crucially, what is subversive or transgressive. To shock only leads, over time, to greater value and status. This is in no way the case in the political realm. Writers and artists now seem less willing and able to risk challenge to an entire society, literally and artistically,

as many still were able to do during the Depression, after World War II, during the Korean War, and even during the American war in Vietnam and its aftermath. By the time of punk, lifestyle and "sub-culture" had become resistance. It was a resistance, one might say, without resistance.

The rise of the social and its overwhelming of culture became evident to me during my time in New York from the mid-'70s through the 1980s, and more and more during visits through the 1990s, after I'd moved to Los Angeles. By the end, it seemed whatever questions there were for the meaning and role of culture had been shut down. Until the mid-'80s, however, it still seemed possible for artists and writers to have their own safe realm. In Soho during the mid-to-late 1970s, and then later in the East Village, the Lower East Side, Harlem, and the Bronx through the early-mid '80s, art and culture spaces that arose signified, for a while, that people could meet, experiment, and provide mutual support through non-market work and display. Social calculation and its payoffs were not the only path. Some of the work was political, much of it was not. What was different was the possibility for culture to develop and nurture outside the economic, through grounded, even neighborhood relations between people, outside lifestyle markers and the growing, ever-more present gear of gentrification. It was possible to find friends in a community of the struggling, live cheaply, with unburdened time to interact and work. People met, connected, and tried things out across strata, giving rise to new forms of work and community. What mattered was coming together, and the possibility something unanticipated, in work, venues, and new forms could emerge and not feed back into legitimating the social ladders. One could say this was not so different from the famous "bohemian" ferment among writers and artists in lower Manhattan of the 1950s and 1960s. But two decades later, for a brief while, this sort of thing was going on without an over-arching emphasis on cool or

avant-garde status, across multiple parts of the city. There was no national advantage or triumph to be exploited in the "new," as with so many of the innovators of that earlier period, even on its fringes, and as would rise in force after Reagan, Bush, and especially under and after Clinton, as artists and even writers became instruments of cultural global production, raw gentrification, and an ever more sophisticated legitimation.

A crucial attribute of this period in New York, especially by the mid-'70s, was the manifest aftermath of war spending in ongoing recession and decay. Manhattan had not yet transformed into a glittering mecca for a money speculation and financialization able to hide everything. The artistic and writerly life, even in the theory realm, retained an "underground" quality, with countless contesting 'zines, magazines, and venues that averted the rule of status and career opportunities. Public spaces arose that were as much for connecting as for presenting and disseminating. The notion of a marketable career was absurd, for a glorious while. This was, in its way, a last holdover from the 1960s ferment of experiment, but it came in a much darker, post-Vietnam context. Venues encompassed different strata and experiment, as roles and methods mixed up and got reworked, physically and visibly, at places like the Mudd Club, the Kitchen on Broome street, and later spaces in the East Village and Tribeca, at Club 57, Tier III, Millennium Film Archives, the Collective for Living Cinema, CBGBs, ABC-No Rio, and performance bars and spaces further east, south, west, and north. The steady gentrification of Soho, Tribeca, the East Village, and eventually even Harlem, and the rise of commercial values and rents—making money and social status necessary—joined with the full fusion of art and fashion to kill this off, step by step, as some, mainly in painting, film, music, and "underground" theory, began to achieve success and work their way into the center of production and status.

This transformation is now an all-too-familiar story, even a cliché, having been extended in variants in New York across Brooklyn, Queens, and beyond, to cities and towns across the world, from London and Berlin to cities in Asia, Latin America, and elsewhere. Artists and writers move into a degraded and impoverished urban area, real estate development, media, shops, and restaurants follow, the poorer and more rooted locals are forced out, the old is wiped out, and those who sparked things follow, dissolving and dispersing whatever plurality and openness had been created. In contrast to more recent forms in Brooklyn and Queens and elsewhere, however, until the mid-'80s, those in lower Manhattan, in those brief years, did not have to hold down two or three jobs to survive, travel all over to find poorly paid work, nor were they homogeneous or subject to sanction for refusing to internalize market calculation. Lifestyle and making did not exist as a determining factor in position and opportunity. People were willing, and found support, to try anything, with anyone of any age or identity, without any particular status or payoff, especially without the need to legitimate the social ladders. Life was affordable. Making a living was something one did at best two, maybe three days a week, and secondary, in every respect, to more important things.

While there is no point in idealizing any period, it is worthwhile to mark things when they existed and were lost. The slow, grinding, Darwinian machinery of labor, commodity, real estate, and service economies began consolidating in the U.S.A. under Reagan and Bush I, then spread, disguising the political agenda they carried forward. Openings in New York City, in particular, became, year by year, narrower. We are now many years on. In the major centers, new spaces, outlets, venues, and modes of appearance come and go with rapidity, the past transformed into an encumbrance, with gentrification internalized. In the prime centers, any realm separate from the social and economic has difficulty

forming lasting resistance, as each defiant thing or person is overturned by waves of new producers and products coming out of training schools. Those seeking an artistic life and environs are forced to move on to ever new places where conditions are initially more favorable, to then start the process all over, and, quite often, give up a cultural and artistic life altogether. An ever-more-automatic metabolism has supplanted a full-fledged, resisting culture, rendering culture fully complicit with the system. The possibility the Beats embodied—that one could acknowledge alienation from the social and continue working, making alienation clear in works—became less and less possible or for that matter conceivable. Seriously decayed urban areas in the U.S.A., like Baltimore, Pittsburgh, and Detroit, and crushed economies in Europe and elsewhere, are left to rummage amidst the rubble created by economics and society. The struggle for artists and writers repelled by society's unreality, yet refusing to withdraw, grows steeper by the year. In those earlier years, however briefly, refuge and mutuality happened in New York, at the very center of a growing storm that would soon engulf everything. Things had not settled. Conflict and decay provided the energy for a nonsocial solidarity in art, film, writing, music, and theory.

This description is necessarily brief and general. But one thing that is clear is that the scene in New York between the early 1970s and 1985, to put a temporal frame on it, failed to engage the people's conditions. It did not produce a lasting and transformative political response or critique, nor did it address the ungrounding of the senses in a lasting, political way. We might think of artistic forms like that, say, of "institutional critique," which also emerged in this period, or the turn to "social space" and small-scale community efforts, and the thinking that came out of emerging "identity" concerns and theories, as attempting resistance. But in all these cases, resistance to the social gave way to a general assimilation making lasting

challenge to the entire society unimaginable. Most artists who used critique and "identity" concerns went on to art-world star status, as the model became the social position of the individual and their work, not building and sustaining a lasting, secure, critical, and resistant space for cultural work and thinking, and so indeed for all of us. One could say in fact that what briefly emerged in New York was not aware of what it had, and was merely a by-product of recession. But this also, for me, pinpointed precisely the loss of a cultural and political potential.

On the level of artistic works, Smithson and Matta-Clark's efforts, in a small way, perhaps because both died before social calculation took over the art world, hinted, quietly, at a kind of response that was emblematic. Though not in any way a commentary on or critique of the price of society or mass society, their work addressed the problem of sensory ungrounding, showing someone could transect and interrupt what was customary in landscape, environment, and the organization of daily experience. Their efforts had little to do with critique or identity, and nothing to do with any conventional notion of the political. But in terms of milieu and what is made, they showed a grounding in site could challenge, not through taboo-breaking, not through new spaces and gatherings, not through social assertion of identity, but in terms of concrete and visible intervention in physically experienced reality. Appearance, one might say, and in a different way than is normally imagined, was engaged and opened up, by long, hard, physical work into a shared world. Through documentation and report, this appearance gained striking memory. That Gordon Matta-Clark and Robert Smithson have, like so much, been turned into fetishes signaling market value in no way buries their challenge, even if their fostering the mystique of the artist could be exploited to defuse a unique, quieter kind of resistance their work posed.

III

These losses, trials, and alternatives, or what I experienced as them, in the late 1970s, '80s, into the '90s, were on my mind when I took on the running of a poetry and culture space in an old, Spanish-style city hall near Venice Beach, in Los Angeles. I had moved to Los Angeles in 1984, very happy to leave New York, and began working in the movie industry to pay rent and continue my writing and critical journalism on the side. I was invited, in 1992, by then-curator of events at Beyond Baroque, Benjamin Weisman, to do a series of public discussions around various topics at this cultural space I'd heard about. Beyond Baroque was a refuge unlike any I'd experienced in New York, or for that matter in Los Angeles. Passing through its doors was like entering another era. Difficulties for free, grass-roots spaces and institutions were growing, and Beyond Baroque was no different. Tumult engulfed the place. Seeing danger, and wanting to help, I applied to become director in 1993, was turned down, was invited onto the board in 1995, and finally stepped in, unpaid, as director, in 1996. My goal was to see if the institution—decimated by the so-called "culture" wars, miniscule public and private funding, factional battles, and a climate increasingly hostile to the informal, open refuge the center represented and had protected—could be built back up on a stronger foundation.

With the help of many, the principle was to protect the unorthodox, spontaneous, and free form, and bind it intensively to an attention to site, one where people, informally and freely, could gather, "be who they were," and work at writing and art safe from status, clique, and all forms of social climbing. The principle was to be open to anyone who wanted to come together and try something out, not to advance themselves. It would not be a venue for self-promotion, but for community and memory. Those who had something larger to say about the society, and who

might even express unhappiness with the status quo, were welcome, while less so those who thought everything was just fine. In a way, from the beginning, I had picked up the "beat" sensibility, not in "being hip," but in being disaffected and opposed to the society and continuing with the work anyway. Whoever came was there to share, to add something to a shared sense. Site was where we convened and met, and an atmosphere of some sort of equality could be presumed. This atmosphere had been maintained from the center's founding in a Venice storefront, nearby, in 1969. Venice had been a beat and hippie redoubt, and this unique atmosphere was, for me, the whole point. By the end, two lease battles and countless social pressures, from funding to endless factional campaigns for control, tested my efforts to the limit. I believed, nonetheless, that the responsibility of public space was to provide a counter to the social, that thing I felt had undone the scene in New York by the mid-'80s. Culture could push back, and needed to, hard.

The Center's dispositional spine, from the beginning, had been its free Wednesday Night Poetry workshop, gathering, since the institution began, around a table in a room, each person taking turns handing out a printed sheet with their poem, then remaining silent as that work was discussed by peers. What is the written object in front of us, those gathered around the table asked, what is this work? What had the person made? What do we think? So it would go, week after week, month after month, year after year, around objects, around the table, at no charge, for anyone who walked in. This openness was possible in the programming as well. I did my level best to give those who were reaching for something more than a career or a leg up a chance. I would often say, in private and in an occasional article, that it was the movie industry—where I'd worked upon arriving in L.A., until 1992—that had taught me the greater importance of an audience of only a few. How many readings we had with only a handful in the audience, often

with crucial contributors from out of town! I felt a resistance in the poets and artists that congregated at Beyond Baroque. This informality and continuity, this effort at working and coming together, had, through the successive efforts of many, resisted social trends, retaining an underground quality and affirmation of new forms. It was a refuge for the mixing of strata, ideas, and approaches. My inherent dislike of celebrity society would grow and finally prove a major bone of contention, for not everyone shared my desire for resistance against it. The status grabbing of the Hollywood world, fully as much as the corporate mindset, perpetually loomed. But for a while, I was able to establish and sustain a counter-space where no faction or superstar could dominate, however much behind the scenes, where bureaucracy was loathed, careers and training were not the issue, and the judging of created work, in workshops and events, was the main activity. The money power, and official and status concerns, were to a great extent blocked. I believed this was the center's founding spirit, and I had a responsibility to do what I could, not only to protect that spirit but extend and build it out. It was not difficult. Poets and artists, but especially poets, retain a diffidently non-social aspect to their work. It is paradoxical: poets thrive on public life, yet fear it. For poets, the struggle with society is great, with little money or "success" possible. Some secure positions in the academy, but most work on, surviving however they can. That their work and life could be protected, at a site with a full and complex history, in a neighborhood with its own history, protected by convening, day after day, week after week at that site, made this real. The building, the physicality of its public space and its history, was crucial, extending from the black box theater to the bookstore, archive, gallery, our eventual publication efforts, and even to the decidedly, and understandably for some, frustratingly non-professional management I ran. For me, the organization and its programs could be about something more than pre-

sentation and dissemination. The center allowed a convening of part after part of a community, and different communities, taking turns, informally. Those wanting dominance or a single vision had to step back. What mattered was the convergence of plurality and site, and the safety for that to occur and unfold spontaneously, in public. During the Center's first two decades, Venice had been a cheap place to live. By the time I stepped in, this was no longer so. Even with spreading gentrification, severe transportation and funding challenges, and the continuing, sometimes shocking jockeying, a stable interweaving of plurality and site took shape.

The principle was broad. The idea was to preserve and relate cultural differences around working and meeting, week after week, pushing towards a deeper sense of who people were and how much they were willing to take on, as artists and writers. The living, spoken aspect of language needed a grounded relation to people, text, object, and site, and this had to be distinct from vanity work, the ready-made, and job-hunting. The repetition of society, in object or gathering, needed to be resisted. For the poet, and especially the poets who frequented Beyond Baroque, some of them distinct loners and "nobodies," from every imaginable area and concern, what mattered was an identifiable community of speaking, hearing, encountering, and mutuality. I wanted it to be a refuge for what Havel called "living in truth." It was a parallel, safe realm for that, and for any artist or writer compelled by deeper yearnings. There was a known history of alliances and forms produced there, in performance, writing, and art. Those who challenged conventions had a berth, regardless of stature, amidst a history of so many who did crucial, important early work there. The Wednesday Night Workshop model, or principle, of a peer group taking turns around objects and a table, in a shared, linking space and the objects brought to it, could define the center even as it challenged it. The result, in the end, was very much like a school, but not for society.

In addition to a steady and growing schedule of readings, performances, and events, I embarked on a series of efforts aimed at expanding the workshop principle. The first programming breakthrough, conceptually, and one that informed all my subsequent thinking, came with the site-based Beyond Music series and Beyond Music Sound Festivals created by sound artist, musician, theorist, and publisher Brandon LaBelle, in the late 1990s. LaBelle had served on the board with me before I stepped in as director, and stayed on to help, from the board and in programming. With my periodic support, but also independently, always in consultation, LaBelle began to develop programs that involved sound works intervening in the building physically and architecturally, overtly using interaction with site as the ongoing practice. Leading through his own work of attaching pieces to, and intervening in the building and site to create sound, LaBelle invited other sound artists from around the country and world to perform, attach, and install pieces in the building and on its grounds. The artists usually performed, but the performances engaged the space of the building in a crucial way, not only in our black box theater. During the festivals, site works were embedded in the lobby, bookstore, stairwell, closets, gallery, archive, and outside, on walls, fences, the lawn, and even on surrounding palm trees and crossing busy Venice Boulevard fronting the center. Site and sound interwove, highlighting their difference and relation, posing questions about what experience meant and could mean. This activity and curation began to build a community, and anticipation for events grew. LaBelle's Beyond Music Sound events and his five festivals completely transformed how I imagined culture might be able to work.

The active relation to site echoed the poetry, film, political evenings, workshops, and community and self-help groups that filled our rooms on a steady basis. While there was no absolute intermingling of the many different

activities—part of the principle was for whoever wanted to gather to be safe and undisturbed in their space for the duration—each nonetheless complemented and intersected the other, occurring in proximity, taking turns, and feeding memory and a lived activity. Permission encouraged engagement, engagement permission, and the regularity of convening around shared things and activities became an ongoing, open principle, whether or not one group or person even had a clue what others were doing. This was tied up in creation, at all degrees and levels. I will never forget a particular piece outside, as one of LaBelle's sound artists, as part of one of his festivals, used the high, chain link fence marking off our back yard as an instrument, playing it with a bow, as the crowd milled about, some up close, listening intensely, the ocean breeze and air mixing with made sound and the boulevard's rushing cars. The piece was not only a perceptual intervention, but did so by engaging context and audience explicitly. Others doing work at the center might come out, or arrive, and pass through this, continuing on with whatever they were doing.

The principle of the activities LaBelle was able to foster, with my support, I felt, could be extended to the visual and plastic arts. Attending an evening on films of Smithson's and others, I approached and met, for the first time, the curator, Jeremiah Day, and asked him if he would join our efforts. Around this time, I, the editor of the art world 'zine I was writing for, *Coagula*, and a few others attempted to start an "art school" different from the model of the art training schools in the area. We were a public space, and this seemed ideal as a chance to break out of well-grooved forms. We called it, in high hopes, Black Mountain West, in tribute to that legendary school, Black Mountain College, with its principle of artists working, separately and together, as the sole educational environment, in contrast to professionals passing on skills to students in training classes. The principle we hoped to foster was more one

of mentoring. We advertised, and some word got out, but we received only a few sign-ups, even with prominent artists willing to join.

The school, unable to offer a degree or professional stature, was predictably still-born. The class I had proposed, on Hannah Arendt, was an effort to rethink the private tutoring method of my friend H.R. Shapiro—reading works of his, Arendt's, and others, aloud, around a table, week after week, in his apartment—for a public space. I decided to test and revise my approach, and a few showed up. Day was the most consistent, and so we met, in the bookstore, week after week, around the Wednesday Night Poetry Workshop table, reading aloud.

During these sessions, Day and I began discussing an idea I had of building a form for art similar to what was happening in writing and sound. This emerged during wide-ranging discussions of Smithson and Matta-Clark, notable publishing efforts during that time like *Avalanche* magazine, and political concerns Day and I uniquely shared. This converged with my experience of developments in New York, living in the East Village and Murray Hill. I missed the ferment I'd experienced in New York, and with Los Angeles so spread out, I believed Beyond Baroque could be a gathering site. Day had already recommended the center to the dancer Simone Forti, whom he had worked with in her speaking and moving improvisation classes a couple miles away, at the Church in Ocean Park. Forti, looking for a new direction, began intensively attending our workshops and events, and after a while presented a piece to me she had developed there, which I suggested we develop into a book for the imprint I'd started a few years before. This would become her book *Oh, Tongue*. Day, keeping the focus on Venice, curated a show on the neighborhood, then with Forti and three other dancers, performed in a dance event. Out of these experiences and discussions, Day and I devised the idea of a Beyond Baroque Working Group.

Day gathered colleagues in the visual and plastic arts, dance, and architecture, including a person I introduced him to, Ken Ehrlich, who had been working with LaBelle. The Working Group would meet on site periodically, engaging the building, and creating works and experiments together, there. This extended links outwards, based on showing up, leaders alternating, self-critique, and occasional documentation of efforts. The Working Group met on and off for over two years, doing interventions in the neighborhood, on the roof, in the back yard, and finally adding a table to the back yard, in concrete and metal, built over a long period from a group concept, by the last remaining member, Ehrlich. As is often the case in Los Angeles, with infrastructure and support desperately meager, pressures on the experiment had grown too great. Working Group members left, except for Ehrlich, one by one, for more supportive countries. An attempt to fund the Working Group through a major artist's bequest foundation left no positive impression with the grantor, no doubt because the effort, like Beyond Baroque, was unconventional, bare bones, rough, and diffident. It was precisely not about packaging or product for the social, and we had designed it that way. Both Day and LaBelle, for separate reasons, frustrated with American indifference, parsimony, stress, and in Day's case, our dismaying foundation rebuke, joined the exodus abroad. I was left to my own devices.

The lessons from these efforts, for me, had proved informal plurality and site could work together, but they had to be rethought. This led me to a question. Might different sites be energized and link up, not simply their participants? Could this be developed with other neighborhoods, cutting across and through the city? I was constantly thinking about structure. Could a different structure be devised? Around this time, and following a workshop we had sponsored at the center, I began meeting with its leader, African-American writer and poet Michael Datcher, from the

World Stage, an old storefront community-based poetry and music venue in the neighborhood of Leimert Park, far from Beyond Baroque, in South Los Angeles. Like Beyond Baroque, the World Stage had a rich neighborhood history, an informal, open atmosphere, and its own longstanding, free workshop, the Anansi Writers Workshop. Datcher and I were deeply frustrated by the lack of exchange bad public transport, sprawl, and entrenched racial biases enforced. A shared commitment to neighborhood and community seemed a way to activate and link. The idea was to create something that was not social but political in a new way.

Our solution—grafting together the names of each of our centers—was the World Beyond. An ongoing, regular series of evenings would feature poets from each of our sites, putting them on a common bill that moved, month after month, from one site back to the other. Poets read round-robin style, taking turns, each of three poets proposed by each center reading a poem followed by a poet from the other site. The contrast of voices and their juxtaposition and rotation, taking turns, back and forth from site to site, created a completely new kind of energy. Audiences came with each poet from their differing communities of friends, met, mingled, listened, talked, and performed. Some poets and audience members had encountered each other before, mostly in passing, from travelling around town; many were new to each other. Now they brought their communities and their differing contexts, styles, energies, and histories to bear, in each neighborhood with its own related but distinct array. The structure kept things rooted in our two sites and those based at, or working through, each. After several months, with the method working, we expanded outward to two new communities. We approached first, because it too was a well-established institution, Self-Help Graphics in East L.A.'s Boyle Heights, working with a couple different curators to draw on the Latino, Chicano, Central- and Latin-American, Spanish-speaking poets that had

some identification, if extremely loosely, with that site. Later, when we began to plan a larger, city-wide festival, we brought in another group, through Philippino poet Irene Soriano, without a stable center, but nonetheless drawing on poets in communities with ties to Malaysia, the Philippines, Vietnam, India, Pakistan, Japan, China, and beyond. Beyond Baroque was "Westside," which to many meant "white." But many had read with us at some point, as they had at the World Stage. The desire to join us and meet in new places, with new people, was clear.

The equality of the structure—no site or institution had a higher position, and everyone took turns through the repeating format—established a mutual support protecting and enhancing our differences and our links to different neighborhoods. Each person had to step into the others' shoes, as it were, and have others step into theirs, physically, in a grounded place. On a particular program, a language poet influenced by Wittgenstein might be followed by a poet whose example was Tupac Shakur, then on to a poet whose concern was their barrio grandmother, then to one challenging the President or celebrating a love. Poets drawing on influences and styles that had never had much contact met and did not have to fit in or assimilate. Each remained linked back to, and put forward by, their proposing neighborhood institution, appearing with others linked to theirs. This grounding, by occurring with and for work, activated a common sense and experience. There was unprecedented energy in the form, drawing as it did on four very different cultural and site constellations. So it went, in clashing, relentlessly articulating rounds, poem after poem, person after person, site after site, month after month.

Datcher and I had designed the World Beyond format to be different from the slam and "spoken-word" poetry forms. Presentation was grounded, but not on a "stage" for entertainment. Readings were from handwriting and text, poets working from chapbooks, books, and single sheets

of paper. They came out of the neighborhoods. There was no way to be better or more important; all were needed. At our first lunch together in South Los Angeles, Datcher and I had agreed in no uncertain terms: no prizes, no winners, no losers. This was not a sport or game, but about deepening histories and lives. The rotation was not about who was a better or lesser known poet, or a better or worse entertainer. Those travelling from one neighborhood discovered what another meant and how, and many for the first time. Each reality supported the other. The public life of the city began to fill out and be embodied through a multi-site institutional structure that provided a refuge for such life, and for poetry.

In time, the success of the series gave us the confidence to go a step further and stage two citywide festivals, planned with each group following the model, moving from one part of the city to the next over four or five days. With national funding secured by Beyond Baroque, and money going to honoraria, each site could add a national poet respected in their community. By the second festival, we had a hundred poets from all over the city on the multiday bill. Prominent poets with several books from out of state would read before or after someone who'd been writing on loose sheets of scrap paper and had never been published, and might well never be. It didn't matter. All were effectively structurally equal. The way the structure featured spoken or performed work, and the differences between them, rendered the nature of status as secondary. There were no headliners and back-ups. Groups with a related institutional origin were not gathering around that, but going out to mix with another group with their own origins, anchored each time in the neighborhood and the round-robin. In the end, the only thing that brought the effort to an end was the enormity of the final festival, and the inevitable jockeying that began then. The model, nonetheless, was solid, and generated an unprecedented, if mo-

mentary exchange ranging over vast distances, stitching a flexible, real, space together in a city that had made such a thing nearly inconceivable.

If there was one thing the World Beyond, Beyond Music, Beyond Baroque Working Group, and all our efforts shared, it was that unity was not the issue, either of style, method, stance, or approach. What mattered was being willing to take a risk through works and coming together. Structural plurality transformed assumptions, turning the ever-insistent, ever differing "identities"—whether cultural, race-based, or artistic—into a meeting ground and foundation for everyone. This alone was a kind of cultural statement. Aspirations ranged widely. Conviviality and friendships grew. Participants within each of the center's efforts were almost always curious what the other person in that form was going to do or propose, precisely because the structures created this sense of respect and equality. The normalized form is to gain social status precisely by focusing on climbing, the quality and concerns of the work an instrument; at the same time, those with superb work do not gain status, and in particular those who challenge and are not interested in climbing. The programs tended to equalize this. Sitedness, neighborhood, environment, and works all came together in a cultural, living way that was not merely social. With the Beyond Baroque Working Group, artists from all over the city convened to experiment and create at our site, engaging site and reaching outwards. This resulted, in one emblematic example, in the group taking on the old children's game of "telephone," attempting, madly, to stretch cup and string from the roof of the center to a building across Venice Boulevard. In the Beyond Sound programs, someone might come from a distant country but would set up, for a few days, with some installation, bringing the rootedness of their far-away home with them to make their home temporarily with us. For the World Beyond, racial polarities and heavy segregation were

challenged, with each person experiencing the other, and their grounded neighborhoods and differences, as if for the first time.

In each case, while the assemblies in word, art, and sound were temporary, effects endured. Programs disclosed, in a fundamental way, what was latent in the artist or writer's experiences and the world they came from, in poetry, in sound, or in exploring an art proposal. Each brought their vantage, while the structure preserved and highlighted it precisely as a vantage. Givenness was the starting point, so coming together could create new perceptions and awareness. The round-robin style, or taking of turns, was echoed in the structure of each of the efforts, so the given shifted, moved, and was protected. Culture could disclose. Though the sound and art efforts emphasized our site, this awareness was not so different from what the World Beyond sought to develop at multiple sites. Just as the neighborhood around Beyond Baroque had a chance to be felt, so did neighborhoods in South, East, and West Los Angeles. Each person brought skills and work to support a shared space, grounded in who and where and when they were. This, not status, was the measure that bound everyone together, according to their differences.

The result of these efforts was different from how culture is usually conceived and practiced, with the emphasis on dissemination of production and recognition of position. If there were positions to be had, for the most part, they were, for most, a door to a different meaning. The ground of "institution" was public space, aiming not into the social but towards a plural public life. Culture could renew and disclose the vantage, contribution, site, and origin of each participant, emphasizing their equal importance. A space between was embodied and brought to life. The attempt was indeed to create a space of appearance, a kind of cultural *polis*, for all. Art and politics, art and public life, were mediated by the effort of an institution grounded in the "cultural,"

coming out of institutional capacity, however loosely defined. What would otherwise be isolated in a social set-up was articulated and grounded in a public way. Art and public life could advance each other, finding a place and space to meet and support each other. Culture could mediate.

IV

While public address and speech are crucial, the artifact is also key. Public gathering is ephemeral, it comes and goes. It needs artifacts, just as artifacts need it. A crucial component of the assault on reality and our ground is very much the undoing of this relation. Science reveals the bias: the "artifact" is the thing that jeopardizes the experiment. In the public realm, it is the opposite. Grounding requires artifacts; artifacts are its reflection. Text, also as an art object, is part of that, and it can be material and public, sometimes both at once.

These were the sorts of concerns, though at first undeveloped in my mind, that drove my creation of an imprint for the center, in 1998. Could text come out of public space, and public space out of text? I began with works from the Wednesday Workshop, then a workshop hosted from the World Stage, then an author, Nancy Agabian, who'd run a workshop there for years. This evolved quickly into working with others. The works I chose needed to be more than another piece of production for a career. Who was the author? Where did they come from? What was their connection to us? How was their vantage unique, and what could it lend to deepening plurality and sitedness? The many books I edited, designed, and published were not meant to be autobiographical for the authors; they were crafted and edited to emphasize account. The deeper the vantage, the more it could contribute to a kind of objectivity, precisely because it was grounded in the author's life. Deepening the connection to a person's history and roots could be tied back to public space and extend from it. The physical appearance

of the person at Beyond Baroque was a start; it could be a simple event they performed at. I preferred the authors to have some engagement with community, however they saw it, and with some connection to ours.

The object itself needed to reflect a ground, not merely in content but in its exterior, and it needed to be well made. This proved difficult, for while wanting the production to remain local, excellent printers with long history and experience were, due to endless tax and market structures, hard to find. I settled on one, and we ended up working together extensively, however frustrating it proved. An extra burden was the crushing problem of distribution for a small press. All of this affected the creation and life of the artifacts. Beyond Baroque had been home to publishing efforts over the years, offering free space to set up, and at points even equipment to do layouts, but this was not always linked to other activity there. This was a model, but I wanted to deepen and ground things in public space, to have public space be the originating point. This meant the collision of different notions of whom we served. As projects expanded out to San Francisco and New York, tension grew with local poets that wanted to be first. I felt, however, and much to the dissatisfaction of some, that the local needed to work out and be part of a wider and broader context. Production had to link to the widening of public space, rather than to social and individual pursuits. The components needed to include local, national, and international writers. This led to featuring the work of authors from Europe, the Middle East, Latin America, and Asia, particularly in the free anthologies I edited which, no doubt many locals noticed, did not highlight them. Was I violating my own principles of site? It seemed to me there had to be a moving back and forth for appearance to have real depth. A poet or artist in L.A. could only benefit from a poet or artist based far away, especially if both were committed to sitedness, where they were, in principle. At various

points, I even felt it would be better to publish a poet from far away who cared about site, rather than a poet down the street who lived there but wrote about no place in particular. It was all about groundedness of the account.

One particular publishing endeavor epitomized this. The gound-breaking, Brooklyn-based poet, critic, historian, and activist Ammiel Alcalay, who'd worked on Middle East culture and politics extensively, had lived in Jerusalem, was a classics scholar, and had a very broad perspective. He read with us and was clearly engaged with questions of site and plurality. His writing veritably pointed to a very braod world. I wanted to produce an object for him, to show his digging into documents, shards of memory, and roots in Massachusetts, Bosnia, the Middle East, and broader cultural history. The extent of what he could draw on was vast. After publishing his *from the warring factions*—a long, experimental reworking of the epic form, dedicated to the city of Srebrenica because of the massacres there—I spent more than a decade working with him to edit a new work, *a little history*, building from a wide array of materials he dug up and presented in multiple forms. The idea was to examine and rethink the landscape of Cold War American poetry and its suppressions. This, crucially, circled back to the work and commitments of Charles Olson, whom Alcalay had known during his youth, during summers in Gloucester. We had begun long conversations about Olson. I sensed, from an interview with Alcalay I'd included in the first book of his I did, the possibility of a deep re-orientation of poetics, politics, and more around this crucial figure. Olson was known for his time running Black Mountain College, his poems to Gloucester, *The Maximus Poems*, and his time working high up in national politics. Olson pointed to a wholly different kind of scholarship from the academic, and for me this was everything. He'd turned his back on all of that to pursue a synthetic, deeply rooted mode of knowledge, one where account and

accountability were intensively bound together. Alcalay's work adopted a similar grounding, now from a broader world, using his equally outward-reaching cultural attention. The interest in Olson, and my friendship with Alcalay, grew out of our mutual love and admiration for the Gloucester poet Vincent Ferrini, whom I'd brought to the center several times, through the graces of a San Francisco poet involved with Beyond Baroque in its early years, Jack Hirschman. Ferrini had been dedicated, since the 1930s, to the life and politics of Gloucester and areas nearby. He was an early interlocutor for Olson because of his deep, working class commitment to place and a sense of the interlocking foundation of the political and poetic. Out of this, Alcalay and I devised many projects. But conditions were brutal, and few but his books, one by his friend Benjamin Hollander, and some isolated poems from the Middle East, got published. Something new, nonetheless, had begun.

With the influential dancer and artist Simone Forti, who'd turned to the center to rethink things and focus on poetry and writing, I drew on her long-time roots in the art and performance avant-garde, working to edit a book for her, *Oh, Tongue*, out of her poetry, news animations, reflections on method, and transcribed performances. Here too I had an intuitive sense a kind of new grounding could be mapped out. The texts drew on her experience and roots in multiple places, in Italy, Vermont, New York, and early years growing up in L.A. This meant, as with Alcalay, reaching into the political and historical world and, in her case, specifically to the news. The contents rested on Forti's fundamental concerns with worldliness, embodied in what she outlined, in the book, as the principle of "body, mind, world." This to me was a perfect way to sum up this coming together I was reaching for. Forti performed with us many times, was a regular attendee of countless readings, performances, and discussions, and was an extraordinary example for anyone paying attention.

My public curatorial work sought to articulate such convergence by bringing text into the public realm in a materialized way. Asked to curate poetry to be engraved in a downtown state building lobby, and managing to re-focus a restoration project for public spaces on the Venice Boardwalk, I turned to fragments from poets who'd lived in the city for an extended period or spent time there. In the case of the Venice Boardwalk, I chose poets who had worked in and around Venice, a couple of them famous as musicians, others more obscure, and, with the research and help of Venice poet John Thomas, those that had passed through Venice for a summer, year, or more. Each spoke to a spirit that embodied the community and experience of place. The texts, to be engraved in walls around the beach boardwalk, had been intended by the City to be work from historic figures with no particular connection to Venice. I proposed, and convinced the officials concerned, that pub-lic art speak to and come out of Venice, as poetry. Materials and siting were not ideal, but the purpose was to encour-age encounters by the public with grounding experience in a locality's diversity and history.

The materiality question needed elaboration, how-ever. I wanted to see if "text" could be done on site and at the same time form the basis for live text festivals. The mod-el here was LaBelle's sound events, but this time I wanted to achieve similar effects with text. In two "Beyond Text" festivals, I asked writers to create or bring texts, hanging them on walls around the building and its exterior, treat-ing them as "scores," on site, for the performances. This materialized, for the site, language as object and mean-ing, in a grounded way, activating the location and linking parts of the building. One particular text was embedded on the exterior of the entryway, others on the ceiling, walls, stairways, and grounds. The building became a site of text, much as the boardwalk buildings had through engraved and permanent fragments.

The artifact, however, needed a further grounding. Extensive work on archiving chapbooks and books was a key part of my effort, keeping the artifacts, marking participation at the center, in a shared and accessible public space. One of my first efforts at the center had been to rebuild the archive, thrown into chaos because of an earthquake, cheap shelving, and years of neglect and disrepair. We made a constant effort to buy and collect works of those who appeared with us, especially rarer publications, 'zines, chapbooks, and self-made books. I found collections to add to the center, building on ones donated, and kept expanding the shelving. The archive became a kind of living history of the people who appeared with us, or came to us, now stretching out across the world. This was a crucial part of the fabric, and it slowly filled out half of our first floor, beginning to merge with, and supplant, our bookstore. Writers and chapbook makers could bring works for display and sale, and we would buy outright copies for the store and archive, to help. The possibility hovered of tying everything together through some kind of material record of work done there. Finally, as a kind of coda, in addition to the books of authors that we did, and with the help of others, I edited two free anthologies, drawing on writers, theorists, and artists from all over the world. They emerged from the space and were distributed free around Los Angeles, at cafés and community centers, and at various bookstores and community centers around the country. This was part, I felt, of bringing text from out of a public space into the larger realm. Like the engraved text projects and the Beyond Text Festivals, the emergence into the wider space was to spur encounter and account, and most of all, to deepen, extend, and preserve a plurality of vantages materially.

The shared aspect of these efforts in text, public activity, and preservation, however much it took to hold them together, was to affirm appearance in multiple directions. It meant to insist upon appearance's depth, breadth, and ca-

pacity to reflect, activate, and preserve. Those who would experience works in these forms, I hoped, would in turn be energized to a more active sense of site and vantage, and so a deepened connection to public possibility, at our center and far beyond. I believed work and artifact could dig into location, history, experience, site, and action; their task was to disclose, sustain, and deepen. The intent was to affirm how much culture can indeed ground and strengthen us for the world we're in, where we are when we are there, and the sites we come from and go to. Public activity could enact, affirm, and "describe" itself culturally, using cultural means to make what is apparent secure. World and object could form a kind of table we take turns around, precisely because they are objective. While the made thing lasts, gatherings disperse. Each can sustain the other over time. In all these cases, whatever object or work was involved, anyone could do or be part of this, by creating an installation, by speaking and writing, by climbing to totter on our roof with others, by reciting verse calling out someone or something, by giving us a chapbook to preserve, by putting a sound source in a closet to send out barely audible noise, by miking the outside or rattling every window and door in the building, by creating a book or appearing in a collection, by digging into memories of a civil war or a vibrant expression from a far-off continent, or simply dancing in the backyard and putting one's hands into its earth. Whatever each person or assembly brought, they brought, and the space of appearance grew increasingly articulated and plural, protected by work inside, and always moving out from, the safe four walls of the old Venice city hall.

V

The ephemerality of public space posed a final, intractable fact. I had hoped to build a lasting, secure form for it, and this proved increasingly trying as the years went by, the

procession of events, efforts, and contest grew, and the funding challenges, factional and personal campaigns, and lack of support wore every principle down. As a result, a cultural question arose quite apart from my institutional efforts. Could an enduring object somehow embody these principles, to lastingly enact and embody them? Could pluralizing and grounding be demonstrated, overtly, in an object made to endure? In my work as a critic, I had looked at artists and writers that fought the political organization of the social, to reveal and answer the long-running political assault on reality and people. But this was the work of highlighting others, and making points in discussing them critically. The center had provided a way to site this resistance, on a daily basis. But what would a direct, creative response, concretely be, in a thing? Could the activation I sought in public be captured in a text, and bring site and plurality together lastingly? LaBelle's efforts had achieved this through sound, transecting and intervening space physically. The Beyond Baroque Working Group showed this could be extended to art and performance, taken into the neighborhood from our anchoring site. The World Beyond and engraved text projects moved into other communities and sites, to energize place and public through enduring evidence. The live text efforts, publishing, and archiving all contributed. But could a single object exemplify a plurality of perspectives, to activate a roving yet grounding sense, explicitly?

Reigning theories of text and language presented a problem. The sign, the Swiss linguist de Saussure famously argued, refers only to other signs, not to the world. It has no inherent relation to a referent or to the world. This, for de Saussure, underlay the coding structure of language. Speech could alter the underlying structure somewhat, but like others who argued language had a deep structure, for de Saussure, the spontaneous and persons played no real and reshaping role. Such theory, crucial to the rise of

structuralism, semiotics, and much of post-structuralism, even when critical of coding, seemed limiting not merely culturally but through a linguistic politics that seemed to me quite reactionary. Language is sited between people who live their lives in this world, no matter how abstract, self-referential, and beyond us it may seem. Its structure is part of, created by, and maintained by people in a living body politic, with all its plurality of tongues, hands, minds, bodies, communities, and most of all, facing political and historical facts, obstacles, misfortunes, and even joys. Languages can be changed beyond recognition in a few short years by political forces determined to do so, even unwittingly, and whole words and concepts crucial to understanding can be eliminated or lost. To abstract out language and look at it as a universal, suitable for scientific study and laws, disguises its existential and political root. Oral culture and live performance, so intensively exercised at Beyond Baroque and the other sites we worked with, was a powerful answer, but it was entirely ephemeral. A text object was more durable, but as theory had it, was constituted by its internal elements and their relation to internal elements in other texts across time and space. This did not take account of the way text and political fact point us to, or away from, the world we are in.

Text, as the material form of language, can animate and energize sitedness and our relation to each other through it. The post-modern and post-structuralist notion of fostering a heterogeneity of signs and styles to break the regime of the code, or codes, seemed a little less ungrounded. But it was still trapped within the removal of signs from living, speaking, working people contending with conditions and most of all free to make, act, and revise, as they will and do. Simply replacing deep structure with the machinic and the desiring seemed utterly problematic, for our inherent differences are actually the ground of everything. As a result, a question pre-occupied me: if language is unrooted

and indeed uprooted, how can the writer or artist provide us with a doorway back to shared and grounded experiences, a possibility of wide challenge, and in a made object? This tied to my concerns about culture, for a culture able to mediate and arbitrate between art and politics demands grounding to govern and answer conditions. What would an individual text acknowledging such worldly challenges be?

The text objects I was able to produce with Alcalay and Forti, in particular, crucially explored this by attempting to rethink experimental methods, re-engage worldliness, and do so by engaging the person's own research into, and attention to, political and historical fact. What remained, for me, was to address the reader's own relation to the world around them as they are reading, at a site, and how an author might engage and activate that. In time, and through a series of discoveries and rediscoveries, I came upon a work by British critic, essayist, poet, painter, photographer, and novelist John Berger. Like many, I'd read his ground-breaking, early effort, linked to his British TV series, *Ways of Seeing*, in university. I had been transformed by his disclosure of works' historical and ideological roots, and in a way few have remarked upon, the highly existential quality of the endeavor. Activation for the world was crucial to his effort: one was asked to look at and into, and feel a connection to, the world, through a political, economic, and organizational structure reflected in artifacts. There was, Berger suggested years ago, so much to look at with fresh eyes and even ears, in a way different from connoisseurship or contemplation, theoretical or otherwise. By the same token, "ideology," for Berger, did not exist in the conceptual ether or in the realm of ideas, but in concrete works, objects, and relations sited between us. Because of academic protocols and requirements, Berger was never taken fully seriously for the depths of his effort. Indeed, he was never aiming at the theory mills in the first place. This irreverence and determination to work publicly infused his approach.

Berger's trilogy of novels, *Into Their Labors*, began to materialize a response to this around lived lives, through fiction. There, in tales of rural life, work, and tough, peasant endurance, the reader has a sense of being grounded, not passively, but in an engaged way, as the author is, in how things are done and organized. The endeavor, one could feel, was to protect a different way of life from destruction by the one we know too well. Each story was an example not just of conduct, but of persistence and resistance to an imperial and post-imperial form. One day, in 2000, during a quick stop at New York's Metropolitan Museum bookstore, and energized by Berger's fiction, I spotted on the shelf a book of his later essays, *Keeping a Rendezvous*, published in 1991. I started reading right there, and from the opening pages had the feeling of stepping into something striking and new. I'd been writing criticism on art and politics, but was unhappy with the models I'd found, both academic or journalistic. In an early draft of this piece, and a couple years later, in 2003, I began trying to think out and explain in writing, in accompaniment to thinking out my work at Beyond Baroque, why this book struck me so hard.

In *Keeping a Rendezvous*, Berger experiments with a merging of experience, cultural and political reflection, site observation, and montage, building up a new kind of existential, sited writing. Though his prior work always had this "I am here, looking, would you look at this too?" quality, Berger was now no longer writing "about." He keeps observing, commenting, thinking, describing, and poeticizing, yet the sensation is no longer of a critic but an engaged, living person with others, coping with the serious stakes in culture and lives. The activity was no longer merely discourse. The accountability of voice radiated. The difference, I finally realized, was that in this new work, we are present with him in an attending to what is so—broadly, not just towards artifacts. At the precise moment the author is somewhere, we, the reader, are there too. This concern exists

in his numerous essays looking at art works, the tactics of photography, and moments of living. But *Keeping a Rendezvous* pointed to a new mode, something like "Here, this is for you, because we are together." It begins to move in the world, as part of the world.

In an existentially present and grounded form, the writer shows not only that things are indeed organized politically, but that the moment of writing bears on both participants, writer and reader, in the moment the two are factually together. We are both there, as it were, as is everything the author speaks of and that we as readers are concerned with. We go new places, together, in the moment. The arbitration and mediation between art and politics joins with the risk and venture of living in the world, shaping the object, or artifact. A resistance is enacted that is a disclosing resistance. This echoed what I'd seen in Forti's live, spontaneous, improvisatory, moving attention to moment and world, but it also had the broad and deep outreach that Alcalay was able, and determined, to embody. In *Keeping a Rendezvous*, the activity of the pieces assembled create a materialization, plurality, and depth of address that is fully responsible for itself as a thing and what it is "doing," as a kind of action. Text becomes an enduring and ongoing intervention, precisely because it is in an enduring object. This was the possibility I had sought to achieve with the books of others and public art projects I produced. Digging and recovery, as Olson suggested now decades ago, could go together in an activating object.

The second piece in *Keeping a Rendezvous*, "Ev'ry Time We Say Goodbye," already a cultural act by mimicking, in form and content, its musical namesake, the John Coltrane version of the Cole Porter classic, puts this up front, at the start. It begins: "Film was invented a hundred years ago. During this time people all over the world have traveled on a scale that is unprecedented since the establishment of the first towns, when the nomads became sed-

entary...mostly, the travel has been done under coercion." The piece begins in the middle of a poetic jump or link, accomplished with ease. It opens with cinema linked to the uprooting of peoples in present and past. Berger is not looking at a work yet, but connecting reality and fact: cinema indeed arose at the same time as, but separate from, the ungrounding of millions into stateless persons and refugees, now as a seemingly permanent, mass condition. The rise of cinema echoed the rise of this widespread, and global, uprooting of people and world. Berger's *aperçu* then moves quickly to a meditation on relations between uprooting, painting, the sites of painting, and observations from within a rural chapel he is visiting and we are at, with him. Berger's jumps, more leaps, do not wait, but connect and drive us deeper into the world in its lived present, just as the Coltrane piece does. We are far indeed from the Saussurean, semiotic abyss between sign and world. Each successive sentence discloses and grounds, moving us into what is around us.

The spaces created by Berger's improvisatory jumps and shifts in vantage generate ever greater energy. Elements are neither isolated nor presented as accumulation of knowledge, but direct us to sensing the world's plurality, by moving and cutting through. Boundaries are clear and opened up. A statement is made, barely fleshed out, then we are carried further, to a *place*. One has a tactile, visceral sense, not of a spectator looking at a canvas, landscape, event, or condition, but asking us to join him. This is not the theorist constructing an edifice of terms and concepts. It is a judging person in a shared endeavor, moving from vantage to vantage. Judgment and sense come together. If there is a timeless, suspended quality, it is not of the knower, but of an object, the book we hold in our hands, and the experience of being saturated with infinite time, space, and ground, reaching outward from the spot when we hold the book and read it.

What Berger enacts, in this piece, the book, and the works that followed it, is the capacity to think and imagine in the world, for the world, as action. If works exist, they are part of a fabric that binds us all in potential. They convey how much response is needed, is initiated, and is connected to account and responsibility. This echoes Forti and Alcalay's careful, meticulous, and spontaneous attention to conjoining the aesthetic, ethical, and political. Like them, as Berger moves through literature, film, art, architecture, and history, the result is not interdisciplinary but anti-disciplinary, against the disciplinary forms and fields we are told we must fit into by the social. A living, politico-cultural education frames reader and author as free for the world, outside institutional usages, status, regimes, or positions— as *people*. The work of course sits there, as a text object, for anyone who, as I did, picks it up. But one then enters a space where worldliness is probed, sited, demonstrated, and enacted. This brings in the past, the present where it takes place, and a sense of the future bearing down on us all, as both potential and a matter of concern.

The quality of such thinking is unique. For example, the cinema is not the *same* as masses of refugees and all the desperate and dislocated wandering the globe. These two public things, Berger shows, are different but happened at the same time, and this simple, worldly fact of real time past tells us more than discourse or theory could. We are not in the middle of a theory about this, but a juxtaposition of existential and worldly facts that illuminate. The influence of, and lessons from, Walter Benjamin are clear, but now they are used in a more existential deployment. Berger reflects on what he notes, touches, finds, and sees. Things are, as it were, collected, kept, and thought out for us, but in a new way. A crafted thing from the past, looking to a landscape or building around him, suggests an artist, a work, or a person he knows and their communication with him. The result, as in Benjamin, is a present, "standing now," but one that is

vaster, for it is between us all. Flowers in a window lead to a memory of a bike rider and then a series of observations of cultural things, migrating to a reflection on globalization or the importance of preserving some threatened mode of living, returning to the flowers in the window and then the bike rider, now standing at his, and our side.

The journey or motion Berger enacts happens precisely the way an encompassing life would, were the world fully embodied, with spontaneity, imagination, thinking, object, and people working together. In cinematic terms, it is the opposite of a wide or traveling shot, or, in scripting and prose, making us identify with one plot, character, event, word, or theory after another. Closer to the work of American filmmaker Jon Jost, who also combines his personal perception, reflections, and aesthetic attention in essayistic films very much in a present, with Berger, we are free to experience as we join him, grounded in what he's discovering and pointing to. The montage, with its endless turning, brings us closer to a world that is real, around us, and under assault. Berger shows and speaks of this assault acutely, then shows how fact and reality answer it, giving us a place to resist along with him. Precisely like blocs of sound in free jazz, the reflections zig and zag, becoming memories in a score that, by taking turns, brings us to where we and others are, as readers, as plural people and things meeting for a while, then saying goodbye. Every moment is preserved and articulated. The piece, like the book as a whole, becomes a table around which parts of the world, and we, take turns. The world is indeed a kind of table. Living is living at that table that is the world. It is people and things all meeting at it, now.

The result is deeply cultural and political, simultaneously. Discrete and preserved parts of the world disclose and preserve what groundedness and resistance feel like. We get this sense in the experience of reading. The author turns us from the space of discourse to the sites it might

occur in, forefronting ground. This brings each part of the world to greater life, and yet, somehow, author or theory are not the center. Indeed, though he is writing from himself, autobiography and personal history are seldom highlighted in themselves. In a later book—where he "meets" his "mother" in site after site, after she has died, experiencing and presenting her as a kind of companion and teacher—family and personal history are not forefronted for themselves but as sites of encounter and account, as a door into the world. Berger speaks with his "mother" to show us what "she" sees. A protective wall, or safe space, has been constituted in our reading, to protect a living phenomenology. Text cuts through and transects the world, a world that is old and deep, real and actual. We are pointed to all this carries, that we carry, accompanying the author on his rounds as he accompanies us on ours. Response and responsibility come together in an object.

Berger's writing here, and in the volumes that followed, forms a kind of ongoing object-based schooling in a plural, existential, cultural preservation. Berger's early efforts advance, in *Keeping a Rendezvous*, into a more plural, democratic form that is still more oppositional and existential. Different things are never equivalent or the same, difference and openness are not about identity, the world is not a stage for discourse, things are *not* there for appropriation, theory, status, position, or success. Each of us, each thing, gets its proper sitedness and is important only to the extent others arise, remain different, and are sited and preserved. This renewal and protection, in word, in organization, in the commitment and lived life of the artist or writer, opens up a real and factual power. Berger shows that a text object, a cultural object, can create and sustain this. People, even the person next door or standing beside us, are fundamental to it. We are not anymore part of the endless plantations for the master knower and society's ceaseless production, taking us out of our world. We can go beyond

endless labor and the scramble to get and keep, of desiring, of entertainment, and most of all, we are not forced to judge ourselves, and think, according to specialized knowledge. Culture is not production, but preservation. It is what we choose to accompany us.

Berger's strategy and textual activity address a problem that is seldom addressed. Discourse that merely theorizes or produces knowledge is coercive. It imposes the command of a productive and bureaucratic anti-world: you do not matter as you are, you must learn this special thing, and I the author know it best, I can produce this knowledge, and further, you and I can find and keep positions from that. In reality, systems, knowledge, and expertise keep us fearful of stepping out of line or being branded for not knowing. This is partly the root of our ungrounding and our constant internalization of it. This ungroundedness can be answered, and easily. We can step *outside*, be encouraged on our rounds, defiantly, steadily, with determination. Culture can protect the fact we are there for the world, for existence, and for each and every last person and thing. The resistance to loss and assault is possible. This is precisely the responsibility of someone who, however briefly, gains stature in the public realm—to push, and push hard, to rescue a realm where reality, fact, plurality, and real, living people, facing erasure, need the protection culture, as a free and secure mediating space, can provide.

These are some of the concerns that animated my time at Beyond Baroque. What confronts us, when we try to go this way, was described well by D.H. Lawrence in his flawed, but great, 1923 masterpiece *Studies in Classic American Literature*. When we try to ground ourselves, we find a world long in the making, born at the beginning. We face a world of "barbed wire corrals," where we willingly stay, to produce, and most of all, to go along. Every depth is undone, and in that, endless crimes only accumulate mutely. But one can devise a response. Resistance can block and

respond to this cutting off from a shared world, manufacturing us for labor and production, and counteract it. A shared space engaging plurality and sitedness can be opened and sustained, in its ephemerality and its artifact. Culture can cut through and across the world and preserve the world for us, it can show us that ordinary sense, and not at all specialized knowledge, can step outside the social. It can teach resistance to every barbed-wire corral and come to life. It can challenge customary positions and experiences society presents us with—and that we may even crave—to neuter our sense, our curiosity, and our power. We can face what Olson, and Alcalay, call "the unrelieved." Our world can come back to us—not as new concepts or signs or theories, not as categories or discourse from those who "know better," not as things and people to appropriate, not as product, but as a home with a rich historical and plural shape, based in multiple realities worth preserving. We can be with each other this way, and indeed if we are ever to have the power that is truly ours, this is a better beginning than many.

The lesson all these varied experiments and forms share, in my work and the work of others, is that culture, art, and politics can be more than objects, their makers, their production, and their dissemination. They can be more than positioning for, and production in, society. Further, culture need not merely chronicle misfortune to answer it. It is not a game. It is not a job. Its mediation between art and politics stands before us each morning as a matter of life and death, for us, for our communities, for things, and for the world itself. For this world is constituted in neighborhoods, regions, and places, full of differing people and things. They need remembrance, witnessing, deepening, and preservation. What is missing is only their full, plural appearance and the spaces for that. Such spaces, and artifacts to affirm and remind us of such a space, can be built, sustained, and found.

No matter how robbed of power and fact systems labor so tenaciously to render us, no matter how demoralized we might be, culture can restore us and the world, showing us how to resist and find who we are and where, precisely when we are there. The experiences fostered while I was at Beyond Baroque show that if one rethinks culture's terms a little, culture can answer the crisis in appearance. It can build a school for us, as adults, where all that matters can appear and be responded to, be brought out of hiding in a privative realm, to join in a shared world that needs us all. Culture can point us forward and back—to a polis of resonant things and people, full of life and possibility. In the face of the assault on our reality, culture can assert our reality and our response to conditions. It can take a stand that is more than political or artistic. It can stand between, and mediate and arbitrate between politics and art. When the political and artistic seem unable to halt the assault on reality, culture can stand between them and protect both. Its starting place is a simple observation. When we, and others, are deprived of our human condition, we need the solidarity of all to assure us of our rightful place. For at the beginning of each day, we, and all things, are indeed, and need to be, "all here."

13.

In 2008, the kind people from the Los-Angeles-based Journal of Aesthetics & Protest invited me to participate in an informal political and cultural assembly in Central Los Angeles, staged in an empty supermarket parking lot on Alvarado Street, in Echo Park, at night. The spontaneous event involved food, music, talks, and temporary display of works proposing alternate systems of organization for agriculture, art, mapping, and other activities. I, deep in the middle of the second, bruising battle to renew, and now significantly extend Beyond Baroque's lease for its City building, had not been writing. I was in deep despair over worsening economic, political, and cultural conditions in the U.S.A. Yet another presidential election was looming, and while we all wanted change, something seemed fundamentally broken. In my life, two Venice poets I'd been very close to, and who had been crucial inspiration for my life at Beyond Baroque — John Thomas and Philomene Long — had died, under conditions no human should ever have to endure. I was keen to give voice to my semi-retired avatar, now a furious Freedom X, and devised a call. I alerted the organizers, and when I arrived, was handed a stapled cardboard megaphone and a box-crate to stand on. I turned to address the rag-tag but otherwise occupied gathering, under a buzzing, orange street light, lending to the dark, as street and roadway lights can in outdoor "public spaces" of the U.S.A, a prison-yard ambience. For this site-based performance, on May 20, 2008, I wanted Freedom X to summon the dead.

Calling All Freedom Ancestors!

Some years ago, a pied piper appeared on stage at Whiskey Pete's, the first casino in Nevada past the California border. In a glittering nightclub jacket, he announced to the audience he wanted to *suicide himself*. So said Jean Baudrillard, French philosopher of simulation.

Look around you, Los Angeles. That's what we're offered!
The nuclear society has done its handiwork.
Objects and people are melting.
The blast is channeling through us. It burns out and disappears us.
Desert winds blow radioactivity into our hearts and minds.
Everything is going—relations are going, freedom is going, people are going...
The nuclear casino is everywhere!
A casino for the implosion of the world!
A casino of life, matter, people, and every last thing!

Look down that street! Look into the sky!
This tawdry gambling joint is ripping our atoms and genes apart, it is obliterating us!
Artaud saw it all coming.
To be suicided by society.

We did not choose this!
We refuse the simulation!
We refuse this suicide!
We call out to all those suicided, come back!

Baudrillard: you are our Oscar Wilde, our Baudelaire, our Giradoux—a dandy, a Quisling, a Tolstoy, a Dostoevsky, a Hegel, perhaps even a Nietzsche of simulation...
But we've seen your stucco angel, Sir, No sir!
Give us back our *POETS*!

Charles Olson left the Democratic party!
Amiri Baraka went back to Newark!
Ed Dorn wrote about the gunslinger!
Muriel Rukeyser, years ago, called out this "long war," built by that Missouri gangster Harry Truman!
Jack Spicer refused the loyalty oath!
Bob Kaufman swore to silence!

Ferrini kept fighting, to his last breath, at a ripe old age!
Hello San Francisco! Hello Newark! Hello Gloucester!
WE NEED YOU WITH US!
Here, in this parking lot, in Los Angeles, NOW!!!

Where are *our* poets who refused to obey, who fought society to the end?
We have them here! Yes!
We have Stuart Perkoff, John Thomas, Philomene Long, even Bukowski...
Beloved ones. Troubled ones. Our describers.
Ones who REFUSED!
Not in San Francisco, or New York, or Boulder! Too many made their deals there!
Not you!!! You paid in full!!!
Here, in Los Angeles, our beats were *different*!

So few know or listen to you....
Suicided because you would not go along....
You died here, all too soon. In hospitals, on jail floors and apartment floors, stretched out, drunk, poisoned, exhausted, suicided, for what?
For your pain? For your sorrow? For your learning?
Because you made *mistakes*?
What about YOUR mistakes, SOCIETY??!!!
We know what YOU did. To Kerouac, at the end drunk and railing, broken by fame, by professionals, by race, by despair. Kerouac, we forgive you your last, desperate years!

The death of so many, suicided by society...
How can this EVER be forgiven?

But the democratic republic has its poets, too.
Ones who fought to prevent this!
Wendell Phillips! Warning us of the *rat in the statue* of the Constitution!

What else did he warn us of? That no man has ever emerged alive from the Democratic party! And the Republican party as well!

Listen! To Thaddeus Stevens! Forty acres and a mule!!

Listen! To Lincoln! There is freedom in the UNION and there is freedom in the SLAVE POWER, and they will NEVER be the same!

Listen! To Malcolm X! First among equals, tribune of self-government! Warning us the Canadian border was our Mason-Dixon line...You were so right, Malcolm. It's *all* Slavocracy, it's *all* the Confederacy!

But they could not suicide you!!

And so our bitterness, our pain, our sorrow grow, those of us still alive to speak.

We call out to you, FREEDOM ANCESTORS!
Help us cast off this vast plantation!
HEAR US, SAM ADAMS!!!
Stuck under a boulder in a Boston cemetery so you could *never* escape. Your birth-site not even marked! We know what that means!
Come back, help us fight this thing *beyond* empire!

For what do we have, now?
We have DICTATORSHIP and SLAVERY, GOODIES and GADGETS,
Y-I-P-P-E-E!!!!!!

Oh graveyard filled with death and dominion.
There are not only dead around us here. There are the suicided...

Come hear us, lend us your aid, teach us again,
OH FREEDOM ANCESTORS!
Help this inferno to crumble!

WE WILL NOT BE SLAVES!
WE WILL <u>NOT</u> BE SUICIDED!!!!

Oh freedom ancestors... Help us see and hear WHAT FREE-
DOM IS!

Our world is rubble, look around you...
This is the dictatorship of the *nuclear*.
The dictatorship and casino where no windows exist...
WE REFUSE IT!!!!

I am FREEDOM X in dead space, standing here.
I call out to ALL lovers of freedom.

Help build *our* spaces, *ALL* our public spaces!

Society! Give us our poets back!
We want our *NEIGHBORHOODS* back.
We want our *LANGUAGE* back.
We *demand* our *LAND, AIR, WATER, FOOD, and RIGHTS...
BACK!!!*

GIVE ALL OF IT BACK, NOW!

NO, a *JOB* is *NOT* enough!
It's not even a start! We won't be fooled again!
ANOTHER WORLD IS NOT POSSIBLE!!!!!

We want <u>*THIS*</u> world, <u>*OUR*</u> world, <u>*BACK*</u>!!!

So I say,
NO
to slavery
to beatings
to marching robots
to endless trumped-up charges

to all the *ghastly enthusiasms* of this thing beyond empire.

OH, FREEDOM ANCESTORS!
Help us find the safe harbor of *THE REPUBLIC!*

I am Freedom X in dead space, standing here.
THIS IS NO SLAVE MARKET!
You have NO SALE!

We REFUSE the virtual!
MEANING is ours!
REALITY is real!

Look around you, Los Angeles.
We have been *used.*
We *refuse* to be the avant-garde of simulation any more.
We say, this far and NO FURTHER!

I call out to ALL FREEDOM ANCESTORS!
Help us END *this theater of cruelty.*
This *war* on each and every last person and thing!

Failed activisms and theories stuff our eyes and ears and mouths and noses. They have us *gagged...*

END THIS THEATER THAT SCARS ALL FACES AND BINDS ALL LIMBS, THAT SLAYS ALL POETRY AND PO-ETS!

The earth is beneath our feet, the sky above,
Someone will hear this call.
For we can hear each other, and freedom is near...

CALLING ALL FREEDOM ANCESTORS!!!!
THE DICTATORSHIP OF NOBODY AND NOTHINGNESS MUST FALL!

....LONG LIVE THE REPUBLIC!!
....LONG LIVE THE SCHOOL OF PUBLIC LIFE!!!!

14.

One year later, on May 9, 2009, Simone Forti, Day, and I convened at the Institute of Contemporary Arts in London, to do a performance for the exhibition "Talk Show," invited by I.C.A. host Richard Birkett and writer and editor Will Holder. Our trio's principle of plurality and improvisation was born: the three of us coming together, each with a different practice, performing separately and together. Forti moved and spoke, Day moved and spoke, with slides, they did a duet, and I gave a talk about them and more. Improvisation is the heart of Day and Forti's practice, and I needed to learn from my friends and try the method. I brought a few quotes.

The long, 1965 quote from Charles Olson, found after my conversations with Alcalay, is from the collection Maximus to Gloucester, edited, with a superb forward, by writer Peter Anastas.

Drawing on my quotes, a reflection on my friends' performance, and the research I'd been doing, I sat down at a small round table and began.

A Different Kind of Research

It's been a long trip from Los Angeles to London. First, some history: I began working with Jeremiah at Beyond Baroque in L.A. where I was director, in the late-'90s. He introduced me to Simone, whom he'd met at her improvisation classes in moving and speaking in Los Angeles. They performed together at Beyond Baroque. Jeremiah was curating for us, he and I read texts together, he did other things there, and I began working with Simone on a book. The three of us go back to that period at Beyond Baroque, where we met and became friends.

One of the things that always interested me in my work is how poetry, language, thinking, and space relate. Especially as this reveals the difference between what might be

called discursive, declarative, or definitive statements and more poetic or metaphorical structures. What is extraordinary in the work of Jeremiah and Simone are their gaps, the emptinesses, the spaces they create as they move and speak. There's a meaning that comes out as they're moving and speaking freely. It is not from statement or definition or rhetoric in any conventional sense. It's from a space opened up by the improvisation, in the moment, to find what the moment brings. It unfolds from the body, researching, speaking, thinking, and editing thoughts, research, and words, moving, live, here, as you've just seen.

Jeremiah and Simone do a tremendous amount of research, then write freely from their research before each performance, to prepare: Simone from what is around her, in L.A., in Vermont, in Florence where she was born, what she's chosen to read and think out, Jeremiah similarly, with photography, in Alabama, Dublin, Massachusetts where he was born, L.A., Washington, D.C., Amsterdam. This emerges in the writing before each performance. They were busy writing this afternoon. What emerges is brought into public and edited here, as they move. Their moving in public governs the editing.

The book Will Holder mentioned, *Oh, Tongue*, is a series of poems and transcriptions of performances like this by Simone that I edited with her at Beyond Baroque. What I was interested in, as director of the center and as editor/publisher, was a way to capture text that is not conventional poetry or literature, but exists in *between*—between movements, between spaces, the way decisions are made moving and improvising, and how this produces a new thing. When put into text, it becomes a lasting object, and the spaces become different again. You would see the result in that book, as well as the book Jeremiah did of their work in Dublin. The text is a result of speaking and moving, it's language, this can become text. What feels like emptiness, here, tonight—in the moving, the silences, the

moments without speaking, the jumps, the gaps—produces a metaphorical or poetic aspect. But on the page it has a strange effect. The "object" of language—language and text as object—is dismantled, problematized, energized.

This brings me to the role of poetry in public space, its capacity to renew language, why poetry does this, why we turn to it. Poetry can be thought of—I think we've all suffered through this at some point—as in a book, as lifeless and dead. Then there's spoken word, let's say in slams and so on. There's a chasm between what we think of as spoken word and the book or page. But there's a third form Simone and Jeremiah have been exploring, separately and together, for a while. It involves research, investigation, performance, and this way of editing while moving.

An American poet, Charles Olson, spent an enormous time researching his seaport town of Gloucester, and over years wrote an extended work from that called *The Maximus Poems*. He had many things to say about his town, and everything was brought to bear. In a film on Olson, *Polis is This* by Henry Ferrini—nephew of my friend the poet Vincent Ferrini—landscape thinker John Stilgoe said of Olson, of his research, that to understand one place— place *exists*—you need every discipline you can bring. Olson didn't produce, let's say, a thesis or a sociological text or historical text, but something metaphoric, with huge gaps and spaces, literally, on the page. He brought space *in*. Olson describes metaphor as *a transfer of energy*. He had a background in the U.S. government, as the last rector of Black Mountain College, as a poet and thinker, and in this history in Gloucester he connects metaphor to place, its memory, to its people and fact. He brings everything to bear. Years later, Henry went through the town and interviewed the truck driver, the post man, the local grocer, the fishermen, they all remembered Olson because he had walked through the town every day, first as postman, then just walking. He would go to the library, he'd go abroad,

he'd go to Berkeley, he'd move *all over,* researching, walking, thinking, speaking, writing, and linking people and things.

On December 28, 1965, as part of a series of letters to his local Gloucester paper, Olson addresses the fact old parts of his town were being torn down and the banality driving that. He makes an extraordinary statement: "We are the created conditions of our own nature. Man is so stolen and cheated of creation as part actually of his own being. I propose Gloucester restore her original selectmen as her governing body solely to re-declare the ownership of all her public conditions, including the governance of anything in that body and the total electorate's judgment. No longer any appeal to eminent domain, or larger unit of topography or environment, than the precincts of the city's limit. In other words, to re-establish the principle of commoners, for ownership of commons, *he the commoner, we, Gloucester, be commons.*"

The principle of this statement, I think, lies in relating language, thinking, and world to what we have. Olson is standing there, against the politicians and economics. He's speaking face-to-face, poeticizing as he thinks and addresses all he is facing.

If any of this is going to mean anything, we need this kind of research and how it emerges, to think about where we are, where we came from, how we're moving, and what's happening: to speak about this, record it, appear, come together, and *move.* The primary is talking with each other, addressing each other about what's going on. The role of art is different from dialogue, although there's certainly "question" as Olson calls it, involved. But what is that question?

What's happening here, in live performance, is an attempt to build that sense of question through a non-one-to-one relationship between meanings, through metaphor, through gaps, through movement and, I don't want to say synthesis or wholeness, but, let's say, *bringing our faculties together.* What you saw just now looked like a

dance performance. But I'm sure in your mind, certainly in my mind, all kinds of things were moving. I had spaces to think about this, to think about that. Jeremiah and Simone talked about the fish, the birds, they had a conversation on economics. But when they talk, it's not like listening to Larry Summers or Gordon Brown, the Clinton and Blair officials. It's a strategy any one of us in this room can relate to. This is a huge plus.

I want to conclude with two quotes. On my first day here, I was in Charing Cross at the used bookstores, and happened upon a little 1906 book on a prime minister here two centuries ago, Sir Robert Walpole. He created the political two-party gimmick that is the heart of your problems and our problems in the U.S.A. This gimmick is met by two quotes by Londoners I brought. One is from Thomas Carlyle: "*Unreality is death to parliaments, and to all things.*" This sums up what we face, and this way of speaking about it arose here, first. Then, going further back to that patron saint of your city, John Milton, from *Paradise Lost*, Book 12: "*To speak all tongues, to do all miracles.*"

The notion of language and speech as the power to speak with tongues, to assemble and think, through our body, together, to move, amidst others: this is a way to research and present our lives. It's about response. This is a way to look at what happened here tonight. Jeremiah and Simone are exemplars.

I am referring to the movement of the human soul, in crisis, which, then, is forced to reexamine the depths from which it comes in order to strike water from the rock of inheritance.
James Baldwin, *Evidence of Things Not Seen,* 1985

Some months after the London gathering, this time the following April, Day, Forti, and I were invited to perform together again, in Los Angeles's Chinatown. Day suggested I make a text to hand out. I chose to do a paragraph by paragraph riff, or exegesis, on what remains for me the crucial section in Hannah Arendt's The Human Condition, dealing with "the space of appearance." In dialogue with Arendt, I found myself bringing in thoughts I'd had at Dexter Memorial Baptist Church in Montgomery, Alabama, where Martin Luther King Jr. had begun his work in 1955. There, King discovered with others a way to answer a problem that has become crucial for us: how can people free themselves when, because of long domination, they have no sense of who they are or their potential as free men and women? What can revive those who are beaten-down and demoralized, when the society is aligned to prevent this revival, using violence and lying to conquer everyone? How can people find themselves and each other? Who are they in actual fact, and who are those who run things, in actual fact? The Montgomery action in 1955 and 1956, known as "the bus boycott," is framed as a history story of Southern blacks and the Civil Rights movement. It seemed to me to have broader importance, especially for the contemporary crisis in appearance. This was one context for the intervention. Another contribution was my thoughts and discoveries concerning the poet and Black Mountain rector Charles Olson. The quote of Olson's in the previous intervention was, in looking back, the foundation for this next text.

The text was written in a fever over a weekend in New York, the performance in Los Angeles only a couple weeks away. My brother and I were clearing out the half-century home of our now deceased parents. It was where we'd both grown up. I'd left Beyond Baroque three months before, having not been paid in two years. I was drained from leading a final lease battle to secure the building and theater intact for the next twenty-five years. We had succeeded. One very long chapter was ending. The pamphlet was printed in Los Angeles, by my friend, a printer, painter, and Iraqi

Kurd, Mazin Sami, who'd done all the books I'd made for Beyond Baroque. Sami had lost his house in a bank foreclosure scam and was about to lose his press. Sami mustered to do an incredible job. This would prove the final work we would finish together, and it was beautiful: solid bright white stock, with an ivory card-stock cover, neat, and simple.

The Los Angeles performances that spurred the pamphlet took place at the Box Gallery, run by Mara McCarthy, on April 15th and 16th, 2010. The pamphlet took on a life of its own. The ending dealing with Rosa Parks was read aloud, a year and a half later, by Jerome Kohn, to begin his keynote for a conference on Arendt and lying in America that I was sitting in on at Bard College, in Fall 2011. Kohn had been Arendt's assistant at the New School in New York, was now the literary executor of the Hannah Arendt Blucher estate, had co-founded the Arendt Center at Bard, and had edited crucial posthumous collections of Arendt's writings. I was a nobody, and this was my first time meeting Kohn, having handed him the pamphlet only the day before. I'd been introduced to him by a Berlin friend, through Day, Wolfgang Heuer, also there to speak. Kohn's unexpected quotation from the pamphlet showed that those connecting to each other are indeed capable of incredible openness and kindness. This was a life preserver, and launched a great correspondence and friendship. The pamphlet was re-published in a Brooklyn literary and art magazine, Zen Monster. Its editor, Brian Unger, a poet and scholar who'd run for political office in his town, liked the pamphlet's principle of "face-to-face transmission" echoing, he said, the Zen method of teaching.

A Polis for New Conditions

Manifesting who we are, along with the need to protect this, each of us in our uniqueness and specificity as acting and speaking beings, brings us face-to-face with a perplexity. We tend to handle human affairs the way we handle

things we make, name, or can dispose of. The affairs that go on between us are, and remain, uncertain. They seem to frustrate and block action because human affairs are so impermanent. Yet this is more because of the way things are *organized*—to not preserve and protect them.

The fact we can act and speak to each other creates an overlay between us that is not one thing or many things, but what relates, separates, and binds us. It is not material. It is, in the felicitous words of Hannah Arendt, "the web of relationships." It is the realm that action and speech occur in and constitute. Without this realm, we are left in loneliness and unrelatedness, prey to the oxymoronic fiction of "self-interest." This in-between is actually what we have most in common. It establishes our plurality, and is as real as things in the world, yet completely different from them. Most importantly, it is not and cannot be *made*. What is between us, its space and time, its location and situation, can be simulated by and filled with materiality, but it cannot be supplanted in reality, only in fiction, only by taking us out of the world we are in. Countless forms over the centuries have been developed to fill this "between," to confuse and steer the web of relationships, to replace this real web with artificial webs and things to undo the political threat of our actual plurality. Our plurality is the target of a siege because it is nothing less than the ground of the people's capacities for independence, action, speech, and power. It is the ground of reality.

II

People want to and inevitably will disclose themselves, more even than through image, sound, or text, as distinct, unique, physical persons. This is where the great realm of mutual support arises, discovered centuries ago in what would become the United States, and that has continued to arise again and again here and elsewhere. The action and

speech protected by, and sustained in, this realm produce stories whose living reality is distinct from the realm of objects. The actor that is revealed and disclosed in the story is neither author nor producer; they are instead part of a storybook, one with neither beginning, middle, nor end, that is history. How we get to actor and speaker, and hold onto and relate and bind to this storybook, is the great existential challenge. This challenge has only grown more arduous with the acceleration of simulation and the capacity to fabricate non-worlds and anti-worlds. To initiate action and speech, to enact and remember them, is challenged by a society of fronts and their organizing unreality. For while action and speech start things, begin processes, they are not always apparent in them. They are not necessarily even put into, or recalled in, stories.

Institution and organization emerge out of action and speech, yet seem more often than not to bury these crucial constitutors of the public realm and the space of appearance. The relationship of institution and organization to action, speech, and especially remembering and preservation is barely understood. Made things, including laws and rules but also art works, materials of communication, and so on, are forms of organization forever playing their part in the web of relationships. Yet the unfolding of development and process, those things that merely play a part, seem to obscure the web of relationships, and most of all the action and speech that make this web up. Development and process, as well as artifact and institution, seem to actually make our right to government of our affairs increasingly hard to assert or sense. They create the fictional appearance of an invisible hand, or invisible hands, at work. Indeed, whole societies are now remade and destroyed to prove invisible hands really exist and decide our affairs, that we are powerless and not responsible for our world, that all is spectacle and play. Eventually, as with all the fictions in our era, evidence is generated to prove this farcical

logic is so. It is as if everything we see and hear and touch tells us that history is not a story of deeds and words but of machineries, bureaucracies, laws we have no say in, and anonymous processes with nobody responsible or in charge.

The actual storybook of history and nature is undone by such fictions. Stories that are not fictions seem, in the face of the coherency and logic of fiction, to be evanescent, unsupported, and impossible to reach. Going further, in the poststructuralist and postmodern era, actor and action seem to have been almost entirely thrown out. One is left to wonder: if stories do not seem to arise out of and remember actions, perhaps actions are indeed no longer relevant, perhaps stories truly can only be fiction. That the stories of history are not made but initiated, in a sense "created," by actions, however, means that we are part of a story whether we choose to see, hear, and encounter it, and each other, in past and present, or not.

For us to show who we are to each other, and to dedicate time and effort to enacting, remembering, and thinking this, seems, finally, to have been put to the side. Though we spend endless hours circling around this in relationships, the "who" is invariably treated more as a "what," as if speech could disclose without action, and action without speech, as if we were psyches and emotions and everything but actors and those who suffer from how and that things are organized. Our very speech which seeks appearance now seems to hide, to render private what is public, forcing us to disappear from each other and from ourselves. Yet it is a great irony and miracle that action becomes more meaningful the greater our fear or even cowardice. The opponent to memory, to protecting action and speech, it turns out, is not so much our cowardice and fear as it is the vast array of organizations that are no longer ours or organized by us. We are responsible for the world, yet have been robbed of our power in it. It is as if this is our world, while the government that organizes it is not and never was ours.

If we seemingly have lost the capacity to see, hear, and encounter ourselves and each other as actors and speakers, as "who" we are, as doers of deeds and speakers of words, as both actors and sufferers simultaneously, then this is merely because, more and more, the conditions we face are new. The many who preceded us and sought at great effort to enable us to see and hear and encounter all that is, who sought to build a roadbed for us, spoke by necessity to very, very different conditions. They could not have known that the difficulties of human existence would remain grave, and perhaps become even graver, or that artifice itself could become more dangerous than nature.

III

The story of actuality—that is, the story of reality, story that is not based on fiction—begins in repetition. When Walter Benjamin in 1939 said that we were losing the storyteller and so the capacity to exchange experiences, even with and perhaps especially because of technology, he was hinting at this crucial act of face-to-face transmission. By it, what was done and said by people could be repeated, recounted, remembered, and preserved, by them in the presence of each other, not to establish intimacy or assuage loneliness but to convey wisdom, such as it is, over generations. The story may be embellished, it may take extraordinary forms, it may even seem farfetched, yet this repetition points us back to the realm of our human affairs and the world we constitute, not to fiction. When Isak Dinesen spoke of two lovers clutching each other as they drifted to sea on an ice fragment, certain to disappear, it was to recount what some legend held, what can be told, to put into a story what is worth remembering because it was unforeseen, because its perplexity makes us think, because we *suffer*. When the Cherokee spoke of bad children cast into the earth and sprouting as pine trees, it was not fiction. It was fully as real

as our very different genealogies. When we hear the story of those who took words of democracy and the republic seriously and led others to fight for this seriousness, as has occurred over and over in our history, from Concord and Lexington, to Little Round Top at Gettysburg, to Montgomery, Alabama, we are in the storybook of history, and, in a sense, participators and representors of a great polis that is carried over and across space and time.

Stories can be remembered and enacted. It is here that meaning and reality arise and that fiction can be countered and put in its proper place. For what matters is what is between us, face-to-face. No matter how much this may be simulated or ignored, no matter how much we may want to ignore our actions and their consequences, it is having a space and time to disclose ourselves, to consider and preserve, that constitutes meaning. To imagine we could disclose ourselves while in isolation, to turn ourselves into operators, transmitters, and receivers of text, image, and sound, that we could communicate with others when we are ignoring those actually around us, is to imagine what never was and never will be. To act and speak, we need living people physically around us. Made things are in the world; action and speech are between us, not in the ether and invisible, but for all our senses working together. We make institutions or laws, but we cannot *make* anything in the realm of human affairs. The most extraordinary aspect of this puzzling and hard to grasp fact—and that we are forever under new conditions—is that we are dependent on each other for action and speech. The one who begins needs others to bring about, just as those who bring about need someone to act in order that they may even have something to realize. Plurality is the condition of action and speech. Yet all around us bureaucracies and fictions undo this traction in the world. The more alone or close together in a mass we are, the less distinct and plural we are, the more prone to fiction, and the less action and

speech have space and time to arise in, as they do and will, spontaneously. Our deeds and sufferings eventually cease to make sense because they cannot appear to us, publicly. The realm of human affairs is constituted by us, by each of us, and every action means consequent deeds and sufferings. No matter how hard it works, fiction cannot disappear our unique and plural actuality or our responsibility for this, for each other, for what we can recover and establish. It can merely make this impossible to grasp or sense.

Action opens things up and crosses every boundary. The great difficulty is that no framework, no matter how wisely constructed, can answer new generations and newcomers. Institutions and laws are frail, as are all human affairs and all matters that have to do with living together. Boundaries which protect and limit, which make identity possible and ensure it a public existence, lend stability to our affairs, and create our conditions. But conditions change. The classical concepts of hubris and moderation point to the consequences of this difficulty. They have to do with what does or doesn't hold up in human affairs, in contrast to the far more durable work of our hands.

Action not only has no bounds but is completely unpredictable, its consequences unforeseeable. It is because of this that story, storytelling, and remembrance become so crucial. The storyteller perceives the story and tells it, in a sense repeats it. This connects directly to what cannot change or be changed. Without stories, not only are experiences no longer exchanged and given a chance to last, but the stable existence and identity of human beings in human affairs becomes hard to sustain and cannot keep up. Everything slowly gives way to a great flux and liquidation. The people lose the capacity to see, hear, and encounter themselves and each other. Story, like poetry, preserves and points us to essence, even if it never reaches it. The great difficulty for us is that action and speech cannot occur without a space secured and a structure constituted for

them, where ensuing actions and stories can take place and be remembered.

The phrase "take place" proves crucial here. When something takes place, it both seizes the fact of place, establishes a constellation of possibility going forward, and confirms what has become. When poet Charles Olson recounted the deeds of sailors and fishermen in Gloucester, and people there decades later could remember these people and stories because of him, it was precisely to affirm the place where history occurs and that makes stories, actions, and history our very substance. It is the polis, the life of the people, that makes this possible and protects it. While action and speech are different from making, poetry, whose sense comes from fabrication, takes the foremost place in a kind of meeting ground between the evanescent and the ever-lasting. Poetry is born of the muse. The muse is nothing more than that which arises in our responses to the world. It is the spirit of response, our doorway into the world, into constitution of every kind. It is the heart of a non-fictional imagination, long before our minds fly off into fancy and dream.

What matters is relationships, establishing them, building them, and securing them. The kernel and preservation we find inside something like friendship brings us to the heart of the polis and its revolutionary, founding spirit. What is a polis? It is a space where the people govern with, and appear to, each other. The reason for a polis is to preserve and activate relationships, in the present and looking back, as we seek to preserve all that makes it worthwhile to be and come together, to return to each other to share words, deeds, recollections, opinions, decisions, hopes, and fears. The polis exists precisely so that each of us can distinguish ourselves with and from each other, for the chance anything will be remembered is not very good. As a result, securing a space for this remembrance becomes all the more important. The polis is the answer to this frailty

of human affairs. And in this, storyteller and poet are crucial but not enough. Storytellers and poets alone cannot be counted on to preserve the realm where their tales can arise and last and be remembered, the *place* where actions are remembered. Their role is remembrance and working meaning, not to establish and secure the space for that. Politics, the polis, alone can assure this—that what is discovered, what is new, and what occurred will endure. It is the polis that preserves; it is the means of witnessing, remembering, recounting, and assuring that existence of, by, and for the people, in Lincoln's immortal Gettysburg axiom, "shall not perish from the earth."

The polis is not merely a mode of remembrance. To put this another way, remembrance is not technological recording or telling. It does not matter and cannot endure except in the web of relationships. Witnessing and preserving need to happen face-to-face to truly matter, to bring to life our recording of things and memories in objects. It is in the face-to-face realm that they provide the foundation of all reality. Without the face-to-face realm, the world inevitably and inexorably becomes unreal, no matter how committed we may be to our authenticity or the authenticity of the world we are in, or to objects in all their solidity. The space of appearance, the polis, is nothing less than the space which protects reality, which assures that we are not only seen and heard but encountered and that we can see, hear, and encounter each other.

This encounter and its existential role in our power is precisely the point of attack under dictatorship and totalitarian rule. Under totalitarian rule, and under all tyranny, the web of relationships is destroyed. If action is the disclosure of who we are, if it needs others to occur, if it is out of action that the polis is constituted, then one can see why action and polis, the people and public life, human affairs and reality, go together and are attacked together. It is recent experiences that show how decisively institutions

cannot protect freedom, and that it is actually the reverse: it is our commitment to freedom that protects institutions.

The polis is not some archaic thing lost in the mists of history, but rather the very possibility of appearance and reality. It is that organization which sustains appearance and reality, that enacts and protects them. It can happen anywhere at any time, as long as the people are with each other in a place and time.

IV

What might a polis for new conditions be? There is no point in attempting to spell it out except in assembly, but the call for it can be made and echoed. One thing is certain: we have little left but the word. "Polis," even though it is the base for the word "politics," has lost its meaning and history. Another way to look at this would be to say that conditions have so changed that this word born millennia ago has lost its living presence, its glory in everyday life. To recover a sense of the word, we need to look back to founding principles as if for the first time, carrying them forward, examining and adapting them—for new conditions. This clear and ongoing examination and development is precisely what has not happened widely and in public for a very long time—*because it has not been permitted*. It has not happened fully and publicly since the forgotten people's upsurges with Robert La Follette, Sr. and the multi-racial Populists of the late 19th century. These moving assemblies were mercilessly attacked and defeated by the consolidation of a war state and two-party domination of electoral space—parties which, it must be said, operated, and operate by expropriating core words of the democratic republic, to destroy their life among the people. The core principles of the democratic republic have not been updated and examined widely by all the people, it would seem, virtually since Lincoln forced the whole country to do this, driven by

so many, bringing a great struggle for freedom into broad, public view. One could argue that Lincoln, tragically, was assassinated for having brought the words we most need into full and public debate by the whole country.

Advances since the Civil War have deepened aspects of democracy. They have, however, failed to concern themselves with freedom principles that all the people share and could engage in debate and action. This suppression has built slowly, until now it is as if society has replaced the body politic. It is very much true that society has advanced, and advanced quite far. Many more people have a voice, and things seem far more representative. Few of these advances, however, have been permitted to be framed fully, openly, and publicly to expand the depth and meaning of founding principles of a democratic republic for all.

One could say that, though American people have remained revolutionary and have constantly pushed, the apparatus crushing and simulating them has grown steadily, redoubling with each people's victory, beginning in 1896 with the fusion of the two parties into a facade for, and protection of, all cartels under Presidents McKinley and Teddy Roosevelt. Miracles have happened, however, and they need to be remembered for what they achieved. The unprecedented revolution begun in Montgomery, Alabama, in 1955, popularly called a "bus boycott," was nothing less than a radical non-cooperation movement of the people, as King preferred to call it. It sent ripples in every direction, bringing about changes we are still the beneficiaries of. Beaten and trapped people, held in place by a vicious psychological and political order, rediscovered their existence and their capacity to see, hear, and encounter each other, finding the power they always had and enacting it. They responded to the world, as a people, as a community, taking responsibility—answering the muse of response to the world as it is, to conditions as they are. The nature of a dictatorship was revealed, forced into appearance, the

people carrying, as the ancient Greeks were wont to say, the polis with them wherever they went, to rebuild the space of appearance. The lessons of this for the democratic republic, for all the people, nonetheless, and tragically, failed to materialize, swallowed by mere social freedom and social change. The general and public discussion and development of founding principles did not continue to advance to all the people. We are now face-to-face with the consequences of this. An upsurge of the people seeking representation and participation was answered by a growing and spreading simulation, crushing the people's power for representation and participation in the organization and conduct of their affairs. Today, the enormous productivity and abundance of society and its practical fictions has reached a seemingly irreversible stage. Instead of political freedom and real power to engage in governing our affairs, we have career, job, money, cartels, and an implacable, century-and-a-half tyranny of intertwined political monopolies. Yet the issue of political freedom and real power is no less pressing now, however baroque the usage of our key words may have become.

How might the polis, and principles of a democratic republic, be updated, how might we begin to think politically again, in shared, widespread discussion, not in response to issues or cult figures, but concerning how we are and are not able to govern our lives, and mutually support each other in this? How does this relate to made things, to culture and to meaning? How does this get picked up by artists and writers and neighbors? Democracy as a word revolves around participation. Republic as a word revolves around representation. The two are distinct and come together and support each other only through the organization of a broad democratic republic, one where the people can seek, and achieve, maximum public life. This would be the protection and security of *both* public and private.

V

The world comes first. What is this world? That which is between us, between things, forms a realm we have the absolute, inviolable right and duty to govern, to move in, build on and critique, to represent and participate in. A polis in which this would come alive can take many forms. The poet Olson, in describing his years as rector of Black Mountain, in 1968, spoke of that legendary gathering place of artists, writers, scientists, and students, in the mountains of North Carolina, as the only true "city" he had known, as the true urban place, even when it had no more than a dozen people present. It operated on what Olson called the "two minute principle." Anything could be proposed and assembled, be done and undone, in about two minutes. It took two minutes to get across the grounds, two minutes to reach someone, two minutes to start or end something, and, as we know now, probably about two minutes to change American art and literature forever. It reached, in a political way, the roots of society and knowledge. Olson had held a high position in the Democratic party and administration of Franklin Roosevelt, and—as several have examined, in particular Ammiel Alcalay—turned his back on this. Olson had, in fact, turned against the society, by taking what was, in reality, a vow of poverty. It was hardly only a turn from party politics. It meant a turn from the literary, academic, and press establishments. His research took preliminary form in his book on Melville, *Call Me Ishmael*. Before taking up at Black Mountain, Olson moved from Washington to a city he loved, the fishing port of Gloucester, there to focus on this relationship to the world and response to it. He began his research, or rather *continued* it, digging into a revolutionary place and spirit, to get at those who worked hard and often died for their work—the fishermen. Olson brought every discipline he could muster, to dig, then bring this up to a public realm to deepen it. This generosity flow-

ered in his friendships, at Black Mountain, and when that was over, in Olson's great letters to Gloucester, *The Maximus Poems*. These poems began out of, and were sustained by friendship with the Gloucester poet Vincent Ferrini.

Culture is concerned with our ground, with making, with work and poesis, with the made as it comes out of our experience on our own and with others, often out of friendship, in representation and participation. Culture has both public and private organization, and insofar as it is public it is political. In some ways, the artistic act is born in this meeting place. Indeed, it is because there is still such a thing as a democratic republic, in remembrance, based on still-living principles, that culture and politics can converge, separate, relate, and differentiate, that they can mean anything to us at all. Politics is always potentially the realm of the polis, for those affected by a policy have the inherent right to organize the conduct of their affairs in a shared world. Politics is the activity of the people, it is their life, the public life. While private life is immeasurably precious and needs protection, so does public life; each needs to be protected from the other, and both need to be protected from society. When the private overwhelms the public, or the public the private, discrete possibility is lost. Freedom ceases to make any sense or display any sense.

Imagination is crucial to this, to appearance, to envisioning how organization of appearance might work. Fiction can organize things and people, through propaganda, ideas, and belief. Fiction can organize our world. It is not the same as, or identical with imagination. Whether the organizing fiction is the Protocols of the Elders of Zion, a dream of some particular utopia of social organization, "weapons of mass destruction," or the notion everyone is nothing but genes or machinery, organizing fiction can fabricate evidence for its unreal logic, making it seem real when it is not. Fiction is the second most powerful tool in organizing the world. It can manufacture reality. When it organizes

things and people, it organizes them out of the world, even as it can create physical, if false, proof of its veracity. It creates unreality physically in the world. And when unreality stands between us, anything is possible. Facts are turned back into hypotheses, and hypotheses into an endless liquidation of fact. When we live under the conditions of fiction, when the imagination is dedicated to perpetuating fiction in the world, it is the imagination itself that organizes us out of the world, whether by lies, by glittering promises, or by sheer absurdity and farce. The imagination itself is immobilized, unable to fulfill its most crucial task: to help us deal with the world as it is and our existence in it.

This is why every discipline and field we know, have forgotten, and may yet envision is needed to comprehend a single piece of the earth, to bring it into the public realm. The task for artists, writers, and neighbors is not to invent and traffic in mere discourse but to *exchange experiences*. It is to get down to the roots of things and relations, to recover and rethink, and to update, founding principles for new conditions. This is the import of Olson's taking up, in the newspapers of Gloucester during the mid-to-late 1960s, problems of development and elimination of historic sites and buildings. In these letters, Olson speaks of recovering and re-establishing our "ownership of public conditions." This is nothing less than reassertion of a revolutionary New England legacy, a principle embodied in the town meeting form of government. It is much more than an expression of opinion. It is a principle for governing that is now giving way under the assault of society. Olson answered this, as if for the first time, making the link of preservation and power explicit, registering it as a pursuit of poetic and political response simultaneously. This form of public assertion, of recovering this assertion, may have been, may long have been, a kind of dream, but it was never a fiction. Public space is very poorly understood today, indeed it may not be understood at all. It is, as a result,

ever harder to sustain, secure, and maintain in its continuity in remembrance. Public space is space of, by, and for the people, and its protection and preservation require constant agitation, listening, and remembering. Society and the social seek to conquer and expropriate this public life, enlisting the people in this expropriation, making it appear power and reality should not and cannot belong among the plural people. The result is that it appears no one makes decisions, nor can we consider who did make them, or why they were made. Only by taking back "ownership of public conditions," and renewing our commitment to the "commons," Olson argued, can this be answered. Responsibility is reasserted, and so response. This is in some sense the root of the free spirit of poetry, for it is the muse that comes alive when we heed, and build upon, our response to the world. It is there that a non-fictional imagination is reborn as the lifeblood of the polis and a democratic republic concerned with protecting that.

VI

Olson in his final lectures, shortly before his death, spoke of "falling into the world." It is possible that a sense of poetic abandon can restore the breadth and depth not only of our senses but of our appearance in the world, for ourselves and for each other. Mario Savio, the famed Berkeley activist, during the 1960s, spoke of throwing one's body into the gears of the machine. To some extent, this is what the descendants of slaves and sharecroppers in Montgomery in 1955 were willing to do, and what was achieved by non-cooperation with a vast and evil system. In fact, however, the recovery of freedom and dignity meant throwing themselves not into the machine, to die, but into the world, to live. This was a new birth. The spirit of freedom is like this, it needs a place, it needs to "take place." It needs a very specific home and a specific time.

What preserves freedom and appearance? This is the great question for a people truly swamped in fiction. What if we were to not cooperate with the organizing fictions society uses to take us out of our world? What if we recognized how much power we actually have? What if we refused to remain in a secondary, subordinate, and humiliating position, and claimed the right to govern all our affairs, from top to bottom? While it is true the result of non-cooperation with fiction and the lie can be grueling, failing to heed our responses to the world, failing to heed the muse, to listen to and respect it, is fatal. Those who simply one day refused to take the bus to work—because some refused to sit where they were told to sit and were arrested—rediscovered themselves as a people, in all their power and richness, bringing Montgomery and eventually the whole Confederacy to a halt. They merely listened to themselves and each other, as if for the first time.

Culture, art, and writing form a crucial part of this listening to, and rediscovery of, the polis. The muse is the heart of freedom, not because the world is poetic but because responding to the world is the heart of action and speech. When a people finally stand up as a plural body— what Gandhi, the great anti-colonial influence on Martin Luther King, Jr. called *soul force*, the force for truth—it is the muse speaking at last, the muse given full speech, reviving the space of appearance and preservation of the memory and life of deeds and words. Words begin to mean something again, actions become effective. Artists, writers, and neighbors together have a stake in this meaning, for they are the ones who deal every day in response, and can, if they choose, keep it alive. When Thomas Carlyle said so many years ago that "unreality is death to parliaments, and to all things," it was to say, in a roundabout way, that being caught in a floating condition of non-truth and non-meaning, in propaganda lies, in what William Morris would call, some years later, "the puffery of wares," is nothing less

than to lose our soul, and so our truth. As King and those in Montgomery showed, as Olson showed in Gloucester, not cooperating with the lie starts something. It is the rebirth of action and speech, and reconnects us to the power that resides with us, between us, in the web of relationships. The total rule of unreality, of manufactured reality, does not block reality. It merely takes away our traction in it. It is as if we have been talked out of our experience, talked out of our power, talked out of the very world we are in. This is done by taking us out of responding to the world, and so out of poetry.

To not be trapped in fiction, to not be trapped in a cruel and brutal regime of confusion and unreality, requires non-cooperation with the lie. The price is steep, though not nearly as steep as it seems, for it occurs inside the web of relationships. The price of remaining within the lie, within fictions of commerce and violence, jockeying and attack, is higher, the highest of all. While action and suffering are two sides of the same coin, the revival of the space of appearance, of the polis, means our suffering can at last stand clear and be answered. Reality, our reality, can finally appear for us.

VII

To say that the polis is about self-government of, by, and for the people, in Lincoln's immortal words, is to elevate the matter of art, culture, writing, and thinking from its cellar in private, and privatized, life. It is to bring up geography, history, anthropology, music, mathematics, literature, art, all forms of work, and so on. To have a space to be in, to act and speak in, can be imagined in all its forms. For organization is our concern, just as addressing organization in all its forms is our concern. "Give me a solid place to stand and I will move the world"—this archaic statement from ancient Greek times, attributed to Archimedes, conveys something deep and essential about human existence and power. It

is related, by a kind of inversion, to Socrates, who came at this from the opposite direction. The stingray of thinking left one standing still, motionless on the ground, in awe of the world. Moved by the world yet motionless, unable to move, one was left only to *think*. To move the world, to be moved by it without moving—here are two primal and archaic, forever contemporary potentials. One would have to say, from where we stand, that we the people, as in each of us distinctly and altogether, are losing these great animators of soul, truth, and life. We are thoroughly immobilized and, it would seem, thoroughly unmoved by the world. We have fallen not into the world but into the abyss of ourselves, unmoved by the need to attend to the world we are in and in which we have played such a great role. This is not by chance, and to a very great extent, it is not even our doing, though we are responsible for it.

With all the suffering our deeds have caused here and across the earth, listening to the world, and to our responses in it, constitutes a beginning. An imagination that does not cooperate with the fictional organization of things, with invisible hands and anonymous processes, begins here, on the ground, in a real place and time, where we stand and move or do not move. A polis for new conditions means merely to look at what our new conditions are, not to become free of care but to bring core words back to life, to find common terms and senses which the different, plural people might share and care for. Simply standing still, refusing to cooperate with the bustle around us, listening and seeing and encountering who, where, and when we really are—this means to begin thinking. Socrates was, as we know, condemned to death by the Greek polis, and one could say, with justification, that the so-called "Western" tradition has moved little from what may be one of its founding crimes. Yet there are other facts. What role did ongoing war and expansionism play in the execution of Socrates? Socrates, in the end, refused the counsel of his

friends. He chose to be alone, to die, to cease the motionless moving which he brought to the polis, to cease to agitate for the public realm as a space of reflection, examination, and thinking. Socrates drank the hemlock, but we no longer need to follow him there. We have countless examples of the refusal to cooperate with an evil system and remaining not merely alive but more alive. We do not need merely to be a mob or a mass of lonely, desperate individuals moving this way and that. So-called powerlessness comes from failing to see the crucial thing: that we live in a shared world, that there is a commons to be sustained and preserved, and that thinking and imagining are what we need to answer the muse and our world, a world so diverse it can only equal reality itself. Whole empires have been rolled back by very small gatherings of people engaged in simple actions and speech together, refusing to abide by insane and farcical logics, lies, and deceptions, and there, to find countless others.

To be moved or to move is not the same as to be with. Who are we with? Do we respond to those around us, with us, do we think about what we share, and how we share it? What is it that we share? Friendship is in many respects our most profound experience, and it is there, in friendship, that we can begin to see what a polis truly is and could be. It is not merely contesting each other, or striving for excellence, though these play a role. For the space of appearance, the space of action and speech, is part and parcel of remembering, of experiencing all that is around us. This requires love for plurality and so the world which is not always easy. Here, art, writing, and culture, if they are not about entertainment and commerce, about making one's way in society, can build our capacity. They can be a mode of relating to each other that takes its cues from friendship, from engaging each other as separate, related, and different people committed to each other in mutual support and protection.

When Rosa Parks, following less known actions of others, refused to be humiliated and was willing to be

arrested for this, a spark was lit that animated a country and a world. For finally, she asserted what she had in common with many, many others. While she acted alone, she acted into the web of relationships. This changed every constellation. She showed how to take ownership of public conditions. She acted and "spoke" into a web of living presences, one she was deeply aware of, more aware, perhaps, than many have realized. Countless people like her, before and after, acted this way, both preceding her, making her deed possible, and following her, making new deeds possible. The frustrations and sufferings of neighbors, strangers, and friends had built and built, and finally led to action and speech, to non-cooperation with the lie, to resistance to the lie.

Each person who creates something, who seeks to speak and be heard, to see and be seen, to be encountered and to encounter has this power. In exercising it with others, one affirms and carries the polis, the space of appearance, to rejoin others in deed and word. To update and rethink a polis for new conditions: such an activity begins with words and with actions. It is there that the life of the people resides, and can begin anew.

Now is precisely the time when the country needs the counsel of all its citizens.

> *Senator Robert LaFollette, address to the U.S. Senate, on the eve of entering WWI, October 6, 1917*

Rise up and know that if you struggle for justice, you are never alone.

> *Martin Luther King, Jr., Birmingham, 1956*

16.

Invited to join Jeremiah Day's May 2011 reading group in Berlin, marking the 50th anniversary of Arendt's "Crisis in Culture" essay, and asked to deliver two talks for it, I took an apartment in Berlin. When the session was over, I continued the Arendt reading group at General Public, renaming it a "working group," and set about exploring, with those who came, Arendt's texts on friends like Walter Benjamin and Karl Jaspers, alongside texts of their own. In December 2011, Michael Schultz, my host and an active participant in our group, kindly forwarded an open-call email for an event at a sister institution in Berlin, Salon Populaire. The email proposed the night's topic: "What is power?" I sent in an abstract and was invited to open the evening. I spoke in front of young artists, activists, teachers, and arts professionals, in January 2012. In the aftermath of Tahrir Square and Occupy, I wanted to address what I felt had led the assembled protesters to tragically underestimate what they had. There were similar difficulties among artists in Berlin, distressed over accelerating gentrification and the sense a moment of extraordinary freedom was being lost. My thoughts, expressed in the opening line, grew from further reflection on the actions in Montgomery in 1955 and 1956, and how this had revived real public life. This resulted in real change, rather than disaster, repression, and mere imagery. The assumptions underlying recent protests, and affirmed in reigning theories, was that the system has power, power is a difficult thing, that it is something over there against us, and that the only solution is to oppose it or try to get it. The sad fact is that our notion of "government" clouds our notion of power, and vice versa. Both are clarified by the notion of self-government. We have learned to think that what power is is obvious. It is not.

What Is Power?

Power is actually the easiest thing, for it is what we *already* have. This is contrary to most everything we are taught.

We are taught we do not have power, that we must work to get power, that not we, but others have power, and often not even them, especially when it comes to bettering things and halting harm. Power is said to be hard. That it is easy and that we have it, of course, is not the same as knowing we have it, knowing what it is and would be, where it is, how to exercise it, or how it could easily answer all we face. Power cannot be taken from us. It exists, as it were, between all of us, not potentially, but inherently. It is what keeps every system, society, and situation going. The problem is, we can be deceived, and learn to deceive ourselves, about this. We can lose the sense of what is truly political, and so we lose what is right there among us.

Power, every day, is made to appear as if we do not have it, that it is not available to better things and make clear what is so. Every day, our so-called knowledge, our archives, our systems, our ideas, and our representatives teach us what is not so. Historians, critics, theorists, even those who call themselves, and are called, radicals, affirm what is not so. We are told we lack power, that it is beyond us, we must oppose it, and must try to get it, because we lack it. But when we do finally try to get it, it seems nowhere to be found. This usually ends badly, in impasse, in despair, in rage, in violence, or worse. Why do so many things end badly? Because we are defeated before the fight has even begun.

Systems and societies rest, in reality, on a fiction that organizes lives and things—that the world can go on as it does without our power or that it is power that oppresses us. In fact, it is the people, all of us, everywhere, who keep every situation, system, and society going. Nothing could go on at all without our power. Endless images, sounds, sense, and words are manufactured to hide this, to hide how much power is, and remains, between us, driving everything. Instead, power, the power to fix things, to preserve and realize our differences and reality, is *disappeared*.

The political is *disappeared*. We are trained to believe "it" is nowhere yet everywhere, controlling things, that power is something individuals and systems have, but not us. We are told we have it in a kind of final insult, because how we are told we have it is a fiction. None of this is so, not at all. Were we, all of us, to see that power remains between us, not with others, that it can be exercised, quickly, to repair and resolve, and that we could withdraw it at a moment's notice, we would reveal the true nature of its home among us. If we were to withdraw not our consent, but our power, we would discover what is so, and very fast indeed.

Systems and societies, with their parties and bureaucracies, are held together, for the most part, not by power, but by deception, lies, force, and *violation*. They are held together by making sure their rival, people, are violated and confused. Were we to withdraw the power that keeps this going, the reality and truth of power, and the system, would finally appear. For the system's nature, and the people's power, are hidden together—precisely so the people will never withdraw their power and discover it is they themselves who sustain things.

There is plenty of power to fix things, to end every impasse and violation, to make sure our differences are respected and can appear, and to form something utterly new. But here a second, massive fiction comes into play— that horrors are unresolvable, that they must go on and on, when even only a few could recompose things easily for everyone's benefit, and quickly. *That* would be power.

How is it possible something that is clearly so is not obvious? This brings us to the heart of the political question, the question we are taught every day, ingeniously, to avoid. How can power exist among and between all of us, yet we cannot sense it, do not believe we have it, and cease to believe it is even there? Because we are taught, each day, to confuse power with violence, with force, with control, with domination, with confusion, with systems and establishments, with

all their parties and bureaucracies. We are taught to think power is *over there*. Systems need us to believe this—that *they* exercise power, that *they* are the powerful ones, even when they harm things and people, obscure conditions, and keep freedom and public happiness far away.

We hear from theorists, as well as those justly angry, that power oppresses us, that it disciplines and punishes, that it does this or that, that it is communist or fascist or capitalist or military, that it exists everywhere controlling things, yet is not ours and is not available, between us, to end all our miseries. We hear over and over that the problems inside and outside us are *because of* power, that politicians, parties, bureaucracies, and the economy have power, that bosses have power, that technology, some organizing committee, some figure, some avant-garde or clique, some military or police force, every poobah everywhere, has power, that all those making our conditions worse and unreal *do so through power*. We hear and are told even our power figures, and the systems harming us, in the end, can do nothing to better things with all this "power" they claim to have and to be. They too, they always say, are powerless to change how things are. Societies and systems tell us every day that power is what ails, besieges, imprisons, and immiserates us, not that it is what can resolve and fix things easily. We are convinced power is a disaster. Everything and everyone, even those protesting or opposing, say power is the problem, it is not ours, it is not there for us, not now, *not quite yet*. It is impossible not to believe this. We must make a monumental effort simply to experience what is so, and to do so, we must unlearn everything we have been taught.

Reality, it turns out, is not a matter of *being*, but of *power* and *truth*. If we are convinced we do not have what we have—power—and so cannot recognize truth, we cannot possibly be real. If we cannot see we are real, we cannot find the power and truth we have. But how can we discover such things? If we do not exercise our power to fix and

repair, and if power figures do not exercise their power to fix and repair, none of us can be real, or have reality. We can never discover what is so or who we really are. Power will never be revealed where it actually is. Reality slips away, and in the end can be openly stolen. We are talked out of our power. There is the disaster, and there is the fight.

Society and its forms of knowledge and organization are able, by many tricks, to hide all that is true, disguising and disappearing our reality and our power—anything, it turns out, to keep us from withdrawing and exercising what keeps every situation, society, and system going. Society will do unspeakable things to us and the world, simply to tell us that things need to, and must, continue on as they are, that we cannot govern, that we must never govern, and that things cannot run better and more truthfully, and far more easily, for all of us. That is why systems and those who say they have power and knowledge say that power and knowledge are hard, and *they* have it. But this is not so, it was never so. They do not embody real power and real knowledge. Things could change overnight, and easily, in our favor, if we could see this. The fight is hard because it is over what we think is *real*.

Disclosing reality, it turns out, is what we are blocked from doing and having. For who contributes the power that makes things go? We do. But who defines what is real? By convincing us power is not ours, a system, a regime, a ruling order, even a military or police, a culture, but not the people, can define what is real when it is not real at all. What decides is what is disclosed, what appears. If we withdraw our power, rather than try to take it, or seek it, we show how we had the power all along, not the system. Then everyone will join. For power is, of course, what is at stake. Power is not resistance. It is not protest. It is knowing and showing the truth of who we are. How could this be? How could something seemingly so small be so important? Because we have been taught power is lying, violence, and force, when it is actually their opposite.

It is the capacity to fix and repair. But how could massive systems violating us not be real? Because they are not power, but violence, force, and deception. In the end, this is how it comes to seem as if non-entities, nobodies, and unreality have all the power, and that we, and those who rule us, are powerless to make things better.

Systems and societies know and make sure of a crucial thing: that the people remain confused about the most crucial fact in their lives. Even protests do this, saying we must get this power we do not yet have, we must mass together against power, we must do this or that, we must engage in endless, fruitless battles to have what we and everyone already have. Of course it seldom seems so. The forces arrayed against our power, our reality, our truth, and our freedom may be large indeed. But they are only force and lies. People can come together, and be with each other. But why is it always so hard for us to find and exercise power when we do? Because it is hard to see what is real: that we are the ones who keep everything going.

Climbers and leaders and those aspiring to rule scramble to hold and build position, pushing upwards, never "downwards" to *all* the people. To struggle "downwards" to all the people would be to lose position, to lose this thing called "power." In fact, it would be to join the people and reality and truth. For the people live in the world. They cannot appear because they do not know they are the power. Those who rise above become jealous and want to keep this fantastic set-up. Some even like being opposed to power, because then they have something to take and to get. Then they can become the ones with "power." Yet it is *our* power, the people in all situations, that keep things going: not the 51%, not the 99%, but 100%, even 1000% It is we who matter, and so it is we who must be tricked by those who seek to rise, to steer, to govern, to get and keep "power," telling us it is not ours, but somewhere else, and can only be somewhere else.

In reality, every leader and system and social form well knows that they are, in fact, on *loan*. They know the people could call their loan in tomorrow, or even sooner. This is why people who come together must be steered from truth and reality, so no one will ever challenge anything. The people are taught to not know truth, and by the people's leaders most of all. It is easy to control leaders. It is much easier than controlling the people. No wonder those who benefit from this convince themselves they are better, that they are the ones who "know" and have "power," because they are ones who *lead*. They must hide our loan, they must tell us we do not, all of us, keep everything going, and that power is not right there, right here, to improve things, now. They cannot hide power with power, because power remains with us. Those who rule can seek to take our power, but to do that would actually mean to halt the system and end things as they are. So they lie about what power is and where it is. They must turn to deception, and the hardest thing for us to resist, *self*-deception. They convince us it is not we who loaned power to them, and who keep everything going, but they who hold power and will decide what to do with it.

How power is represented is everything. It is easy in this to be convinced responsibility for the world is a burden, that it is better to just govern some tiny piece of the world, that only a few can stomach the whole thing because it is so onerous, that only some can handle it, even when they do a rotten job. This is the cruelest trick of all, because with power, things always go easier. Things could be resolved and improved more easily than anyone might imagine. *That* is power. That, indeed, is the *point* of power. If we knew that we and others already had that, and could exercise it, everything would go easier. But this must be hidden. Everything must seem hard and complex, that it's simply too hard and complicated to govern. This keeps every element in place, even as we rail, as we protest, as we

suffer, as we gather, as some of us are evicted or fired or jailed or even tortured and disappeared and killed. Nothing is better at silencing the people and destroying their discovery and recovery of their power than violence, force, and lies. Why? Because they undo and destroy the space of appearance, they make what is so vanish. If the reason for our miseries were to appear, if the "normal" and "proper" were to appear as they really are, we, the people, would take back everything, and now.

The people, taken out of everything, out of monitoring and governing politics and economics, out of science, media, religion, culture, art, and so-called knowledge, have been taken out of everything *except* what is so. The people, all of us, dimly sense this. But what can we do? We, those who hold up every society and system, are undone by this thing called knowledge, by this thing called power, by this thing called tradition, by this thing called authority, though they are neither knowledge nor power nor tradition nor authority. Every force and violation and deception society and political systems can muster, and they can muster a lot, takes aim at our senses to prevent us from grasping the one fact that could change everything.

This theft of our reality and our power is the lie. For do we come together to see and hear, to confirm all that is so? Are we, and all involved, there for each other, in mutual support, aid, description, repair, and governing? Do we have any idea how much power we have, how we keep everything going, and could withdraw this and end our misery, bringing back reality, in an instant?

It is unfortunate but a fact that what binds the people into the lie does so by undoing appearance itself. What organizes can have nothing to do with reality. This is how we are taught to believe we are powerless, even when we are together and could actually create a whole new government on the spot. Fiction, not power, corrupts. Why? Because destroying truth and appearance produces obscurity,

misery, and endless, insoluble problems. Power does not produce fiction, corruption, and insoluble problems. It is being convinced we are powerless that permits fiction, corruption, and insoluble problems to spread and multiply. Power does not oppress, it does not discipline and punish, it does not immiserate, it does not hit us over the head. Violence, force, lies, and deception oppress, discipline and punish, immiserate, and hit us over the head. They discipline, punish, immiserate, oppress and defeat *reality* and *truth*. They replace and shut down the space of appearance where all things could be disclosed and be addressed as they are.

We are the power that keeps everything going, and we deserve to have our power. This is no dream. It is real. What defeats us is a *weakness* in society, system, and situation, for nothing gets addressed. Reality is kept from appearing. Nothing is addressed because system and society rest on the lie. This is why self-deception becomes serious, why seeing power as a burden and a disaster is fatal. For when we are oppressed, a strange, unknown fact comes into play: the forces that call themselves powerful have *lost* power, for they have silenced our power, they have *violated* us, they have created *unreality*. This makes sure problems go unaddressed. In the lie, the system is exercising violence against reality and truth, and this is the opposite of power. Power and violence, power and the lie, are opposed. What those who claim power have actually gained is *illegitimacy*, and this is the one thing the people must never, ever learn.

When Rosa Parks refused to move, and was arrested, people joined her because she said the truth. She did not say she was 99%, or 51% or 5% or 1%. She said she was only one person. She spoke the truth about who she was, and others joined her, because the fact was, she was fed up, as were so many others. Those who kept the system going were fed up. And suddenly they saw they no longer had to lie that they loved and supported the system they kept going. They could act. They could shut down the

bus system, and so the whole city, and then the state. They did not show they opposed power, they showed they'd had it all along. They withdrew their participation and cooperation, and suddenly the truth was revealed. They could see, all of a sudden, who they all really were. They revealed they were the power, and that the system was not power. They discovered it was their power that kept things going. And so they simply said, we can do this thing, but we will not do that thing any more. And so the system was forced to reveal itself, and everyone could see, at last, what the problem was. What called itself power was never power. It was not complicated at all. It was violence, not power, and it was illegitimate.

Were we to withdraw our power, were we to not cooperate, were we to exercise and see our power, everything would come to a halt and become clear as it is. That would reveal our power, it would reveal the society, the system, and the lie. For it would disclose a truth, it would disclose reality, for us, of our power and who we are, who they are, all those who claim they have "power." To withdraw our power, to keep the system from going on, would disclose how crucial we are to each other and how much we keep everything going.

Power is nothing less than what we have and are. It is easy, not hard. We have never given power up because we cannot give it up, in spite of everything we are told, have been taught, and that situations keep telling us. Power remains with us. To discover power has remained ours, that it remains among all concerned, even in impasses and horrors, that it can be withdrawn, easily, and be exercised by us, quickly, to reveal power's true home—this is the beginning of politics. This is what brings to life, at last, the school of the people, the school of our lives, the school of reality, the school of all that needs to be, and must be, addressed. This is the school of public life.

When we withdraw the power that keeps everything going, we discover and begin to exercise and live in

reality. Everything can change for the better and become so much easier. This is happiness. We discover how much support there is, and that mutual support is the heart of power, our power. We have been trained to not see, to not find, even to resist and reject this mutuality that keeps everything going. But the people are a people, not atoms or trends or information or processes. And systems, regimes, and tyrannies are the first to practice resistance to reality and truth. They are the real resistance. They are the first to tell us we are not a people, that it is not our power that underlies everything, and that it is not we who keep everything going. This is so we will not govern, in fact, what we already govern. We are tricked so we do not govern things for ourselves, but keep everything going anyway, for them, for the lie. And *that* is reality.

Were we to withdraw our power we would bring our misery to a halt, and discover what is so. We would see that mutual support, power, and freedom are *inseparable*. As Martin Luther King, Jr. said, "All men are caught in an inescapable network of mutuality." But this is not just some beautiful image or fairy tale. This is the foundation of freedom and power and reality. Our freedom, power, and reality can be disappeared by the lie, but they are reborn in the truth, in mutuality, for they are connected, and they are real. Self-government, the claiming of our power, is merely to take what we have. It is the root of our freedom. It is true that if we believe we do not have freedom, we think we do not have power, and if we think we do not have power, we think we do not have freedom. But this is the most devastating fiction of all, for we already have freedom and power and truth and reality. We have each other. We must simply claim what is ours, and that is right there. It is the power to govern, and it is our freedom. It is the thing that establishes and keeps open the space of appearance. It defies every violence. It is what Gandhi and King called *soul force*. When we withdraw the power that keeps everything

going, we have not given power up, but taken it back, and everything appears as it is and the lie dissolves away. We can say at last, with Rosa Parks, "The only tired I was was tired of giving in." And everyone everywhere can see reality as it truly is, at last. The lie and its violence are revealed.

To secure our power is to appear as we are, as who we are. It is to show that what governs is ours, and it is this that kept, and keeps, everything going. It need only be claimed and be seen and heard and touched to learn what is so. Everything then goes so much easier. When power reveals itself as it is—as the power to fix and repair and restore the people and world to truth and reality—things can be addressed. We are the only ones who can do this, who can protect and secure things, who can protect and secure appearance, and make truth real at last. It is to see, at last, that what calls itself power is not power, that what calls itself knowledge is not knowledge, and finally what claims authority is nothing of the kind. It is illegitimacy. Illegitimacy is the true thing that is tiring, it is exhausting. For authority and knowledge are ours, and to be taught they are not is exhausting.

Power is the power to govern, it is the power to govern all representation and to govern all participation. It is our power alone to do that, and that is reality. We need only ask, who are we? When we withdraw what keeps every system and society going, we can find out who we are, in all our differences, in all our mutuality. It is to see at last that the governing we are turned against is not theirs, but our own, and to answer back, at last, with our own. It is to turn back the system and to answer every government with self-government.

This is the true beginning of the union of the people in what is so, in what is true, and what is real. For it is we, the people, who hold up the world, and we are all here. Our plurality is our power. Our power is our plurality. This is why only self-government can protect the school of public life, and why self-government is our *only* security.

When one asks what about the *people*, one response contains all others within it. It is we who keep everything going, it is we who actually govern. The answer to who we are is a truth, it is the greatest truth, it stands as clear as day. It is the easiest thing of all, for it is obvious.

Who are we?

We are *people*.

We are *the people*.

We are the ones who hold up the world.

Epilogue

As the book is concerned partly with words, a few words remain to be addressed. One is "intervention." While the word can be helpful, it has also developed a rather bad aroma. Intervention as a word is used all too often to describe overthrow, conquest, disregard, denial, even destruction. In the 1950s and 1960s, in the United States, when the federal government stepped in to force a militantly recalcitrant part of society, the South, to honor rights for all, this was a kind of intervention. It was not a lasting rebirth of self-government, even for those members of society treated so poorly. Federal intervention was very much perceived by local white rule to be conquest and overthrow. For blacks, in spite of their discovery of power, self-government continued to remain a distant dream. A great revolution was halted. Some got voting, and a better position in society, but this became enough. The sad lesson of this has expanded ever outward. Intervention, like resistance, on its own is neither good nor bad, just nor unjust. It cannot be the goal and end. Freedom is the goal, with self-government of, by, and for all, not mere representation or participation. What, then, should intervention seek? Does it seek to control or dominate? Or does it seek to step up, to open up a free space for people to appear where no such space existed, securing the activity of self-governing for all, and so their appearance, mutuality, and power? A beginning is only that, though it remains a lot. But what follows decides.

Do we have any business getting involved? "Intervention" in psychology often means to step into a crisis to help: one intervenes to save someone, for example, from an addiction, or from destroying themselves, or from hurting loved ones, or from violence. But this does not necessarily apply beyond friends and family. And there is a political problem: the blacks in Montgomery, on their own, independently intervened in the lie, indeed they intervened for their very lives. And the system felt quite intervened in. This intervention, for the segregationist system, was an assault, and the system responded with mass resistance and even greater lies. Martin Luther King, Jr. often described the

fighters for justice and freedom as an army. It was crucially, how-
ever, non-violent, and therein King discovered a great principle.
It was concerned with a kind of truth. Though truth as an abso-
lute is unknowable, here was a truth everyone could see. The goal
was not intervention, but to bring the space of appearance fully
into existence, to secure freedom.

Here, as in every case, first principle is crucial. Is in-
tervention to advance self-government of all the people, or is it
trying to assert and confuse, to use the word "self-government"
to advance something very different? Unfortunately, we have
some experience with this thorny problem in domestic and in-
ternational affairs. At a certain point, the only criteria may be
non-interference, or non-intervention, in the affairs of others.

To create neighborhood councils in Los Angeles was a
kind of intervention, achieved by only a few. But it was non-
interference in the larger body of the people's lives. It very much
did interfere with the City Council, countless politicians, and
various developers and businessmen who ruled, and continue to
rule, with near impunity. They will no doubt resist and seek to
intervene in their way. But the goal was to restore a little more
power, and thus freedom, to the people themselves. One might say
things were shifted, a tiny bit, onto their proper foundation. But
whether this shift will go further to a full, public life and reality
remains an open question. The system, every system, will resist
devolving power and reality back to the people, that is, where they
already are, and where they belong.

The actions and statements recounted here were intended
to be, and I have described them as interventions. In many cases,
they were made of "mere" words. They were intended to be, if not
always in fact, a form to show public speech can be thinking, that
pursuit of public space can be a kind of thinking for and amidst
the public. Did I seek to conquer or destroy or occupy? Some at
Beyond Baroque, the cultural center I became director of, saw my
work for public space not as an intervention for the people and
more freedom, but as a conquest that had to be reversed. It inter-
fered with agendas and goals. When I fought, I intervened in the

goals of others, for the building, for the site, for works, for people on behalf of public space as I saw it. I led two, bitter lease battles to protect this public space, and Beyond Baroque won both. The site is safe to govern itself for the foreseeable future. But what it does with its security is, and must be, an open question. How culture works and what it means is uncertain, fully as uncertain as the realm of politics. And while the cultural realm has been the primary field I have sought to work in and for, it was not there but in the political realm that an enduring and real change for people was achieved, and one small cultural space for the people was protected. I left Beyond Baroque, and though I helped secure its existence for long after me, the question of any lasting change in city culture remains unresolved.

Sometimes we need to intervene to build and protect public space, and then to fight very hard. This is clear. But it is also friends that constitute one crucial part of this. I could never have done what I did without courageous friends. While sometimes we need to intervene in friends' lives, we may need our friends to intervene in our life. Sometimes it is necessary to intervene in the life of our communities, cities, towns, villages, even our country. But how much would we wish for them to intervene in our life? Non-interference in the affairs of others may indeed be the only guide. But our affairs concerning a shared world, and culture itself, are a political matter of the first order. All these questions require more stories, more thinking, and more care. They require better questions, deeper questions, and finally no answer but the effort to deepen the working-together of thinking and practice.

Every struggle and story inherently involves twists and turns, and this, too, must be attended to. In January, 2013, in Los Angeles, I sat in on a neighborhood council history and evaluation session, held at the L.A.P.D.'s Parker Center auditorium downtown, to debate "reform" of the council system. I sensed the City was again trying to intervene in the councils, and so to neuter them. But there were many people there—many, many more than at our first N.C.M. meetings in the early 1990s—who felt this, and were eager to block this, or at the very least, to challenge and resist it. It was there

I learned that the Venice council had lastingly banned slate votes and was thriving. But this was not all. I learned the people had become, as I and others hoped, jealous of their power. They would not allow the City to intervene. They had their own form, and it was evolving. As the City was trying to push its "reform," the people in an auditorium in a non-descript police building, from neighborhood councils all over the city, were watching and questioning. And there I witnessed something I had believed might never happen.

An area the least responsive to our early push for councils, a Central American immigrant community in mid-city—beaten-down, under assault, and desperately poor—was beginning to come to political life on the question of their neighborhood. They had experienced, and helped initiate, immigrant rights' movements, and used them. But something else was now at work. The youngest members in the room, Spanish-speakers from the MacArthur Park neighborhood, were watching, listening, and engaged. After the meeting, when I approached them, I could feel their fire to bring power to their neighborhood, to step in and keep building their space. They had sat through the session with headphones, thanks to a City-provided translator into Spanish, their eyes and ears alert and alive. These youths were vigilant, understood all too well what was going on, and they were there to find out more about their new reality. A change in law had made this possible.

In May of the same year, at a later session of the so-called "reform" process, in Hollywood, I had a second such experience. Representatives elected from the various councils were there to discuss, with the City's Board of Neighborhood Commissioners, or B.O.N.C., whether to alter rules for the composition of the councils. There was vociferous debate over changing even tiny parts of the rules governing the councils. The process was jammed, as various representatives resisted and pushed, retreated and advanced. The City's effort at intervention was meeting heavy resistance, and the City's so-called supervisory body for the councils was not able to dictate. This, to me, was progress of a wholly new kind. At this May 2013 meeting, a neighborhood representative from one part of the city spoke to a representative

from another part, across a large table, with the City watching, and said to that other neighborhood's representative, not to the City: "We like how you formulated this, we agree." This was precisely what I had yearned for: elected representatives from different neighborhoods, in a vast, incomprehensible urban landscape, talking to each other through the aegis of their councils, across a table, not in secret, not in the City's administrative corridors, but in the open, on behalf of good ideas, challenging bad ideas, for their neighborhoods and for themselves and with each other.

A small, fragile, and tentative public realm has begun to exist in Los Angeles. Small, it is true, but something that did not exist before. Perhaps, in the end, this too will prove ephemeral. But the law is there. If all this was a simulation, it was far lighter, more truthful, the people had more of a say in governing it, and so a little more of the power to disperse and dispel raw fiction. A neighborhood council system, for the second largest city in the United States, is in place. As of 2013, there were ninety-five neighborhood councils in Los Angeles, in poor and rich communities, in different ethnic areas, in all shapes, sizes, and forms. It is also clear that, as the hearings above reveal, the attempt to intervene by those who "know better" and claim they have "power," is determined, will never let up, and will grow. But the people are there now, a little more, to answer back. And they will.

In Los Angeles, as in so many places everywhere, many think those who control appearance and run things know better, that the ordinary person, and neighborhoods, and every assembly, do not matter and deserve full meaning, and that the fight for public space as a space for all is a pipedream and a utopia. The words of the December 23, 2012 Los Angeles Times point to how this is sustained. For the last remaining city-wide newspaper, what was needed politically in the city was not power among the people, but "tightening rules on who is eligible to vote in neighborhood elections." This is always how it works, in every realm and place, since the beginning of time. Even in this, the paper that never covered the Neighborhood Councils Movement, and at the end only endorsed a need for a new Charter, hardly

the people's power, had to confess it was "Los Angeles' ongoing experiment in community representation." As astonishing and affirming as this recognition is, it hid the paper's long and revealing neglect, and how fierce the battle was to make even one tiny step. "The people" do not appear in the paper's begrudging, single-sentence summary. It is clear the people do not yet exist for the City. Further neighborhood assertion, by the people, in assembly, will be necessary. Still larger questions—what this means for public life in the cultural realm, and whether a larger public life stands a chance—remain to be addressed. But signs of "community" life in Los Angeles, if not precisely public life, have begun. Is it a secure public life for all the residents of the city? Is it a school of public life for all, where all pressing issues in the body politic and reality can be discussed, worked for, disclosed, and resolved? By no means. And the people could be out-maneuvered again by the system, rendering this fragile experiment stillborn. Perhaps it is a school only for a few more people, but an example has been set in motion. There are now a few more who will help protect it. And if they need support, perhaps new people, and better people than we were, will be there to help.

Meanwhile, the inadequacy of our definitions of public space, culture, and politics continues apace. At an academic conference at Harvard University's prestigious Design School in the winter of 2013, experts and experts-in-training assembled to discuss, yet again, as keeps happening, how to put "place" back in public space. The Conference program did not mention Los Angeles' ongoing experiment, and made no publicly announced effort to address the resistance of the center to power among the people—as the single, greatest thing undoing every place—still, two decades after I saw real people in bureaucracies of "knowledge," "power," "design," and "authority" dismissing power among the people. Two decades later, place and public space are still viewed—by "those who know" and claim "authority"—in social, architectural, physical, and administrative terms. And no less at Harvard, the most prestigious design school in the country. The contempt of experts and professionals is palpable, if always veiled, towards a school of real public life.

Politics and culture among the people, in and for their own gathered body—two decades on from the signal of the Los Angeles police acquittal and the riots that arose against it—remain a closed question for those at the center and in the schools and academies that train and discipline the center's new members. What was not to be found two decades ago, and is still not found now, among those who control virtually all our debates, is advocacy for a politics and a culture rooted in disclosing, and being accountable to, the people, as the only source, security, and foundation of power, freedom, knowledge, and authority. The ungrounding of reality, a long war against the people, continues. What remains, and will remain, however, are the political question and the cultural question. To ask, in the end, "What about the _people_?" is to discover how little what needs to be sensed and addressed is sensed and addressed still. Systems depend on not sensing or addressing, on not seeing or hearing, and those who neither sense nor address, and do not see or hear, and will not, exist to secure the lie and the growing misery it is exacting. Such people will continue, whether they know it or not, to crush the people as an empowered body, protecting the full capacity to address and think all that is so.

The reign of manufactured reality grows longer each day. But there is a different tradition, and if we listen we can hear it. It is a history that few recount and no system or bureaucracy will preserve and protect. It is the possibility, and reality, of the school of the people, and lives lived for and in that. Interventions on its behalf seem, to me, only more valid, just, and crucial. If public life is part of the history of revolutions, it is because it is the activity of the people holding onto their fair weight in all matters of truth, reality, self-government, authority, power, knowledge, and happiness. This may come in the form of interventions, but the right of the people to conduct their own affairs and fully answer their conditions remains first and can never be taken away. It is inherent, and it has its tradition, however dimly heard now. The work here is just one exercise in listening to, and amplifying, that tradition and that spirit.

The small test case of Los Angeles—one of the most hostile places on earth for the people's self-government and a culture commensurate with it—shows that even a place seemingly deaf to such a tradition can be turned a little, even overnight, by those open to the unexpected and unpredicted in events, committed to the people and their plural governing, and to thinking in the face of given reality. What has developed in Los Angeles may not yet be political, and it is most likely not yet anything close to self-government, but what happened there, in the range of my life, constituted a few small victories in the right direction. More will come. The councils remain intact. And fifteen years at a public space for poetry and culture, in Los Angeles—attempting to halt the reproduction of society and nurture culture in and for public life—no doubt also led to good things. Relationships that formed there have gone on to lead to new things, and those who might not have had a chance to explore possibilities in creative work and public life were fostered. This book is itself an artifact born of that affirmation.

The town-meeting/federal principle, the power to constitute, and the power to secure that constituting, take many forms and will. Even an artifact can spur on such efforts, and will lead in turn to other artifacts. It is the chain of such artifacts, and its role in memory, that endures, however hidden, to remind us, when events themselves have passed, that thinking and practice can work together and deepen each other. Whether specific instances and interventions succeed, what happened, with all its successes and failures, is an example. Some of the interventions may have been misplaced, but they were non-violent in every respect. The school of public life needs all such stories, it needs all such thinking, it needs sorrows and joys to be told. It needs an art, a culture, and a politics strong enough to protect the space of appearance enduringly. The people, reality, and thinking belong as inextricable, never-to-be parted friends. This is a friendship that needs every understanding, every protection, and it is the only form where security can have meaning.

Near the end of what would prove her final book during her life, Crises of the Republic, Hannah Arendt offered a sober-

ing reminder: "I am certainly not of the opinion that one can learn very much from history—for history constantly confronts us with what is new." This is surely one lesson of this book. But there are, nonetheless, Arendt added, "a couple of small things that it should be possible to learn," mainly "recognizing realities as such, and taking the trouble to think about them." It has been the purpose of this book, proposing a school for that, to show that such an activity can indeed be built and secured. Even more is possible if we are willing, wherever we can, to turn our attention at last in a new direction, toward building new spaces, not just of freedom, but where it is possible to "remember the Republic," and so build a form truly able to secure our freedom, our power, our rights, and our reality. That would mean building again, perhaps on a stronger, more solid foundation. There, perhaps at last, something broadly new could be born, something not at all manufactured, but rather found, and so strong enough to enduringly disclose all that was, is, and could be. That, indeed, would be a true school of public life. It is to that next step that this book is dedicated.

That is the political question. But culture and art are an integral part of these matters, even if they form their own questions. This book has focused much less on the cultural question, trying to address structure first. But a lingering matter has to do with the relation of art, politics, and culture. For example, can art be based in politics, and politics in art? One must ask the same of culture. These are fraught questions, and few answers are satisfactory. They also require more questions, more stories, more thinking, more care, and the working together of thinking and practice. Art and culture have a central role in political freedom and the people's self-government, and while they can exist under tyranny, they are usually the first to go under it, with people not far behind. To ask with art and culture "what about the _people_?" is to ask one of the most difficult questions there is. One thing is clear. This has nothing to do with popularity. Politics is not the nursery, but it is also certainly not high school. Our world has long since come of age.

It is for the people that all such concerns and stories are raised, and among whom they bear fruit or are lost. As such it is to these questions and potentials that the examples here are posed. For art and culture are concerned with meaning, and in the end, this is the first concern of politics as well. Can we find and preserve meaning, or will it be lost forever? Who will decide?

The School of Public Life
Fred Dewey

ISBN: 978-0-9889375-1-2
© the author

Errant Bodies Press: DOORMATS[4]
Los Angeles / Berlin
2014
www.errantbodies.org

Series editors: Riccardo Benassi and Brandon LaBelle
Printed: Druckhaus Köthen
Design: Riccardo Benassi

Focusing on contemporary issues, events, and discourses, DOORMATS is a series of publications aimed at contributing to the now, talking about issues that are present and that demand presence.

DOORMATS[1] - Franco Berardi Bifo
Skizo-Mails

DOORMATS[2] - Brandon LaBelle
Diary of an Imaginary Egyptian

DOORMATS[3] - Valentina Montero
By Reason or By Force: The Chilean neoliberal model and its implications for education and culture

DOORMATS[4] - Fred Dewey
The School of Public Life

DOORMATS[5] - Riccardo Benassi
Techno Casa

DOORMATS[6] - Lucia Farinati / Claudia Firth
The Force of Listening